creative
BIRD
PHOTOGRAPHY

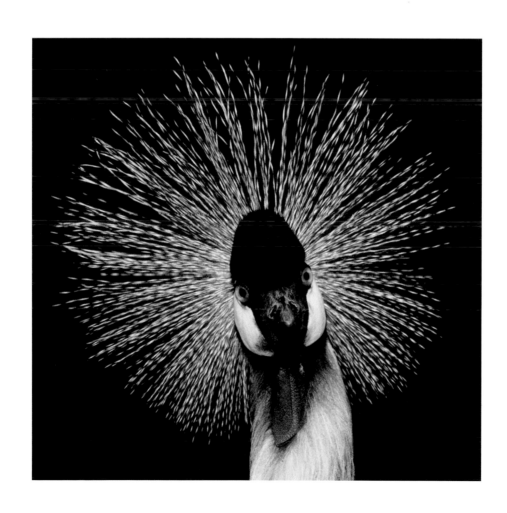

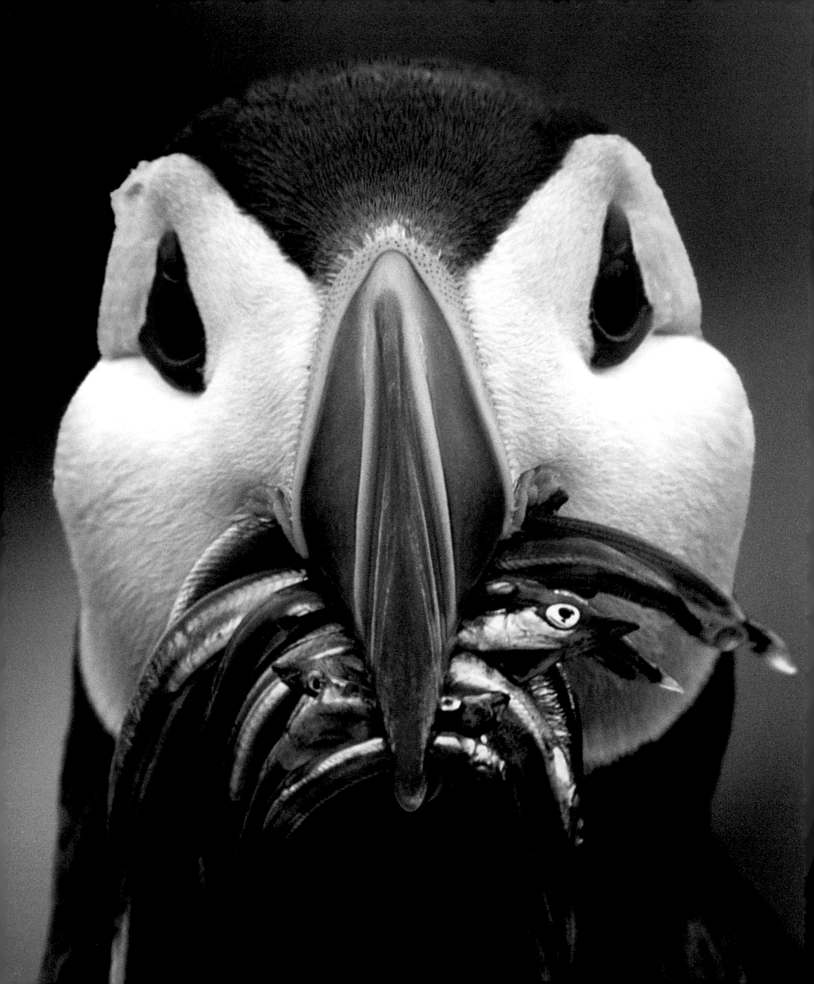

creative
BIRD
PHOTOGRAPHY

Bill Coster

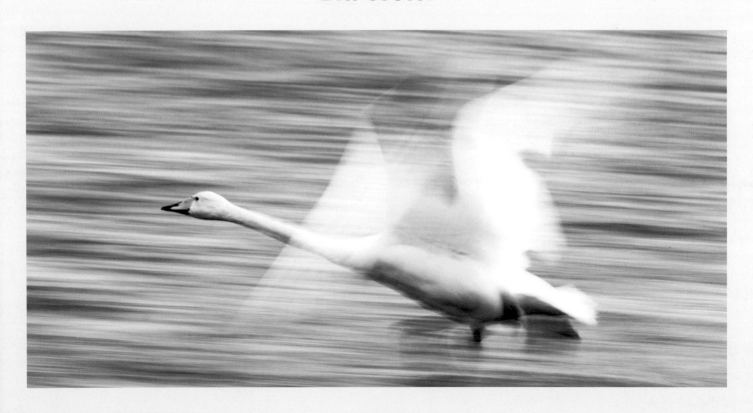

**To my wife Diana, whose love and support for everything
I do makes life so much more worthwhile**

First published in 2009 by New Holland Publishers (UK) Ltd
London • Cape Town • Sydney • Auckland
www.newhollandpublishers.com
Garfield House, 86–88 Edgware Road, London W2 2EA, UK
80 McKenzie Street, Cape Town 8001, South Africa
Unit 1, 66 Gibbes Street, Chatswood, New South Wales,
Australia 2067
218 Lake Road, Northcote, Auckland, New Zealand

10 9 8 7 6 5 4 3 2 1

ISBN 978 1 84773 509 6

Senior Editor: Krystyna Mayer
Design: Nicola Liddiard
Production: Melanie Dowland
Publisher: Simon Papps
Editorial Direction: Rosemary Wilkinson

Reproduction by Modern Age Repro House Ltd, Hong Kong
Printed and bound by Tien Wah Press, Singapore

Contents

Introduction

My interest in the natural world goes back to when I was child, although being brought up in the East End of London was probably not the best environment for searching out wildlife. No one in my family was interested in nature, so where or how I become so fascinated with it is a mystery, even to me. In the urban environment of my youth, it was small creatures such as insects that first caught my attention, mainly because there was quite a diverse range of them around, even in a cityscape. As I grew up and travelled further afield, my interests broadened while I encountered a much wider variety of animals and plants, particularly birds.

Photographing wildlife started as just a way of recording what I had seen, but gradually took over completely, until my trips away were centred around what I could photograph, rather than on how many different species I was likely to see. One aspect of bird photography particularly fascinated me – birds in flight. In the early days of slow films and manual focus there was not an abundance of flight shots around, and I discovered that I had a knack for taking them. This enabled me to carve out a niche in the market, getting published in bird magazines and eventually signing up with one of the top natural history agencies in Britain.

While all this was going on I was working in the IT industry, so I was at rather a disadvantage to many of the full-time photographers my pictures were competing against. As my sales increased, I finally decided the time was right and gave up the day job, something I have never regretted, even for a second. Now I travel the world to photograph landscapes, mammals, plants, insects and of course birds. This is a lifestyle I would never have dreamed of as a boy, searching for caterpillars on the waste ground between houses in London.

Bird photography is a surprisingly broad subject, covering not only different aspects of birds' behaviour, but also different ways of capturing this with a camera, from simple portraits to impressionist visions of the birds in their environment. To try and cover such a large subject matter in one go would be very confusing, so to simplify things I have divided

the main subject of bird photography into several categories, thus allowing us to concentrate on one aspect at a time. One chapter is devoted to each of these categories, using examples of pictures that are further split into the different aspects of the subject under discussion. So, for example, the chapter on flight photography contains sections on take-off, landing and flocking, with different images used for each aspect.

The book is loosely based on a series of articles I wrote as a photographic consultant for *Birds Illustrated* entitled 'Being creative with your camera'. A magazine article is necessarily quite brief, so the book contains not only many more pictures, but also more categories and much more information.

Although there is a chapter with advice on camera and computer equipment based on my own experience, the main thrust of the book is about using that most precious piece of photographic equipment – your creativity. There are quite a few books on the market that deal with the nuts and bolts of how to use your camera to get pictures of birds, covering the practical side of bird photography. In recent years, with the advent of digital photography, we have learned a whole new skill-set to make the most of digital images using software packages such as Adobe Photoshop, and there are countless books on this subject. It would be pointless to repeat this information in here.

Every image in the main section of the book includes exposure details where available, and the text contains information about the circumstances surrounding the making of each picture. The main focus of the book is on creating good images of the birds you meet, going about their often complex and fascinating lives.

Photography, like any art form, is very subjective, and what one person likes another may not. There are certain general 'rules' about composition, and I refer to some of them while discussing the pictures in the main part of the book. However, I've never been a great stickler for rules in many aspects of life, and over the years have developed an instinct as to what works and what doesn't. Viewed in this light, 'rules' can be seen as simply advice that could help to improve your pictures. They are not to be treated as tablets of stone, handed down from on high, but as gentle reminders that can help when starting out in the fascinating field of bird photography.

The basics

Advice on equipment is given later in this chapter, but if you are new to bird photography (or even photography itself), then a short, down-to-earth description of how to get the best out of your camera gear might be useful.

THE BASIC EFFECTS on the image of varying depth of field and shutter speeds are not covered in this chapter, as these are demonstrated and explained in the main part of the book. Studying the images and their captions should help you to get a feel for their general use. Broadly speaking, unless you are trying to achieve a specific effect, most bird photography is done at or near the maximum aperture of the lens to allow as fast a shutter speed as possible, minimizing camera shake and freezing any movement made by the bird itself. Putting these aspects aside, we are really only left with exposure and focusing to deal with when it comes to getting to grips with the basics of how to use your camera when photographing birds.

EXPOSURE

More than any other subject, exposure seems to confuse many people. Digital makes life easier, as I explain later, but a good grasp of the fundamentals of exposure will help you understand what to do in different lighting conditions.

Three variables that you control are used to determine the correct exposure. These are:

Aperture | This sets the size of the hole in your camera lens. The bigger the hole the more light you let through. Confusingly, the aperture values are counter intuitive, as the smaller the number the bigger the hole. Thus f4 lets in twice as much light as f5.6, which again lets in twice as much light as f8. Note from this that f4 lets in four times as much light as f8 and not twice as much as you may think.

Shutter Speed | This determines how long the camera shutter will be open to accept the light through the aperture of the camera lens when you take a picture. Shutter speed settings are simple as they refer to the time the shutter is open. Thus a setting of 1/500 indicates that the shutter will be open for 1/500th of a second. A setting of 1/1,000 is twice as fast as 1/500, so will let in half as much light as it is open half as long.

ISO | This used to refer to the film speed, but with digital you can set it to a whole range of values. The higher the number, the quicker the camera will record the image. The numbers are simple. ISO 400 is twice as fast as ISO 200.

Let's deal with the ISO setting first. Generally speaking, the higher the ISO setting the more noise you will get in your picture, so the poorer the quality. Most bird photographers use either 200 or 400 ISO, but the quality of pictures at higher ISOs is constantly improving, and in the future we will be able to use much higher values. For now let's set the ISO at a constant ISO 400. That done we can forget it and move on to the other variables.

Aperture and shutter speed work together to allow a certain amount of light through to the cameras sensor. A bigger aperture lets in more light, so a faster shutter speed will be required to limit the amount of time the sensor is exposed to the light. Thus 1/500th of a second at an aperture of f5.6 will produce the same exposure as 1/1,000th of a second at f4 or 1/250th of a second at f8. The total amount of light reaching the camera's sensor is the same in each case. At 1/1,000th of a second at f4 you have a lot of light for a short time. At 1/250th of a second

at f8 you have a quarter of the light, but the sensor is exposed for four times the amount of time.

Assuming that your ISO is always set the same, your sensor will require the same amount of light to make the correct exposure. The brightness of the light available plays a significant role here, as to make up the total amount of light required for the exposure will take a lot longer on a cloudy day than on a sunny one. An exposure of 1/2,000th at f5.6 may be correct when a bird is in bright sunshine, but 1/125th at f4 might be required as dusk approaches on a cloudy day. The total amount of light required for exposure remains the same, however. It just takes longer to collect enough of it when it is dull than it does when it is bright.

We have established how exposure works and what we use to control it, but why bother when the camera has automatic exposure modes that work it all out for you? Auto exposure is a good starting point, but it fails in many situations because it is based on a key assumption – that the world is a uniform mid-tone (often referred to as 18 per cent grey). This means that it calculates the amount of light it requires for an exposure assuming that the image it is capturing is of an even mid-tone. However, in many situations the overall exposure will not be mid-tone, so the exposure will not be correct.

In bird photography, one approach that works well is to ignore the background and expose for the bird. If your main subject is well exposed, the picture is much more likely to work. When, for example, you are photographing a bird in flight, a blue sky generally tends to be brighter than mid-tone, so the camera's exposure system tends to underexpose it. This makes the sky a nice deep blue

colour, but the bird itself is likely to be underexposed. When photographing birds in flight against any background it is always best to set the exposure for the bird manually, because when tracking the bird the background could well change – for example if the flying bird passes a white fluffy cloud, which will play havoc with the camera's exposure meter. See also the examples of Grey Herons on pages 12–13 for the effect of backgrounds on exposure.

One of the most common problems arises in the exposure of white birds or birds with large amounts of white on them. If set to a mid-tone exposure, the white areas of the bird will almost certainly be overexposed. A white bird usually requires a full stop less exposure than a 'normal' bird. For example, when photographing in Britain on a bright, sunny day, my standard exposure would be 1/2,000th second at f5.6 for something like a Mallard in flight. In the same conditions, when photographing a swan in flight I would expose at 1/2,000th second at f8 – i.e. I let half as much light into the camera for the swan as I do for the Mallard. If I let the same amount of light in as I would for the Mallard, this would be too much for the sensor to handle and the swan would be overexposed. In the swan picture the background will be darker than the same background for the Mallard, but as long as the main subject is correctly exposed you can get away with this.

These effects can clearly be seen in the two images overleaf, taken in similar conditions during a British winter. Both are correctly exposed, but the swan picture required half as much light as the Mallard picture. The water in the swan picture appears darker, as explained above – it actually looks good, though it is a stop underexposed.

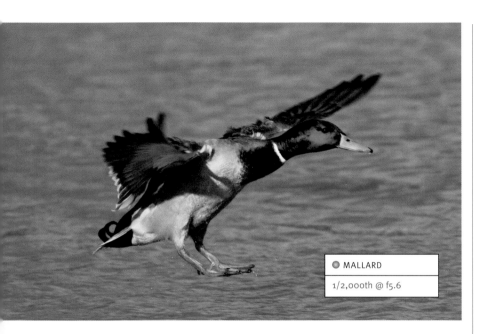

MALLARD
1/2,000th @ f5.6

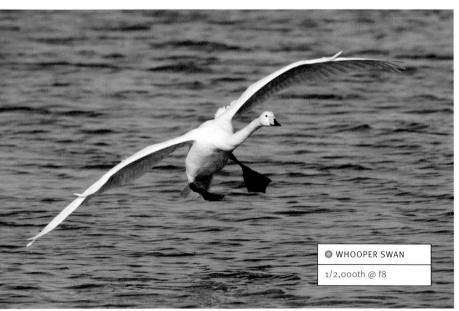

WHOOPER SWAN
1/2,000th @ f8

CHECKING THE EXPOSURE WITH DIGITAL

As mentioned at the start of this chapter, digital has made the whole process of getting the exposure right easier. A digital camera's meter will get things wrong just as easily as a film camera, but the camera can provide you with instant feedback, allowing you to check whether the exposure is correct immediately after you have taken a picture. You cannot determine whether the exposure was correct from the little picture on the back of the camera. However, by setting the highlight alert feature on, you can tell if any areas of the image are overexposed, as they will blink on and off continuously. Overexposed highlights are one of the biggest problems, so this is a useful feature.

Of course, this feature only deals with overexposure; for a more complete review of the exposure, you need to look at the histogram that can be displayed with every image on the back of the camera. The histogram is a graph showing how the light used to expose the image is distributed. The higher the 'mound' on the graph, the more light has been recorded at that particular intensity. The mid-tone is (unsurprisingly) in the middle of the graph. Anything to the left of the mid-point is getting progressively darker until the left edge, which is black. Anything to the right of the mid-point is getting progressively lighter until the right edge, which is white.

If you have overexposed the image there will be a sharp peak on the right-hand side, and if the image is underexposed there will be a sharp peak on the left-hand side.

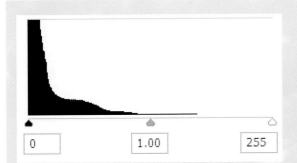

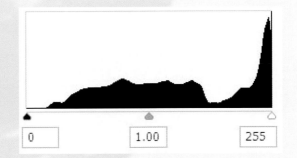

THIS HISTOGRAM SHOWS AN IMAGE THAT HAS BEEN UNDEREXPOSED. THE LARGE PEAK UP AGAINST THE LEFT EDGE OF THE HISTOGRAM INDICATES THAT MUCH OF THE DARKER AREAS OF THE IMAGE HAVE BEEN LOST AND ARE NOT RECOVERABLE. YOU CAN ALSO SEE THAT THE RIGHT-HAND THIRD OF THE HISTOGRAM SHOWS NO DATA AT ALL, BECAUSE THE HIGHLIGHTS HAVE BEEN RECORDED AS MID-TONES.

THIS HISTOGRAM SHOWS AN IMAGE THAT HAS BEEN OVEREXPOSED. THE LARGE PEAK IS NOW UP AGAINST THE RIGHT-HAND SIDE OF THE IMAGE. THIS INDICATES THAT THE HIGHLIGHTS HAVE BEEN BLOWN OUT AND ARE NOT RECOVERABLE. THERE ARE NO BLANK AREAS TO THE LEFT OF THE HISTOGRAM, SO TO CORRECTLY EXPOSE THIS SUBJECT SOME OF THE DETAIL IN THE DARKEST AREAS OF THE IMAGE WILL HAVE TO BE SACRIFICED WHEN THE IMAGE IS CORRECTLY EXPOSED. GIVEN THE CHOICE OF KEEPING EITHER THE HIGHLIGHTS OR THE SHADOW DETAIL, ALWAYS KEEP THE HIGHLIGHTS.

Generally speaking, you want all of the information to be recorded and not touching either edge. Of course, it is perfectly possible to achieve this and not have the correct exposure, because the image could still be either overexposed or underexposed and remain within the histogram's boundaries.

One general rule that many photographers employ is to ensure that the brightest part of the image is close to but not over the right-hand side. This ensures (due to the way that the sensor records the data) that you are capturing the maximum amount of data to make the image as high in quality as possible. This is certainly the technique that I use. As long as no data has been lost, the exact exposure can be set later, when processing the RAW image.

It takes practice to get to the point where you can understand the histogram, but hopefully the following three images, shown with their histograms, will help you get started. All three images were taken on the same day in the same bright sunlit conditions, and the exposure was the same for each of them (1/1,250th sec @ f8). All are correctly exposed, but the histograms are far from alike.

HERE WE HAVE A CLASSIC MID-TONE EXPOSURE, WITH THE DATA BEING SPREAD ACROSS THE HISTOGRAM, PEAKING IN THE CENTRE. BOTH THE BACKGROUND AND THE BIRD ARE ABOUT THE SAME TONE. IF ONLY ALL SITUATIONS WERE LIKE THIS, WE'D HARDLY EVER GET THE EXPOSURE WRONG.

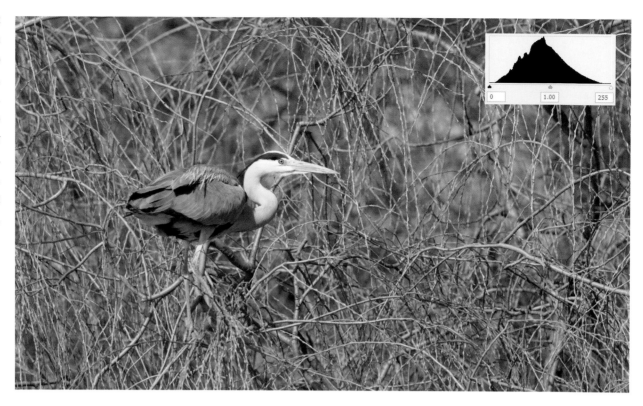

HERE, THE BLACK LINE ON THE BOTTOM OF THE GRAPH EXTENDS RIGHT UP TO THE RIGHT-HAND SIDE. THIS REPRESENTS THE PALEST PART OF THE BIRD AND IF THE EXPOSURE HAD BEEN JUST A LITTLE BIT LONGER, THIS DATA WOULD HAVE BEEN SHOWN PILED UP AGAINST THE RIGHT EDGE WITH THE HIGHLIGHTS BLOWN OUT. THE REASON WHY THE HISTOGRAM LOOKS AS IT DOES IS THAT MOST OF THE IMAGE IS MADE UP OF THE SHADED TREES THAT FORM THE BACKGROUND.

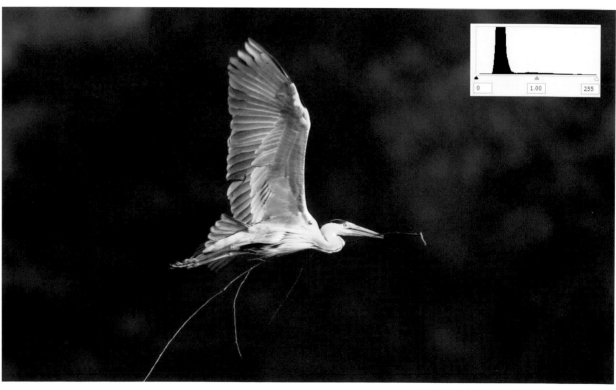

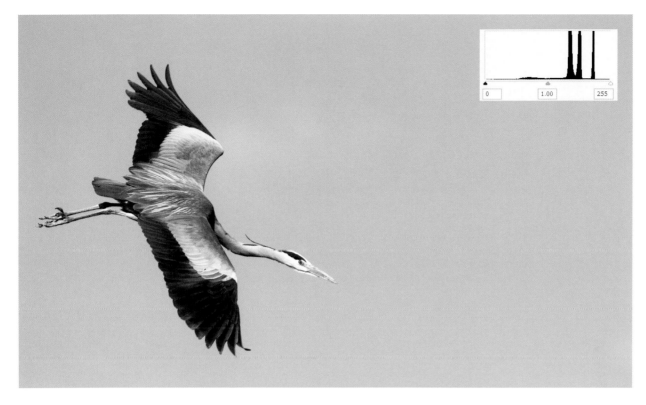

FOCUSING

I use autofocus virtually all of the time in bird photography, but it is important to select the correct 'mode' for the type of picture you are taking. There are usually two modes, one that tracks the subject constantly (AI Servo) and one that doesn't (One Shot). When trying to follow a subject that is moving around a lot, such as a bird in flight, it is essential to use AI Servo. This will keep (or at least try to keep) the subject in focus as long as you manage to keep it in the viewfinder. When I photograph birds in flight I activate as many of the camera's autofocus points as possible, although other photographers will swear that you should only use the central focusing point.

One Shot autofocus – to my mind – is not a very good description, because it gives the distinct impression that you can only take one picture at a time, which is not in fact the case. With One Shot, the camera focuses as you 'half' press the shutter release, just as it does in AI Servo mode. The difference here is that instead of now attempting to track the bird, the focus point will not change while you keep pressure on the release button.

This is extremely useful, because it enables you to focus the camera on the eye of a bird, then reposition it in the frame without the focal point changing. It only works if the bird is not moving around, but it is the best method of allowing you to compose the image without autofocus wandering about all over the place searching for something to focus on. I only ever use the central focus sensor in this mode – I simply and easily position this on the part of the bird I want to appear the sharpest, before recomposing.

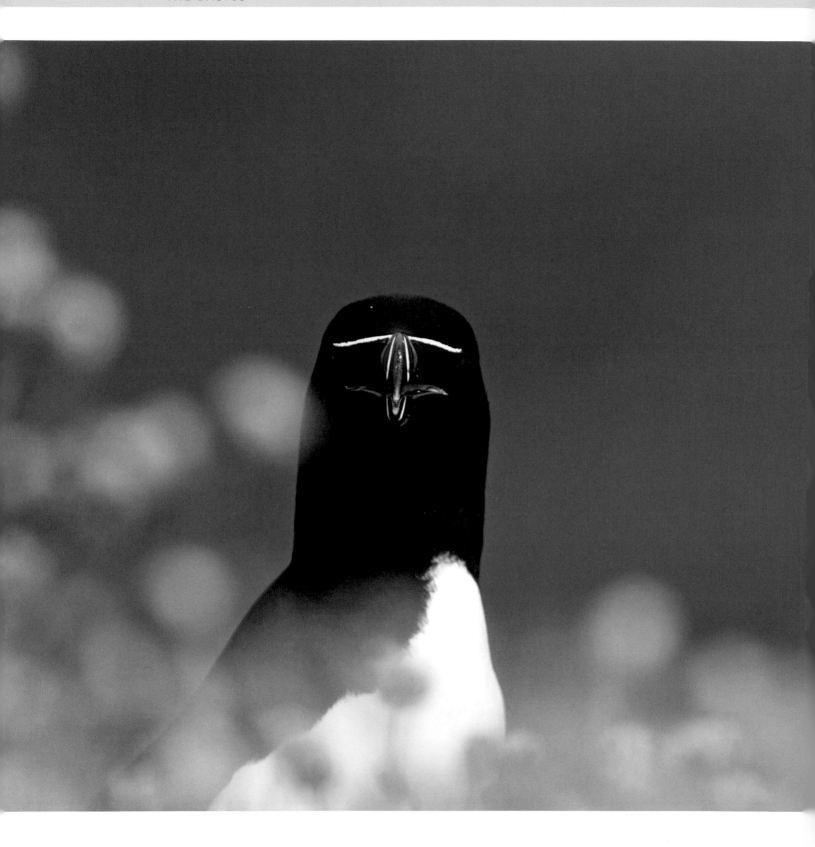

FOR THIS IMAGE OF A RAZORBILL,
I USED ONE SHOT AUTOFOCUS BY
POSITIONING THE CENTRAL
FOCUSING POINT ON THE BIRD'S
HEAD AND DEPRESSING THE
SHUTTER HALF-WAY TO OBTAIN
FOCUS. KEEPING MY FINGER
ON THE SHUTTER BUTTON,
I REPOSITIONED THE CAMERA TO
A MORE PLEASING COMPOSITION
AND TOOK SEVERAL SHOTS. IF I
HAD BEEN USING AI SERVO MODE
WITH THE CENTRAL FOCUS POINT,
AS SOON AS I REPOSITIONED THE
CAMERA IT WOULD HAVE
REFOCUSED ON THE SEA BEHIND.
IT WOULD HAVE BEEN POSSIBLE
TO SELECT A FOCUS POINT THAT
WOULD HAVE BEEN TO THE LEFT
OF CENTRE AND ON THE BIRD'S
HEAD. THIS WOULD HAVE
WORKED IN EITHER MODE, BUT IS
A BIT FIDDLY TO SET UP AND
WOULD NEED TO BE RESET FOR
EVERY NEW COMPOSITION.

Digital cameras and equipment

There is no doubt that the move to digital has revolutionized bird photography in the last few years and, however much you may hear claims to the contrary, film is pretty much dead, in this field at least. Instant feedback, an unlimited supply of digital 'film', usable high ISO and no more airport X-rays are just some of the joys of digital capture. It is easy to get carried away with the advantages of digital over film, but it is not all one-way traffic and there are a couple of areas where film had an advantage.

THE FIRST IS IN THE CAPTURE ITSELF, as due to the way that digital capture works, only a very small proportion of the data that is recorded is from the dark shadow areas of the image, so in this respect digital can compare unfavourably with film. The other big disadvantage of digital compared with film is that when you part with your hard-earned cash for the latest digital camera body, you are effectively buying all the digital 'film' for the entire life of the camera. This means that the camera body now has a much more important role in producing high-quality images than when using a film camera. Before digital came along the most important elements of a high-quality image were the lens and the film. I could produce the same quality of image from a pro spec SLR as I could from a bottom of the range SLR from the same manufacturer by using the same lens and film with each body. There were lots of advantages to the pro spec camera, such as durability and faster shutter speed, but you couldn't tell which camera body had been used when viewing the slides. Not so with digital. In general, the more money you spend, the more megapixels you get and the better the quality of your final image.

One side effect of having the 'film' locked into the camera body is that as this relatively young technology develops, each new camera that hits the market is probably cheaper and produces higher resolution images than your current model. In order to compete in the quality stakes you have to buy a new camera relatively often (and of course your old one will have depreciated massively in the meantime). Good for the manufacturers, not for the photographer. In the days of film, when a higher-quality film was introduced no investment in new equipment was required. Having pointed out the disadvantages, I must say that like many others who rather begrudgingly moved to digital a few years ago, I could never go back to film.

Digital capture enables you to record the image in one of two formats – jpeg or RAW. Jpeg has the advantage of producing smaller files, and the pictures can be downloaded and used straightaway, without being processed first on a computer. If you are serious about your photography, though, you will probably shoot in the RAW format. This means processing every image you want to keep on the computer, but you do have a great deal of control over the final result and will be able to create your final image in the tiff format, which most photo libraries and publishers require. On many cameras you can record both a RAW and a jpeg image at the same time, but personally I have found little use for this and it takes up more precious memory space.

Digital has definitely made the craft of bird photography easier, and has been viewed with suspicion in some quarters because of this. Both flight and action photography are areas that have been most significantly affected by the demise of film, as photographers will often take hundreds, if not thousands, of shots in the hope of getting something good. In the days of film, the cost of so many rolls of film would be a limiting factor for many people, but of course with digital this is not an issue.

Exposure is another key area – I was often surprised to find that even extremely experienced photographers seemed to struggle with this under tricky circumstances. Because of the instant feedback available with histograms, getting the exposure right is now easy, even in the most challenging of conditions. But however easy the craft of photography has become, the art of photography remains firmly in the photographer's hands. Getting all that technical stuff right is one thing, but in the final analysis what makes a good picture is what you point your camera at – that is the art.

HARDWARE

CAMERA EQUIPMENT

Although it is possible (with luck) to take good bird photographs using a compact camera, generally a large telephoto lens is a must for most bird photography, and a single-lens reflex camera (SLR) is the ideal tool for the job. These cameras, with their array of settings and interchangeable lens system, provide the creative flexibility

BUYING NEW TECHNOLOGY

BEFORE WE START TO LOOK AT WHAT CAMERA AND COMPUTER EQUIPMENT YOU NEED, BEAR IN MIND ONE OVERRIDING PRINCIPLE THAT YOU SHOULD ALWAYS APPLY: DO NOT BUY THE LATEST THING AS SOON AS IT BECOMES AVAILABLE. SUCH TECHNOLOGY IS OFTEN REFERRED TO AS 'LEADING EDGE', BUT TO PEOPLE THAT WORK IN THE IT INDUSTRY, AS I ONCE DID, IT IS KNOWN AS 'BLEEDING EDGE', AS IT IS OFTEN VERY FRAGILE. THIS IS PARTICULARLY TRUE OF COMPUTER EQUIPMENT, BUT YOU SHOULD APPLY THE SAME RULE TO DIGITAL CAMERAS, AS THESE ARE EFFECTIVELY JUST COMPUTERS WITH A HOLE IN THE FRONT FOR THE LENS. COMPUTER AND CAMERA MANUFACTURERS SPEND A GREAT DEAL OF MONEY ON RESEARCH AND DEVELOPMENT, AND THERE IS ENORMOUS PRESSURE TO GET THE PRODUCT TO MARKET TO RECOUP THESE COSTS. THIS ALMOST ALWAYS RESULTS IN LESS TESTING TIME THAN IS REQUIRED TO IRON OUT THE INEVITABLE BUGS THAT ARE TO BE EXPECTED IN VERY COMPLEX TECHNOLOGICAL EQUIPMENT. THE BUGS ARE DISCOVERED, OF COURSE, BUT ONLY AFTER MANY EAGER CONSUMERS HAVE INVESTED QUITE A LOT OF MONEY IN THE SHINY NEW TECHNOLOGY AND FOUND THE BUGS FOR THEMSELVES. MY RECOMMENDATION IS TO WAIT UNTIL EVERYONE ELSE HAS FOUND THE BUGS AND THEY HAVE BEEN CORRECTED, THEN BUY. YOU MAY NOT BE THE FIRST ON YOUR STREET TO OWN THE NEW TECHNOLOGY, BUT WHEN YOU BUY IT, IT WILL WORK AND WILL PROBABLY BE SIGNIFICANTLY CHEAPER THAN WHEN IT WAS FIRST LAUNCHED.

to enable you to do the job under all conditions, and it is SLR cameras that I discuss here.

Camera body

Having established that the digital camera body is so important in producing high-quality images, there remains the question of which make and model to choose. As far as make is concerned, there are only really two top names that have a comprehensive range of lenses and accessories. They are Canon and Nikon, and I would recommend either of them. I have used Canon equipment for many years. There is a certain amount of (mostly!) good-natured rivalry between users of Canon and Nikon equipment (brand loyalty is almost a given – once you choose one you'll probably stick with it, largely because you will have forked out a certain amount of cash on manufacturer-specific lenses and other kit), but both manufacturers produce very high-quality equipment. With advances in digital technology, every new camera that comes out is better than the last, so the lead tends to change hands between manufacturers.

Whatever brand you decide on, remember that it's good news that the choice is difficult – competition keeps prices down, so we all need both of the two main contenders to do well.

What model to choose is an entirely different question. With new models being released at regular intervals, it would be pointless for me to recommend a particular model because it will be out of date by the time this book is published. Instead, here are some key areas that you need to consider.

Megapixels (mp) | The more data you collect to make up an image the better. I would say that you should stick to cameras at 8mp and over. Remember, though, that the cameras with the most megapixels are very expensive. Because of the amount of data that they are processing, they also tend to be much slower than other cameras with fewer megapixels.

Magnification | Sensor size varies across the range of cameras available quite considerably, and this affects the apparent magnification of the image. Sensors that are around the same size as a 35mm film slide are known as 'full frame' and have a magnification factor of 1x (this means no magnification). Such sensors are currently only used in top-of-the-range cameras. Of the smaller sensors, Canon produces two alternatives at 1.3x (APS-H sensor) and 1.6x (APS-C sensor). The 1.3x is probably a good compromise and is very popular among bird photographers, as it is much cheaper than the full-frame models; although it produces around half the megapixels of those, the quality is still very good. These models also have good frame and burst rates (see page 20) as they don't have as much data to process. The extra magnification is also very useful when photographing birds. Likewise the 1.6x models have even more magnification and are much smaller and lighter, although not made to the professional specification of the more expensive models. Nikons have two sensor sizes, full frame and 1.5x.

The stated magnification factors are a little misleading, for a couple of reasons. Firstly, these sensors don't actually

magnify the image – the image is just smaller to start with. The easiest way to think of it is that the sensor effectively crops the full-frame image that is being produced by the lens, as the sensor is only big enough to capture part of the data. A full-frame sensor catches the maximum amount of data possible from the lens in a rectangular shape. A 1.3x sensor misses out quite a lot of the picture around the edge and a 1.6x sensor misses out even more of the picture, so you end up with just the middle bit of the original full-frame image. This gives the impression, when you view the image, of it having been magnified.

This is perhaps more easily explained with some examples. The three pictures on the right and overleaf, showing the food pass between a pair of European Bee-eaters, demonstrate the effect of using full frame, 1.3x and 1.6x bodies on the same subject with the same lens.

The other thing to note about the stated magnification factors is that they only refer to one side of the image and not the area. Thus a 1.3x magnification is 1.3x the magnification in the horizontal and 1.3x in the vertical, so in total area the magnification is 1.3 multiplied by 1.3, which

A FULL FRAME **B** 1.3X **C** 1.6X

THESE THREE IMAGES EXPLAIN WHY MANUFACTURERS USE MAGNIFICATION FACTORS TO DESCRIBE THE EFFECT OF A SMALLER SENSOR, AS THE SMALLER THE SENSOR THE BIGGER THE SUBJECT APPEARS IN THE FRAME. THE THREE IMAGES OVERLEAF, HOWEVER, SHOW HOW THE SO-CALLED MAGNIFICATION IS ACHIEVED BY EFFECTIVELY TAKING A CROP FROM THE FULL-FRAME IMAGE THAT THE CAMERA IS STILL RECEIVING FROM THE LENS.

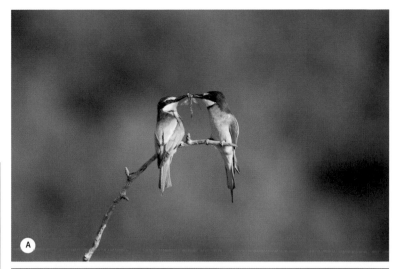

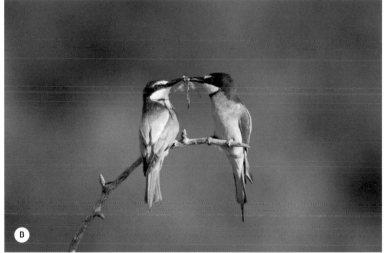

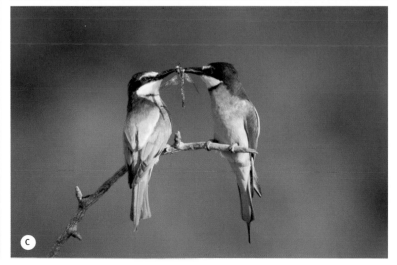

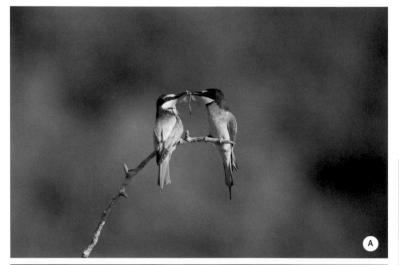

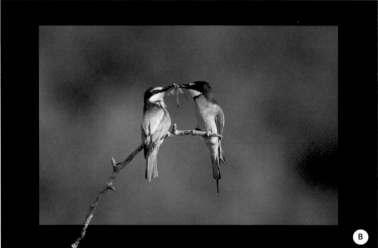

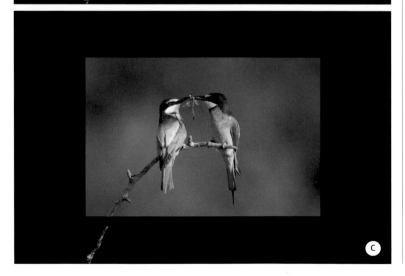

is 1.69x. Apply this same principle to the 1.6x sensor and you end up with a magnification factor of 2.56x in area, or well over twice the size of the original image.

Shooting Rate | For action and flight photography, the more images you can make in as short a time as possible, the more chances you have of capturing that elusive moment. In the days of film, this depended largely on how fast the motor drive could move the film through the back of the camera. With digital it all depends on how fast the data can be transferred from the camera to your memory card so that the sensor can record a new image. The faster rates are usually only available in the high-end pro spec cameras, but the full-frame cameras are usually much slower than the models with smaller sensors, as they have much more data to deal with. This is the primary reason why the favourite sensor size with Canon photographers is the 1.3x, as it can currently achieve a shooting rate of 10 frames per second – but by the time you read this the latest model will probably do even better than this.

Burst Rate | Burst rate is closely related to shooting rate, but is the number of frames that can be captured by the camera before the camera stops and you can't shoot any more until it recovers. This can be very frustrating for the bird photographer, because until the camera is ready you

A FULL FRAME – NO CROP

B 1.3X – THE SHADED AREA IS NOT RECORDED AS THE SENSOR IS TOO SMALL

C 1.6X – THE SHADED AREA IS NOT RECORDED AS THE SENSOR IS TOO SMALL

can't take any more pictures, regardless of what the bird is doing in front of your viewfinder. It occurs when the area that the camera uses to store the data from the pictures has filled up and can't hold any more. This is not the CF or SD memory card, but an internal buffer within the camera itself. As the camera writes the data from the buffer to the card, it frees up space in the buffer and you can shoot again until the buffer is once again full. In practice, you can take one or two pictures as the buffer clears, but you can't shoot continuously until the buffer is pretty much empty.

The amount of data that is captured is key to reaching the limit of the buffer and clearly the more data captured per frame, the fewer frames it takes to fill the buffer, which is another reason why the 1.3x series of Canon cameras is popular with bird photographers. Typically, these cameras can capture twice the number of frames that a full-frame camera can before the buffer fills up. At the moment this is up to 30 RAW frames, but no doubt the capacity will increase significantly over the coming years. You can make the most of your camera's performance by always using the fastest cards in your camera. The faster the card the quicker it can be written to, with the result that the buffer will be cleared more quickly, enabling you to shoot again. The difference between a slow (cheap) card and the fastest cards available is significant, the fastest enabling a full buffer to be cleared in under 20 seconds, the slowest requiring minutes. Eventually the camera manufacturers will come up with what we really want – a 20-megapixel-plus camera that shoots at 10 frames a second and is able to shoot 100 or so frames continuously without stopping.

Lenses

Although there are exceptions, you will usually need a long lens to get a good-sized image of a bird, but which lens? The standard lens for the bird photographer seems to have currently settled on the 500mm f4 specification. I use this often, both on its own and with a 1.4x converter. Although I have hand-held it occasionally, it is too heavy for regular use in this way and I nearly always use it on a tripod with a Wimberley head (see tripods and heads on pages 26–7). A maximum aperture of f4 is important, as this gives a maximum aperture of f5.6 when the 1.4x converter is attached. The value of f5.6 is very significant, because many camera bodies will not autofocus below this. The pro bodies will autofocus down to f8, but at this aperture I find that the autofocus system works too slowly for anything other than the slowest of moving targets.

In addition to the 500mm lens, many professional bird photographers have a 300mm f2.8, which is light and fast enough to be hand-held for long periods. Although I have owned a 300mm f2.8 in the past, I prefer Canon's 400mm f4 DO lens, which is amazingly small and light and weighs around half as much as the 500mm f4. The early versions of the 400mm lens had some problems and were apparently not sharp, but this was resolved in later versions and certainly the one I own is a very good lens indeed. Using this lens fitted with a 1.4x converter and on a 1.3x body, I am effectively hand-holding a 35mm equivalent of a 728mm telephoto lens, which is very useful for flight and action work. I am so impressed with this combination that I often find myself using my light 400mm lens instead of the 500mm.

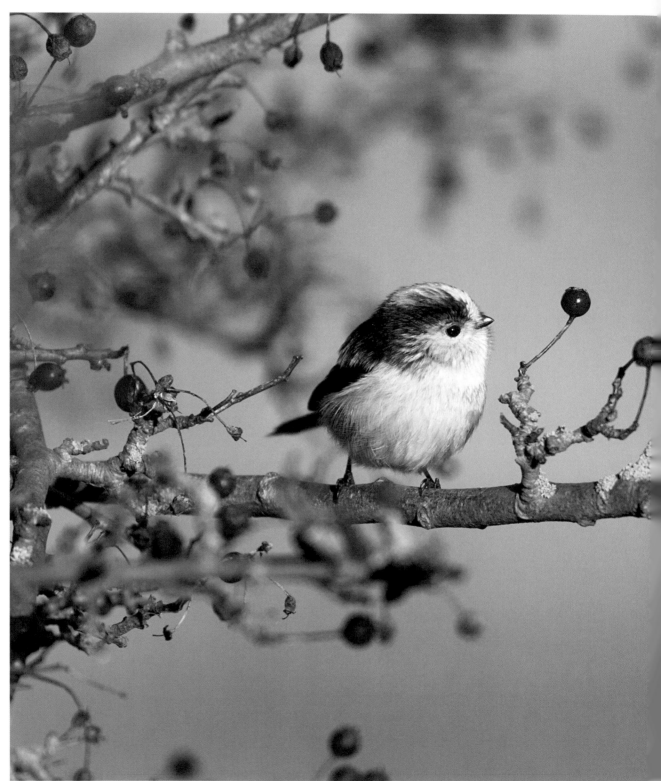

A LONG LENS SUCH AS A
500MM IS PRETTY MUCH
ESSENTIAL FOR BIRD
PHOTOGRAPHY IN ORDER TO
PRODUCE A REASONABLE
SIZE IMAGE, ESPECIALLY IF
YOU ARE PHOTOGRAPHING
SMALL BIRDS LIKE THIS
LONG-TAILED TIT
(*AEGITHALOS CAUDATUS*).

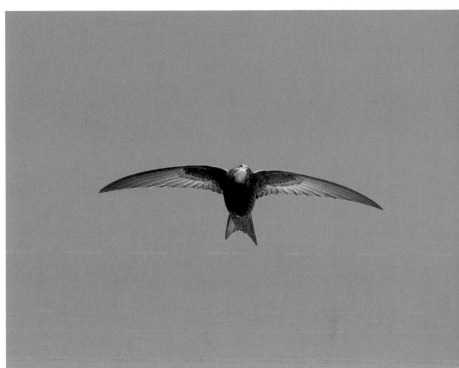

WHEN PHOTOGRAPHING
VERY FAST-FLYING BIRDS
LIKE THIS COMMON SWIFT
(*APUS APUS*), I FIND THAT
HAND-HOLDING GIVES ME
FAR MORE FLEXIBILITY AND
SPEED OF MOVEMENT THAN
ANY TRIPOD HEAD. THE
500MM F4 IS TOO HEAVY TO
HOLD FOR LONG PERIODS
SO I USE MY 400MM F4 DO
LENS WITH A 1.4X
CONVERTER, WHICH IS
MUCH LIGHTER.

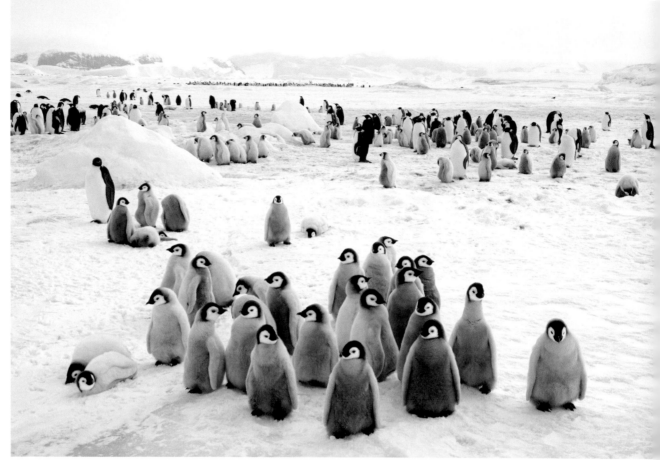

A WIDE-ANGLE ZOOM SUCH AS THE 24–105MM CANON LENS I USED FOR THIS IMAGE IS VERY USEFUL FOR CAPTURING WHOLE COLONIES OF BIRDS SUCH AS THESE EMPEROR PENGUINS (*APTENODYTES FORSTERI*) AT SNOW HILL ISLAND IN ANTARCTICA.

Many photographers also carry a telephoto zoom, and the Canon 100–400mm lens is a popular choice. In places like Antarctica I do the majority of work with this lens because it is so light that I can carry it around all day, and I rarely need a tripod. Nikon makes a 200–400mm zoom, which is of a very high quality and one stop faster at f4, but it is a lot heavier. A standard zoom of somewhere between 24 and 100mm is also useful for general pictures.

Teleconverters are very useful and I would never be without my Canon 1.4x converter, which I use frequently with my big telephotos. A 1.4x teleconverter magnifies an image 1.4x along the horizontal, but (as is the case with the magnification of the digital camera bodies) the area is 1.4 square, so the overall area magnification is a fraction short of 2x. This is extremely useful when photographing birds,

as it means that you can get that extra magnification with almost no increase in your kit's weight or size. There is a price to pay, however, and you will lose one stop of light. This means that your 500mm f4 will now have a maximum aperture of f5.6, but its focal length becomes 700mm. You can buy cheap teleconverters, but these are not a good investment and result in poor-quality images. I would only use Canon teleconverters, and Nikon users should only use Nikon converters. I also own a Canon 2x converter, which gives an area magnification of 4x. A 2x converter turns your 500mm lens into a 1,000mm lens, but you lose two stops, so the maximum aperture becomes f8. I don't use my 2x often, partly because of the two-stop loss, but mainly because I can detect a slight loss of quality when using the 2x that isn't there with the 1.4x converter.

IN PLACES WHERE BIRDS ARE APPROACHABLE,
SUCH AS ANTARCTICA, I FIND THAT, BECAUSE OF
ITS LIGHTNESS AND FLEXIBILITY, A TELEPHOTO
ZOOM LENS LIKE THE CANON 100–400MM IS BEST
FOR CATCHING THE ACTION, AS IN THIS SHOT OF
A KING PENGUIN (*APTENODYTES PATAGONICUS*)
BEING HIT BY A WAVE WHEN IT ENTERS THE SEA.

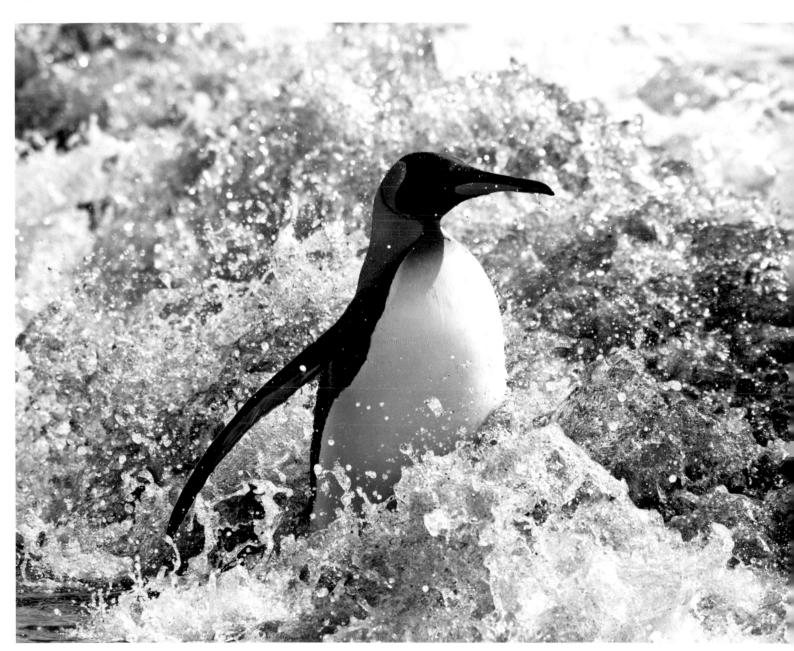

Most of my lenses are Image Stabilized (IS), which I find very useful. With this technology you can hand-hold a lens at a much lower speed than would be possible with a normal lens and still get sharp results. In recent years Nikon has begun to produce workable versions of this technology as well, which it calls Vibration Reduction (VR). Although it's considered by some to be a bit of a gimmick, I wouldn't be without it because it enables me to hand-hold in quite dull light, and frees me from the restrictions of carrying a tripod all the time.

TRIPODS AND HEADS

There is no doubt that a sturdy tripod is essential for supporting your camera when there's a big telephoto lens attached to it. Many professionals seem to prefer a Gitzo tripod and they are no doubt built to a high standard. Personally I feel they are overpriced, and I really don't like the twist action that is required to release and tighten the legs. I use a Manfrotto tripod, which has quick-release catches instead of the infernal twist mechanism, and it is a fraction of the price of a Gitzo. It is certainly sturdy enough to securely hold my heaviest camera-lens combination, and has survived some extremely rough treatment all over the world.

Because I travel the world quite a lot, the weight of my tripod is very important to me, so I did investigate carbon-fibre tripods. After looking at the various models available, I decided to stick to my trusty Manfrotto 055 metal tripod, which weighs just over 2kg. This is only slightly heavier than the very expensive carbon-fibre models, and I'm sure it will take more punishment.

When using a long lens there is no better tripod head than the Wimberley, which revolutionized the use of telephoto lenses for flight and action photography. The Wimberley is a gimbal type that enables you to rotate the lens around its centre of gravity instead of balancing the lens squarely on top, as with a normal head. Once your camera and lens are correctly mounted and aligned on the head, the whole set-up becomes effectively weightless, and you can move even the heaviest of lenses very quickly in almost any direction you want. It also works much better than a ball head when you are in one position all the time, waiting for something to happen. With the ball head you have to constantly slacken and tighten the head when you want to point your lens at a bird, whereas with the Wimberley your camera will sit balanced freely on the head, ready for action at a moment's notice. One down side of the Wimberley is that it is very heavy, weighing around 3kg in its latest version. Another is that it can only be used with

THE MARK 2 VERSION OF THE WIMBERLEY HEAD (LEFT), IS SMALL AND LIGHTER THAT THE ORIGINAL MODEL (RIGHT).

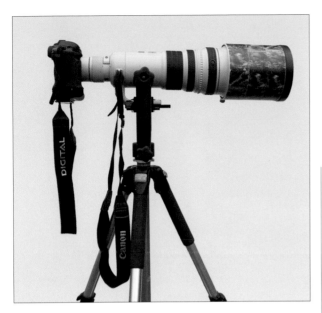

A WIMBERLEY HEAD ON A MANFROTTO 055 TRIPOD, SUPPORTING A CANON 1DS
BODY, CANON 500MM F4 LENS AND 1.4X CONVERTER. THE HEAD IS NOT
TIGHTENED, BUT DUE TO THE GIMBAL NATURE OF THE HEAD YOU CAN SIMPLY
WALK AWAY FROM THE SET-UP AND THE LENS SITS THERE, PERFECTLY BALANCED.

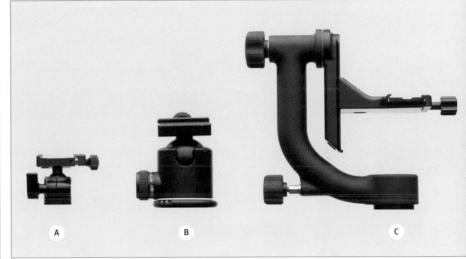

THREE DIFFERENT TRIPOD HEADS:

A – REALLY RIGHT STUFF MINI BALL HEAD

B – ARCA SWISS BALL HEAD

C – WIMBERLEY HEAD MARK II

telephoto lenses that have a tripod collar. I wouldn't be
without one, though.

Wimberley also produces what it calls a 'sidekick',
which is much lighter, but has to be fitted to a ball head.
The whole thing is a bit of a compromise and when you
add the weight of the ball head, you're not really saving
anything. If you're going to go for a Wimberley, do it
properly and get the full version.

I always take a ball head with me. I don't often use it
for bird photography, but I do photograph many other
natural history subjects, as well as landscapes, where a
ball head is essential. For years I used an Arca Swiss ball
head, but on a trip to Antarctica an American photographer
showed me a tiny ball head that he bought in the US from
a company called Really Right Stuff. It is designed to hold
up to 4kg of camera and lens, and is not expensive –
I ordered one as soon as I got back to the UK and have
been very happy with it – its weight is under 200g and it
will slip into a pocket with ease.

OTHER PHOTOGRAPHIC ITEMS

Your camera will almost certainly come with a single
rechargeable battery and charger. You will want at least one
spare battery per camera body. Canon and Nikon batteries
are very expensive, but you can buy independent makes of
battery to match your camera at a fraction of the cost,
which I've found work just as well.

I don't use flash a great deal, but if I do need it
I generally use it at some distance away with a telephoto
lens – and the more powerful the flashgun the further
it will throw its light. To increase the distance for flash
photography with a telephoto lens, I use a 'Better Beamer'.
This is a very simple device that utilizes a plastic fresnel

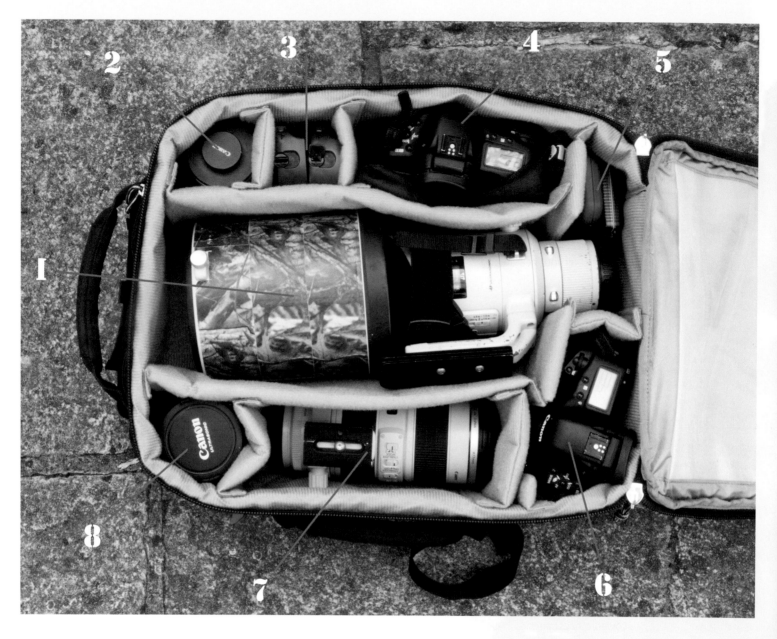

THIS IS MY THINKTANK BAG PACKED WITH GEAR FOR A TYPICAL BIRD PHOTOGRAPHY TRIP. IT FITS
WITHIN THE REGULATION SIZE FOR HAND LUGGAGE. THE EQUIPMENT IS:

1 – 500MM F4 LENS WITH LENS HOOD
(LENS-HOOD COVER REMOVED FOR CLARITY)

2 – CONVERTERS. THE 1.4X AND 2X ARE STACKED IN
THIS ONE COMPARTMENT

3 – TWO SPARE CAMERA BATTERIES (OTHERS ARE IN HOLD LUGGAGE)

4 – CAMERA BODY (IN THIS CASE A CANON EOS 1D MARK II)

5 – CARD WALLETS CONTAINING 40–50 GIGABYTES OF CF AND SD CARDS

6 – CAMERA BODY (IN THIS CASE A CANON EOS 1DS MARK II)

7 – TELEPHOTO ZOOM (IN THIS CASE 70–200 MM,
BUT COULD BE 100–400MM INSTEAD)

8 – STANDARD ZOOM (IN THIS CASE 24–105 MM)

lens in front of the flashgun to concentrate the beam of light and throw it at least twice the distance as the flashgun would without it. The Better Beamer is cheap, light and takes up little room in your bag when not in use.

Finally, you'll need a bag to put all your gear in and keep it safe. For years I used a Lowepro Phototrekker. This has put up with a remarkable amount of abuse over the years and has travelled the world with me. Recently, though, I discovered a new bag on the market that I think is better. This is the Thinktank Airport Acceleration. Both are backpack-type bags, which are best for bird photographers as they are comfortable to carry on your back for long distances, even those large enough to comfortably hold a 500mm lens. The advantage of the Thinktank bag is that it has been designed by photographers specifically to make the most of the hand luggage size limits imposed by many countries and airlines. Whereas the Lowepro bag curves inwards towards the top, the Thinktank bag has a square top that gives more space inside, without affecting the overall dimensions of the bag. The other advantage is that the Thinktank bag is flat, again making the most of the depth available for camera gear, whereas the Lowepro has a padded base. This feature is designed by Lowepro to make life easier when carrying the bag on your back, but restricts the depth of the bag when trying to meet the airline size restrictions. In addition, the Thinktank bag has a removable pouch to take your laptop.

Both Lowepro and Thinktank bags might seem expensive for mere camera bags, but the quality of the materials and workmanship is superb, and they will last for many years. Your camera gear will probably have cost you thousands of pounds, so don't skimp on the bag you carry it around in.

DIGITAL STORAGE

In digital cameras the images are written to removable storage devices known as memory cards. There are several types of card, but the most common are CF (compact flash) and SD (secure digital) cards. The Canon professional cameras are able to take both types of card. As is the case with most technology, the prices of these cards have fallen dramatically in the last few years, and at the same time the storage capability has increased. The number of images you can get on each card depends on its storage capacity, which is measured in gigabytes. At the moment, 2gb to 8gb cards are used most often by photographers, and I wouldn't recommend anything smaller.

If you're simply going out for the day, then several memory cards will probably be enough to cope with the number of pictures that you are likely to take. If you are away for longer than this, it is highly likely that you will take many more pictures than your cards can hold. You will need some method of offloading your memory cards to a separate storage system so you can reuse your cards. The most common and by far the best method is to download your images onto a laptop computer using a special card reader (built-in or separate). Once your images are on the laptop you can review them and delete those that you don't want immediately, so you reduce your storage requirements immediately. This initial edit of your digital images enables you to review your work and make any

adjustments for the next session of picture-taking. There are a number of card readers on the market, and if your laptop has no integral reader it is worth investing in one of the more expensive peripherals as they download the data more quickly than the cheap ones.

There is a cardinal rule with the storage of any data on a computer: always make at least two separate copies on different devices, because computer equipment is liable to sudden and complete failure. Ignore this rule at your peril!

I would recommend the use of portable hard drives to provide a second back-up to your laptop. These are small and inexpensive, but make sure you get one that is described as BUS powered. This means that the power to run the drive is obtained from the USB port of your laptop, so you don't have to find a mains socket to use the drive and can use it when you're running your laptop off its battery. Once you have edited the images you have just downloaded, copy them all to the portable hard drive. This will provide you with two copies, one on your laptop and one on your hard drive. Only once you have secured your images with two copies in this way should you reformat your memory cards to make them ready for your next session. Most laptops have DVD drives fitted as standard and you could write the images to a DVD and use this as a back-up. I wouldn't recommend this, however, as in my experience DVDs are far more likely to fail than a portable hard drive, and are a far less flexible means of storage.

There are a number of portable storage devices on the market that don't require a laptop and once downloaded enable you to view your images on a small screen. They are small and lightweight, and do seem to be quite popular with some photographers, but I would not recommend them for the following reasons:

- Most important is that once your precious pictures are downloaded onto the laptop you can make as many copies as you want. You could overcome this drawback by having two of the portable storage devices, but this means that you would have to download all your cards separately to each device, and if you wanted to edit to save space you would have to do so twice – once on each device.

- On your laptop you can use the same software used on other computers to view and edit the images.

- It is much easier to edit pictures on the larger screen of a laptop than on small viewer screens.

- If you have problems with a card, such as lost images, you can use your laptop to run recovery programs and retrieve these images.

- Lastly, a laptop can perform many other tasks, and with so many places now providing wireless Internet access, you can keep track of your emails, update your website if you have one and do a host of other things.

Laptops vary enormously in specification and price, but if you want to use yours primarily for downloading, editing and copying images, you really don't need a high-spec machine, as none of these tasks requires a fast processor or lots of RAM (working memory). A large-capacity hard drive is very useful, though, for storing as many images as possible. If you travel a lot, weight will be a key consideration and unfortunately lighter laptops are often more expensive. However, note that at the time of writing many manufacturers are launching low-price, basic, ultra-

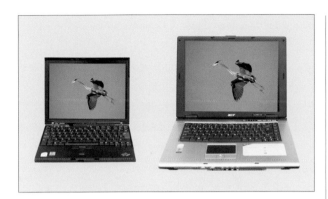

THE 12-INCH LAPTOP ON THE LEFT IS MADE BY LENOVO AND WEIGHS IN AT AROUND 1KG. THE MORE CONVENTIONAL 15-INCH LAPTOP ON THE RIGHT IS MADE BY ACER AND WEIGHS OVER TWICE AS MUCH, BUT COSTS ROUGHLY A THIRD OF THE PRICE OF THE SMALLER MODEL.

small laptops or 'web-books'. These may be worth investigating once they have been on the market longer and any problems have been ironed out. The really lightweight machines have smaller screens, which are not as convenient for editing your images as larger ones. Overall I would aim for a machine no heavier than 2.5kg.

The image library

You will be amazed at how many digital images you will accumulate in a short amount of time. In the days of film nearly all bird photographers would use slide film which, once processed, produced physical 'originals' to be filed in sheets and stored in folders or filing cabinets. With digital there is no such thing any more as an 'original' file, as even the RAW file that you end up with in your photo library has been copied from one storage device to another, almost certainly more than once, and the original file produced by

the camera and the first copy to the memory card is long gone. With digital technology, each RAW file can be copied an infinite number of times, so devising a system to store your images is even more essential than with physical slides. I've tried to keep the technical stuff out of this book as much as possible, but I'm afraid that explaining the essentials of building a digital photo library require me to delve a little deeper into these boring bits.

The first thing you have to remember is that you are storing computer data – it just happens that we view it as a picture, but essentially it is a (rather long) stream of ones and zeroes, just like any other piece of computer data. Once you've decided which images you are going to keep you need to assign an identifier to each one to make them unique. There is a lot of advice out there about how to name your images, suggesting that the file names should include species name, location, date, what the weather was like and so on, but this does not comply with good IT data standards and I would strongly advise against this approach. As is the case with all computer data, you need a simple unique reference (known as a key) that does not contain any information about what is on the image. This may sound counter intuitive, but trust me on this one – it is the right way to go. Having been in the IT business for many years I've witnessed many serious problems caused by the failure to create such a unique 'meaningless' key to data. This is why we all have a unique national insurance number and unique customer numbers when we deal with big companies – a unique reference enables databases to access your details quickly and with confidence that they are the correct details. I would suggest that a sequential

number makes up most of the name for the image, but would prefix this with a letter. An example would be:

A001234

I recommend starting with a letter (any letter will do), which will result in the full name of your file always being displayed and printed. If the letter A was not present on the example above, for instance, the file name printed out or seen in a spreadsheet could well be 1234 and not 001234, as the spreadsheet software would treat it as a number rather than simply a name. Having the letter in the front prevents this and avoids confusion.

The name is applied to the RAW files before they are converted to tiffs. Then type the name, place and any other details you want to record into the IPTC data of the RAW file. When you convert your file to produce a tiff file, all this information (including the file name) will be automatically transferred to the tiff file. This means that you end up with a RAW file and a tiff file that have the same name – using the example above this will be A001234. This is essential as both files represent the same image. In fact, although they have the same name, each of the two files has a different suffix, .tif for the tiff file (no surprises there) and CR2 for the Canon RAW file. (This may vary with different cameras, but that doesn't matter.)

The RAW file is the closest you are going to get to a digital original, so you must store this. I don't intend to cover Adobe Photoshop processing as this would take up a book on its own, but when you convert a RAW to a tiff it is standard practice to do this as a 16-bit file. After you have

made all your adjustments in Photoshop, you convert that 16-bit file to an 8-bit file, which is the preferred format for photo libraries and publishers. Many people recommend keeping the 16-bit tiff in case you want to rework it in Photoshop at some point in the future, but I only store the final 8-bit version – I rarely find that I need to rework an image, and a 16-bit file takes up twice the storage space of an 8-bit file.

So having saved the two versions of your file with meaningless file names, how do you know what they show and where you should put them? The answer to both of these questions is to store them in appropriately named folders. With a subject like birds it is pretty straightforward – you simply have a high-level folder named 'Birds' under which you build any number of folders to reflect the species of which you have pictures.

Exactly which structure you use doesn't really matter as long as you are happy with it and understand it. You may, for example, decide that you want every single species to have its own folder under 'Birds', so you would simply create a long list of folders under birds as in figure 1, opposite. When you photograph a new species you can simply add a new folder. The folders can be displayed in alphabetical order so it is very easy to find the pictures of the species you want.

Alternatively, you might decide to group different types of bird together as in figure 2, opposite, where all the ducks are gathered together under one folder, with a species folder under the ducks folder for each duck species. If you already have a library of physical slides, you can organize your digital images in exactly the same way

as this – simply create folders and sub-folders to reflect the structure of your slide library.

Looking at the diagrams on the right, you will notice that there is a separate folder under each species for RAW and tiff files. I find it most convenient to keep the two types of file separate, but you can if you wish store both files in the same folder.

Using this approach I have all the images in one easy-to-find location. I don't need to have the species as the name of the file because I know where to find it from the structure of the library. It is a simple but effective method, and if you think of the structure as a filing cabinet, it works in exactly the same way as the filing cabinet or folders that you used to store your slides in.

Once you have your RAW and tiff images stored away, you must apply the cardinal rule of computer storage and back them up to another device.

If the internal drives on your computer are large enough to hold your library, you must use an external hard drive (or drives depending on the size of your library) as a back-up copy. If your computer does not have the space to hold the library, then you can simply use two hard drives, with a copy on each. You needn't copy the whole library every time you add to it – just add the new images to each of the two copies when they are ready to be stored. This minimizes the risk of data corruption to your existing images, because every time you copy an image there is a small risk of data loss.

You have now established your basic digital photo library. Should you have a failure on one drive you must immediately take another back-up to a new drive to ensure

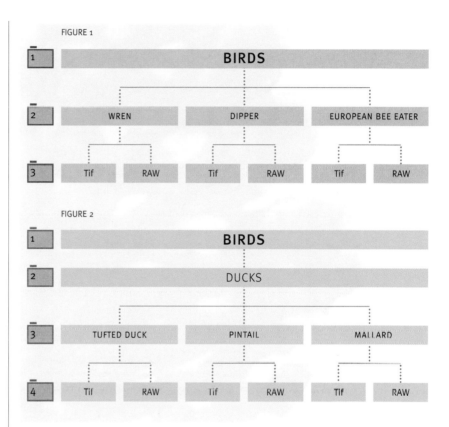

FIGURE 1

FIGURE 2

that you always have two copies. Failure to do this could be disastrous, and you could lose many if not all of your precious images.

Congratulations if you got this far – I did warn you that this was the boring bit. However, discussions about this subject with many fellow photographers have made it clear to me that good, established computer naming and storage principles are one of the least understood aspects of this new digital world that we now inhabit, yet one of the most important.

Portraits

As we start our exploration of different categories of bird photography, it seems natural to begin with the most common type, the portrait. Here I define a bird portrait as one where the bird is static and basically not showing any signs of action or noticeable behaviour.

THIS DEFINITION ILLUSTRATES the problem with portraits – total inaction. It results in you having to work much harder at producing an interesting image than with any other type of bird photography. Let's face it, a simple close-up picture of a bird can be quite boring. The challenge, then, is to make an interesting image from a static subject, often one that has been photographed hundreds of times before.

Of course, there is absolutely nothing wrong with a straightforward close-up picture of a bird, and for many people this is an achievement in itself. Getting close enough for frame-filling images is often very difficult, and it is only natural for us to want to capture the beauty of a bird in this way. If we weren't fascinated by birds we wouldn't photograph them, and getting close-up pictures of a range of birds, showing the characteristics of each species, is something that many photographers are happy doing. There is nothing wrong with this approach at all, but this book is about much more than that – it's about creating interesting and artistically satisfying images.

When faced with an attractive, brightly coloured, possibly rare bird sitting on a branch in front of you, the quality of the resulting images will be most determined by which of your own traits comes to the fore – the birder or the photographer. Sitting back in your armchair reading this book, it is easy to imagine that it will be the photographer in you who wins out. In the excitement of the moment, however, your eagerness to bag such a prize will often take over, and the aesthetic quality of the image will suffer. I've done this enough times myself – particularly when I first started. Nowadays, however, I'm much more likely to remain calm, think about the photograph first, then press the button. This really is the key to a good portrait – think first, and take the picture second. The more experienced you get, the quicker your brain kicks in, so that after a while choosing a nice composition becomes intuitive. If all this fails and you just end up with a rather dull picture of that lovely bird, then don't beat yourself up about it; just appreciate what you've got and with the picture in front of you try and think what you can do next time to improve it.

I have come up with a novel way of levelling the playing field when evaluating a bird photograph without being influenced by the species of bird – I call it the 'sparrow test'. Take any bird photograph of a rare or colourful bird and in your mind's eye replace it with a very common, dull-coloured species – it doesn't have to be a sparrow (I found that didn't work very well with wildfowl pictures!). If the picture still works, the chances are it's good photographically, as well as a record of the subject.

THE GLAMOUR SHOT

The picture opposite of the Iiwi is a good example of what I call a 'glamour shot'. The picture is all about the subject itself, not the aesthetics of the overall photograph. In this way it has much in common with 'glamour photography', where the target audience is very much interested in the subject (i.e. beautiful, scantily clad bodies) and has very little or no interest at all in any artistic considerations. Compare this with artistic nude photography, where the emphasis is on shape and form, and you'll get my drift.

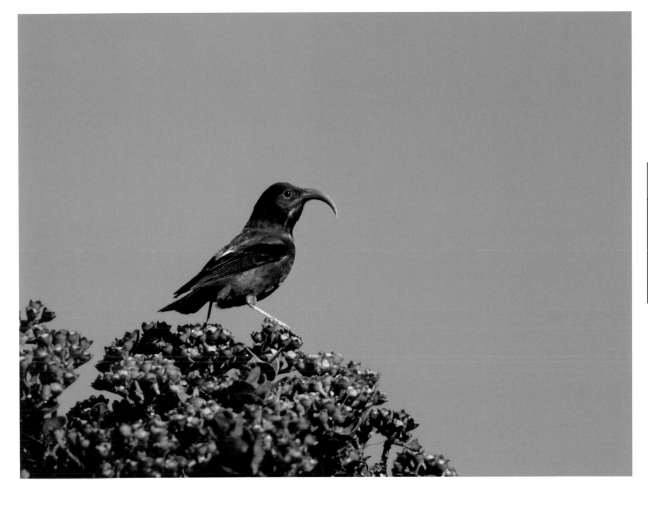

IIWI
(Vestiaria coccinea)

Canon EOS 1V,
600mm lens + 1.4x
converter,
1/500th sec @ f5.6,
Fuji Provia 100

Big Island, Hawaii

As well as being rather gorgeous, the Iiwi is a Hawaiian endemic that has not been photographed that often. It is certainly not the rarest of the Hawaiian honeyeaters, but with its bright red feathers and that magnificent curved pink bill it is certainly iconic. It was one species I really did want to photograph. This was not an easy task, and my wife and I spent a total of eight hours perched on rough volcanic rock hoping for the bird to put in an appearance. We had noticed a few Iiwis around the area, but chasing them around proved a pointless exercise, so we chose a suitable bush and settled down to wait. Five hours on the first day resulted in nothing but cramp, but on the second day (our last day on Big Island) a further three hours' vigil was rewarded when a group of three adults did show up, for a grand total of three minutes. During that time I managed to fire off two 36-exposure rolls of film (with a very rapid change of roll!). I was delighted to get the shot.

This was bird photographer as hunter. My technique was simple: get bird in frame and shoot – nothing fancy, just get the picture. Granted, the shot is technically well executed, but at the end of the day, from a purely photographic point of view, it's just a bird on a bush – it's the species that counts, not the picture. This certainly doesn't pass the 'sparrow test', but I really did enjoy taking it. If the birds had hung around and been easier to photograph, I know I would have made better pictures, but you can only take what's on offer.

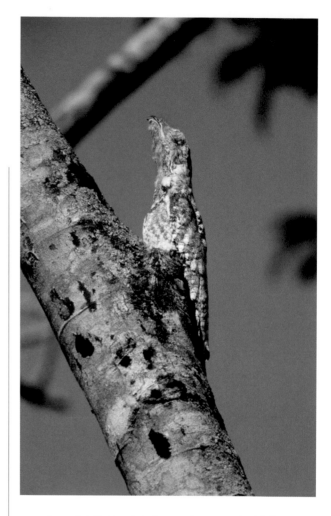

BAD BACKGROUNDS

GREAT POTOO
(Nyctibius grandis)

Canon EOS 1V, 600mm
lens + 1.4x converter,
1/500th sec @ f5.6,
Fuji Provia 100

Manu Region, Peru

Probably the most common reason why a portrait is bad is that it has a bad background. A portrait such as this results when the birder comes to the fore and you simply concentrate on the bird and ignore everything else.

I have seen countless portraits with bad backgrounds, whether it be twigs sticking out all over the place (sometimes even in front of a bird) or out-of-focus birds in the background that distract from the subject. Interestingly, in landscape photography it is the opposite problem – it is the foregrounds that tend to be overlooked, because the photographer concentrates on the main subject in the picture. Just as a landscape picture can be made great by an interesting foreground, a bird photograph can be made great by an uncluttered or relevant background.

So why did I take the picture of a potoo shown on the right? That's a good question. I had visited South America on several occasions and had never even seen a potoo, let alone had the chance to photograph one. It was a species I had always admired when I saw it in field guides, and I longed to see it. Like owls, potoos are usually nocturnal, so your only chance of seeing one during the day is to spot it roosting. Because the birds do a rather good impersonation of a tree trunk, this is not easy.

As soon as I saw the bird, high up on a forest tree, I just had to take a shot there and then. My enthusiasm for the bird got the better of me and I got the shot I deserved

– pretty awful. Fortunately for me, because the bird was at its daytime roost it wasn't going anywhere. I came to my senses, wandered around the area and found a much better vantage point from which I could create a far nicer image, as you see in the picture opposite.

Another interesting point about this picture is that it demonstrates the use of a vertical format instead of the more usual horizontal format. In this instance the upright format was much better suited to the subject and its surroundings. The upright format is usually referred to as 'portrait' mode.

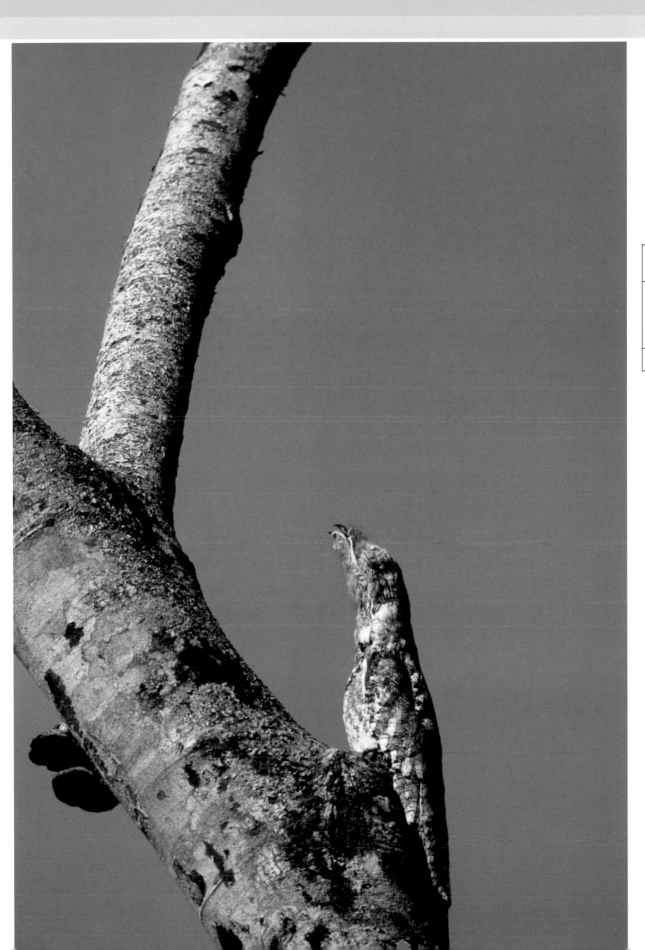

● GREAT POTOO
(Nyctibius grandis)

Canon EOS 1V, 600mm
lens + 1.4x converter,
1/500th sec @ f5.6,
Fuji Provia 100

Manu Region, Peru

● SMEW
(Mergellus albellus)

Canon EOS 1V,
600mm f4 lens +
1.4x converter,
1/1,000th sec @ f5.6,
Fuji Provia 100

Norfolk, UK

BACKGROUNDS THAT ENHANCE THE PICTURE

This picture of a male Smew is all about the fantastic background, and it was the background that I was attracted to when I was visiting Pensthorpe Waterfowl Park in May one year. I usually photograph waterfowl in the winter, but I had just bought a new 600mm f4 lens and wanted to give it a thorough shakedown, so I went to a place where I knew there would be lots of birds to point it at.

Pensthorpe has a large collection of exotic wildfowl. During the winter these act like a mass decoy – the wild ducks then stay on for some free food and quickly get used to people milling about. When winter is over wild ducks are far fewer in number, but the collection birds would do fine as test targets for my new lens. Spring brought one big bonus – the shrubs surrounding some of the lakes were in flower. In this case a group of bright yellow-flowered bushes was producing amazing reflections on the far side of the lake. The reflections were so nice that they would have made a decent abstract picture on their own.

The area of yellow water was not huge and I needed the big telephoto to isolate it. I set it up on a tripod and simply waited for something to swim into view. One of the first ducks to put in an appearance was this male Smew, one of my favourite ducks. Its simple black and white colouring stood out perfectly against the yellow background. If you took this background away and replaced it with plain blue water the result would be extremely dull.

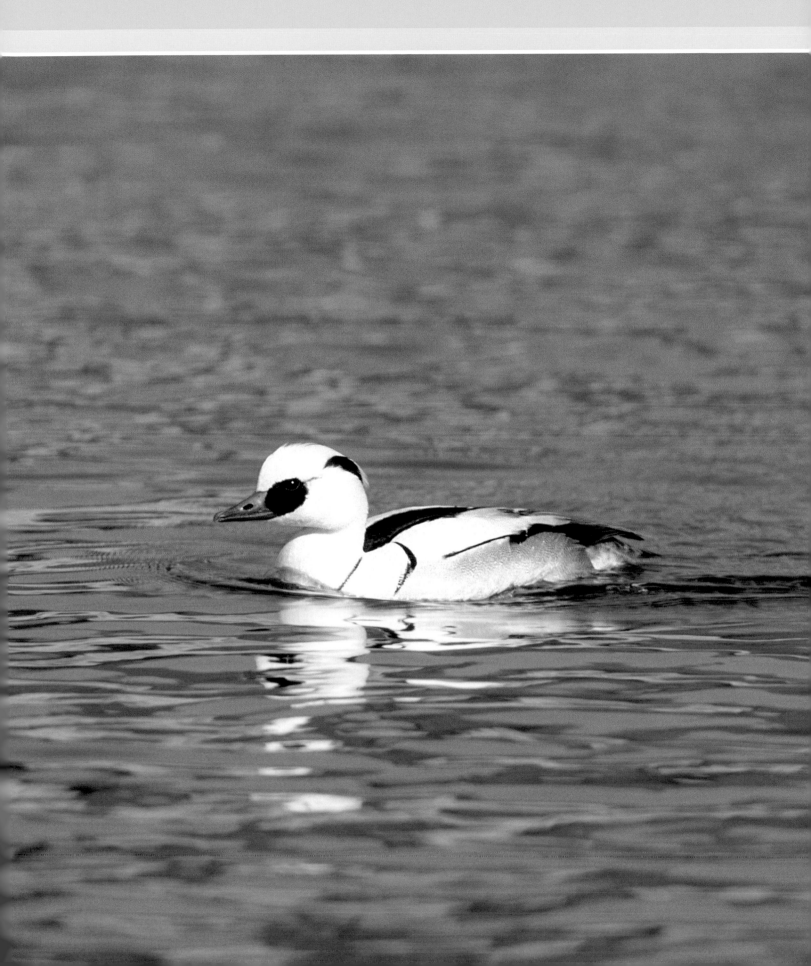

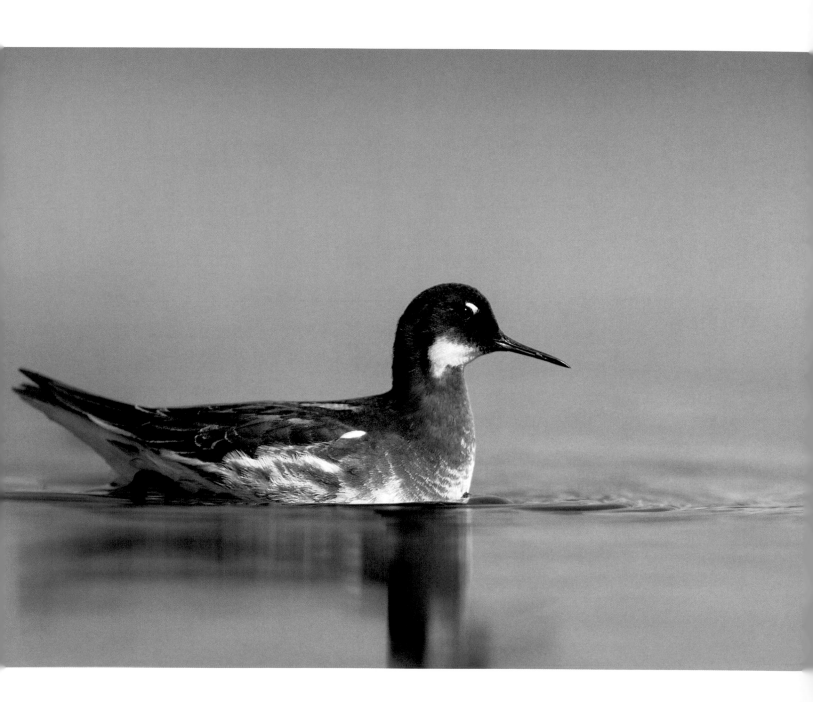

LOW ANGLE

Shooting at eye level with a bird adds great impact to the simplest of portraits. It works really well with birds on the water, as this picture of a Red-necked Phalarope demonstrates. Red-necked Phalaropes are very confiding birds and as long as you move around slowly they seem to ignore you altogether, sometimes even coming too close for your long lens.

I had taken some 'normal' portraits of this lovely species while kneeling down by the side of the small loch on which the birds were swimming around. I then decided to try and get lower, and to do this I slowly dropped onto my stomach and hand-held the camera in front of me to get the angle I wanted. The bird just carried on, taking no notice of my antics whatsoever.

This is not the best way of going about getting low enough, however, especially if you are over six feet tall like me. It's better to prepare for the shot by fitting a right-angled finder to your camera. This fits over the eyepiece and enables you to look through the viewfinder from the top of the camera body instead of the back. This puts much less strain on your neck muscles, although using the right-angled finder does take a bit of getting used to.

If you do this sort of photography in public places, you will no doubt attract attention and get all sorts of strange looks, even from other photographers. You will also get rather grubby – but then you have to suffer a bit for your art. Apart from these non-photographic issues, there are two compositional considerations to be aware of when using this technique. The first of these is to ensure that the water or ground is parallel with the bottom of the picture. This may appear obvious, but it is particularly important when you are down at ground level. The second thing to consider is the background, particularly on water. When shooting slightly downwards on the subject you can isolate it against the water. When shooting at a very low angle this isn't the case, and you must keep a lookout for birds and other obstacles in the background that will spoil the picture. It's definitely worth the effort, though, and you will end up with something just that little bit different from most portraits.

● RED-NECKED
PHALAROPE
(Phalaropus lobatus)

Canon EOS 1Ds Mark II, 400mm f4 lens + 1.4x converter, 1/1,000th sec @ f8, digital ISO 400

Shetland Isles, UK

● ANDEAN
COCK-OF-THE-ROCK
(Rupicola peruviana)

Canon EOS 1N,
300mm f2.8 lens,
1/200th sec @ f2.8,
Metz flashgun with
flash extender,
Fuji Provia 100

Manu Region, Peru

FULL FLASH

Like many wildlife photographers, I'm not a great lover of using flash as the main light to illuminate a subject, because it's very difficult to produce natural-looking images. In the middle of a particularly dark stretch of Peruvian rainforest just after dawn, however, I needed all the help I could get. I was photographing the spectacular cock-of-the-rock males at a lek site, and was perched on a platform that was rather flimsily built on the top of a slope that dropped away steeply to a river far below. The lek was very active around dawn, but at this time it was just too dark for natural light photography (I was still using film in those days), so even fill flash was impossible.

One of the problems with using flash as the main light is that the exposure of any element within the picture is dependent on how far that element is from the flashgun. The closer it is, the more light it receives as the light from any flashgun drops off rapidly. In practical terms, this means that you must compose the image with the main subject (in this case the bird) as the closest thing to you, otherwise anything in the frame closer than the bird will be horribly overexposed and ruin the shot.

In a dense rainforest understorey this is easier said than done, but I did notice one particular branch onto which the males would occasionally hop during their display that had no other branches or leaves in front of it, once I'd positioned myself in the right place. Of course, the other effect of flash fall-off is that everything behind the main subject is underexposed, and this often creates a very dark or even black background that can look unnatural. In the case of the picture opposite, however, the dark background has covered up a multitude of sins, because the background was, in reality, a complete mess of intertwining branches and leaves that looked pretty unattractive. Also, I think the dark background rather suits the subject, as a rainforest is indeed a dark environment. A plain background such as this also emphasizes the subject and produces a nice graphic image. Contrast this image with the completely different cock-of-the-rock image on page 53 (which was taken with natural light much later in the day, but from exactly the same place).

BACKLIGHT

In most cases I try to photograph a bird with the sun behind me, because this provides an even light on the bird and in my eyes produces the best results. I've experimented with side lighting and feel the harsh shadows it produces often spoil a picture, so I try and avoid this (although there are exceptions, of course).

Backlit images, however, can be very attractive, as in the case of the bee-eater shot on page 44. I define a backlit image as one where the details of the bird remain clearly visible. This separates it from a silhouette, where the details of the bird are lost and often completely black. It is a simple composition, a bird on a stick, but the backlight raises it above what would be a rather average image if the sun had been behind me. This shot was taken quite late in the day, when the sun was low in the sky. In the morning I had been photographing bee-eaters from a hide facing west. This gave lovely light early in the day, but as the sun moved around through the day, normal

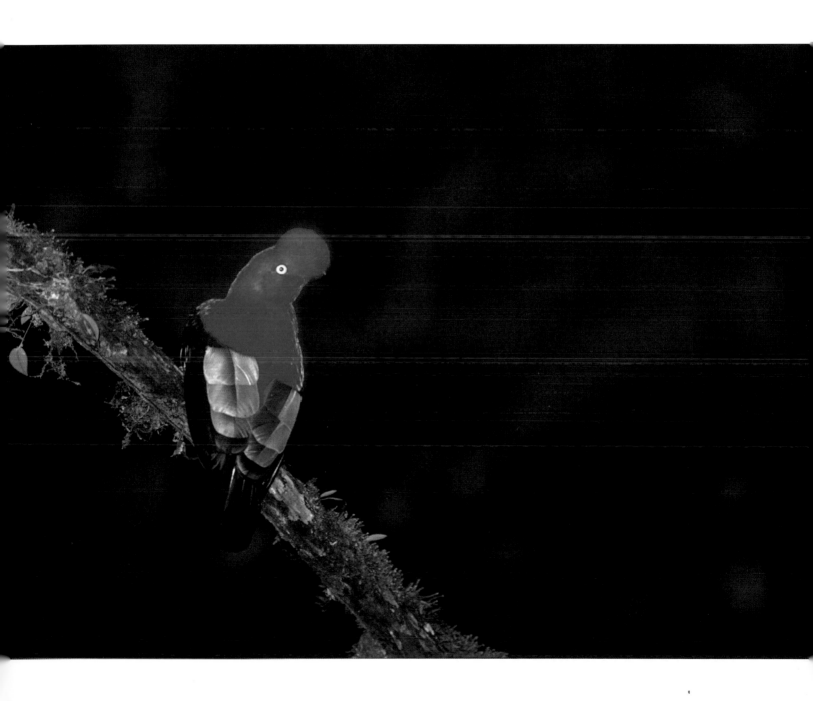

● EUROPEAN
BEE-EATER
(Merops apiaster)

Canon EOS 1Ds
Mark II, 500mm f4
lens + 1.4x converter,
1/250th sec @ f5.6,
digital ISO 400

Hungary

photography became impossible. I revisited the hide about an hour and a half before sunset in the hope that the birds would still be active and land on the perch that had been set up specially for them.

I waited and waited, until finally a male landed on the perch and I got the shot I was after. The surroundings were just right for this sort of shot, with the forest that formed the distant background in shade as the sun went down behind it. The bird itself is softly lit, but what makes the picture successful is the brightly lit feathers, particularly on the back and tail. I thought that the exposure was going to be very tricky, but plain old aperture priority mode worked fine. If taking backlit pictures like this, the main thing to check after you have taken the picture is that the 'rim light' highlights around the bird are not overexposed. Once these are OK, the rest falls into place.

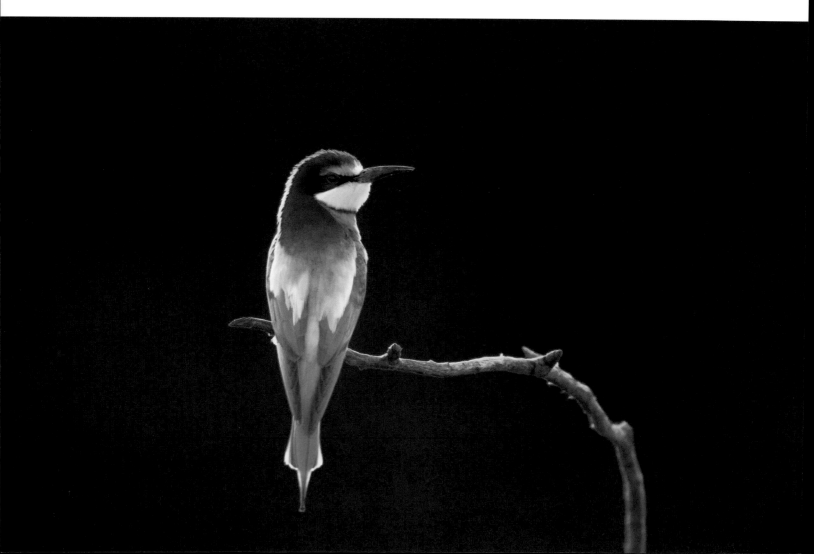

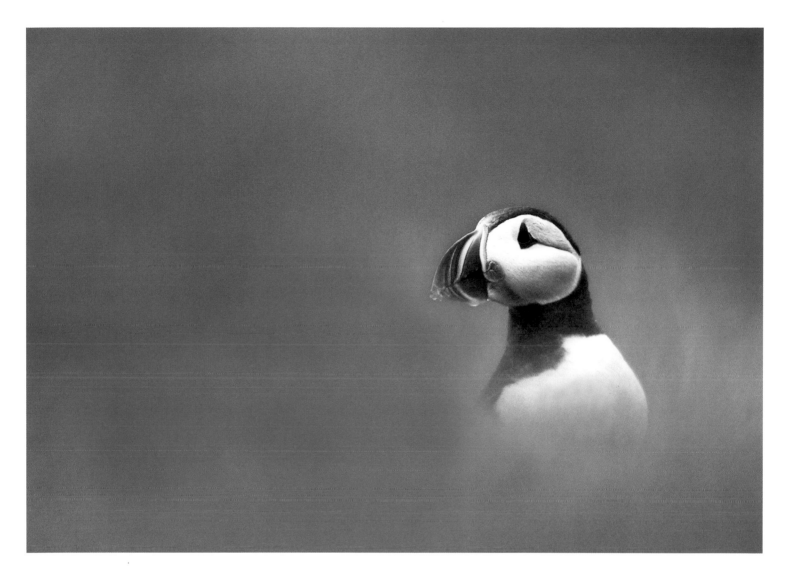

USING THE SURROUNDINGS

For this section I have used two pictures of Puffins to illustrate how utilizing the immediate surroundings can produce completely different images of a very familiar and much-photographed species.

The first (above) was taken on the Farne Islands, a great location for photographing seabirds and Puffins in particular. Many thousands of Puffin pictures have been taken here, and I was really looking for something a little different. The weather conditions were perfect for Puffin

portraits, because although it was very bright there was a covering of high white clouds that reduced the contrast. This is very important when photographing on the Farnes, as although the islands are wonderful, the earliest you can land on them is around 10 a.m., by which time the best light has gone, and on a sunny day the light is very harsh.

Puffins are unpredictable birds. There may be hundreds sitting around close together on the rocks and outside their burrows on one day, and only a few scattered about on the next, even if the weather is the same. On this occasion there weren't many birds around, which actually

● PUFFIN
(Fratercula arctica)

Canon EOS 1N,
600mm f4 lens +
1.4x converter,
1/640th sec @ f5.6,
Fuji Provia 100

Northumberland, UK

45

made it easier to get pictures as I didn't have to contend with other birds getting in the way. There was a fair amount of grass growing just above the rocks, close to the sea, and although the green colour was quite nice, lots of grass stalks sticking up can often be intrusive and spoil a picture. This particular Puffin was standing on a bare patch of ground with the grass a little way behind it. I got down low to use the much closer foreground grass to frame the shot and hide the bare ground. By using a very long lens and wide open aperture I was able to keep the depth of field to a minimum, which rendered both the foreground and background grass a soft green and resulted in one of my favourite Puffin portraits. The position of the bird in the picture is also important, as I have placed it clearly to one side and it is looking into the picture. Had the bird been positioned in the middle or looking out of the picture it really wouldn't have worked at all.

The second picture of a Puffin (left) couldn't be more different. It shows the bird sitting quietly on a cliff edge surrounded by the pink blooms of Thrift. This is a classic image – in fact, many would call it a cliché because it's been done many times before. I never let such comments put me off, though. As a professional wildlife photographer I can never worry about what other photographers are doing – I just decide what I want to do and do it. If it has been done a thousand times before, then so be it. The important thing from my perspective is that I hadn't done it before and I like the shot. And I do like this shot very much. I had planned this picture before I arrived in the Shetlands, and after finding a suitable flower-covered bird cliff I settled down and waited.

⬤ PUFFIN
(Fratercula arctica)

Canon EOS 1Ds Mark II, 400mm f4 DO lens + 1.4x converter, 1/1,000th sec @ f10, digital ISO 400

Shetland Isles, UK

47

Unfortunately, this was one of those days when Puffins were not sitting around in numbers, and I had to wait for several hours for a couple of birds to arrive in a suitable spot. This one was high on top of a very dangerous cliff, and I had to lean out over a dry-stone wall to get the angle I wanted. I'm sure some photographers have turned up, seen loads of Puffins sitting around in the flowers and thought how easy a shot like this would be to get. I was not that lucky, but I find that perseverance (some might say bloody-mindedness) is usually the key to success.

Unlike the bird in the first image, here the Puffin is pretty much in the middle of the picture, but the key difference is that it shares the picture with the flowers, which play an equally important role (in fact, without them I would not have taken the picture). The bank of flowers on the left of the image counterbalances the central Puffin and effectively pulls it to one side, leaving it looking into the open area to the right.

TWO'S COMPANY

Making a portrait with more than one bird in the frame is much more difficult than doing so with just a single bird. Firstly, there is the question of depth of field, which when using long lenses is very shallow indeed. Due to this factor, both birds need to be on the same plane (the same distance from the camera), so that they will both be in focus. Secondly, a good composition requires some symmetry between the two birds to make the picture work. In the case of the picture opposite, the birds are both looking in the same direction and are sitting close together. Although the male kestrel is pretty much central, it is anchored in the picture by the female on the left, which results in an attractive composition.

When I took the picture I was perched on top of an old, very dirty grain silo. It was in the old tiled roof of this building that the birds nested. Someone had thoughtfully provided a perch for the birds, and this had been securely fixed to the roof. With little else suitable around, this proved very popular with the birds and this pair made the most of it – the birds were regularly seen perched on it side by side. The problem was that it was a rather dull, overcast day and the light (such as it was) was coming from behind the birds. Even on a cloudy day I will try and position myself with the sun behind me, but balanced on top of a building as I was, I couldn't move around. To overcome this, I used fill flash to balance the light and bring out the feather detail in the birds. Fortunately, they were quite close to my hiding place, which meant that I could use a relatively short lens. I stopped down to f8 to give me more depth of field. Stopping down often results in too much detail in the background, which can be distracting, but here the ground was far below so I could get away with it. I couldn't stop down any further as I was already shooting at a mere 1/60th second. The 100–400mm lens was an IS (Image Stabilization) lens. This was a great help in the low light situations, particularly because it was impossible to use a tripod in the very cramped conditions I was shooting in.

This is quite a complicated picture from a technical point of view, but in the end one that works very well.

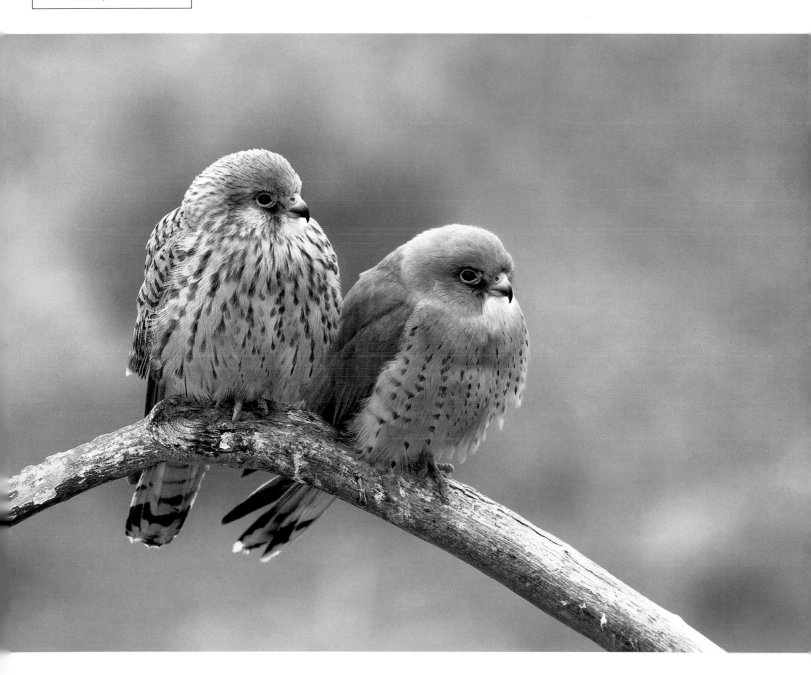

REFLECTIONS

In these portraits of a Nightingale, the key element in each is the reflection of the bird in the water. They are of the same bird and were taken around 20 minutes apart at a drinking pool in the middle of a Hungarian forest. There are two clear differences between the shots, the most obvious being the orientation, one being in landscape format and one in portrait. In the landscape format the bird is placed to one side of the frame, effectively looking into the empty space on the right. Had the bird been in the centre, it wouldn't have looked as nicely balanced. I have mentioned

Both pictures:

● NIGHTINGALE
(Luscinia megarhynchos)

Canon EOS 1Ds Mark II, 500mm f4 lens + 1.4x converter, 1/250th sec @ f7.1, digital ISO 400

Hungary

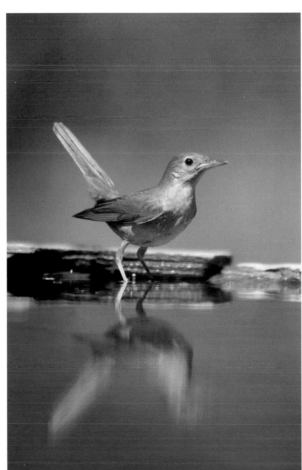

this about other pictures in this chapter, but it is well worth repeating, because having the bird smack in the centre is a common compositional weakness that occurs in many bird pictures. The interesting thing about this compositional 'rule' is that it doesn't apply when you turn your camera through 90 degrees and shoot in portrait mode. This can be clearly seen in the 'upright' Nightingale image, where the bird is pretty central.

The second main difference between the two images lies in the quality of the reflection. In the portrait-mode picture the reflection is very soft, but in the landscape-mode picture it is sharp enough for the bird to be clearly seen. In both cases, however, the reflection adds greatly to the overall impact of the picture – even the blurred reflection adds balance and to my mind works well.

When photographing a bird with a reflection, I always think it works best if there is either equal space above and below the bird and its reflection, or alternatively more space above the bird than below its reflection. If you have more space below the bird's reflection than above the bird's head, the picture just doesn't look right.

A good, sharp reflection can be very fleeting – the slightest movement of the bird causes a ripple that destroys the reflection, as does the least breath of wind. The reflection's quality can change from second to second in these circumstances, so you have to be very alert.

BREAK 'THE RULES'

The portrait of a cock-of-the-rock on its lek site in a Peruvian rainforest (opposite) is completely different from

the one taken with flash in the same location (shown on page 43), and it's worth comparing the two. In this case there was just enough light to make a natural light exposure, but using flash on this bird simply would not have worked, as all of the out-of-focus foliage in the foreground would have been lit up like a Christmas tree and dreadfully overexposed.

The main point of including this picture is to show how a picture can work, even if it breaks normal compositional rules. Actually, I think the picture works very well and shows the bird in its typical cluttered, busy, rainforest understorey environment. It was only by careful positioning that I managed to find a gap in the vegetation to enable me to photograph the bird at all. When I finally got into position I noticed that the group of leaves on the left of the image was on roughly the same plane as the bird, so I included it in my composition. These in-focus leaves balance the picture and make it work.

In this final section in the portrait chapter, I'd like to mention two points that apply throughout this book when discussing the rights and wrongs of composition. Firstly, the compositional 'rules' or advice provided in this book will help you to improve your bird photography. They should, however, always be treated simply as basic blocks on which to build your own photographic style and approach. Breaking the rules may often help you achieve original pictures, and by having a good grounding in 'normal' composition aesthetics, you'll know when and why to go outside them. Secondly and equally importantly, if you've taken a picture that you like and are satisfied with, don't be put off if others disagree.

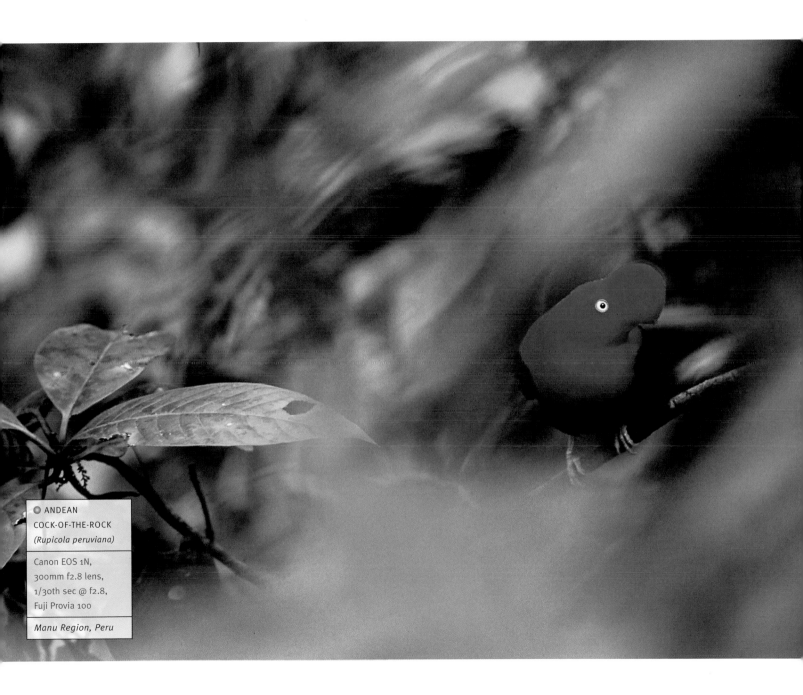

○ ANDEAN
COCK-OF-THE-ROCK
(Rupicola peruviana)

Canon EOS 1N,
300mm f2.8 lens,
1/30th sec @ f2.8,
Fuji Provia 100

Manu Region, Peru

Flight

Capturing bird flight with the camera has always been one of the great challenges of bird photography. It is also one of my favourite types of bird photography – as soon as I picked up a camera, I set out to freeze a fraction of a second in a bird's life as it hurtled through the air.

IT PROVED MUCH MORE DIFFICULT than I had anticipated, particularly given the primitive equipment and relatively short lens I was using. This was way before the introduction of any type of autofocus, when a sharp image of a bird in flight was a rare treasure to be held up and admired by all. To make it even more difficult, the only decent film available was a paltry 64 ISO (or ASA as it used to be known at the time). With the introduction of autofocus and 100 ISO film, the success rate boomed and more and more good flight pictures hit the market, although these were mainly of large, slow-flying species at first. When film was replaced with digital capture, just about everyone was taking flight shots and a new breed of photographer hit the scene – the digital blaster.

The problem with taking flight shots using film was that even with autofocus systems there was a lot of wastage, and wastage meant money. Using Provia film processed and mounted by a professional lab cost around 25p per slide, so taking thousands of pictures in the hope of getting a couple of sharp ones could get very expensive. With digital, however, each picture costs nothing, and with cameras now shooting at 10 frames a second you can capture countless moments that are over too quickly to see. Major competitions have now been won by that one-in-a-thousand sharp shot – with luck surely playing a much bigger role than skill. Having said that, some of the results of this approach have been wonderful photographs. As always with these things, there is an alternative view and you could argue that if the autofocus systems were good enough, you wouldn't need to take so many pictures to realize your aim in the first place.

So digital and autofocus have without doubt reduced the skill level required when facing up to the challenges of capturing a bird in flight. What these technologies won't help you with, however, is producing an aesthetically pleasing image. This is up to you, the photographer. Remember, the craft is all about the operation of the camera, while the art is what you point it at and no technology can help you with that. When locking on to a bird as it flies swiftly by, you still need to think about the overall picture and make your composition pleasing for a flight shot to be successful – but you have to make these decisions in a fraction of a second.

STARTING OUT

If photographing birds in flight is something you haven't done before, do start with something easy. In practice this means something big and slow like the Bewick's Swan featured opposite, which was photographed at the Wildfowl and Wetland Trust's Slimbridge reserve. Because of the bird's large size, you don't have to get too close to it to get a good-sized image, and also the further away the bird is the easier it is to track as it flies across your line of sight. It helps to photograph your subject on a bright, sunny day against a clear blue sky. This above all other factors allows your autofocus system to lock onto the bird, as with this clear background there is nothing to distract it.

The picture works well, except for one common problem with this type of shot, which is the shadow of the bird's body on the far wing. This shot was actually taken

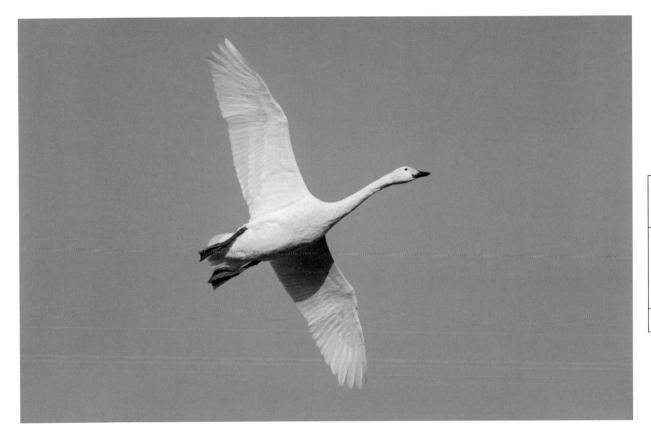

● BEWICK'S SWAN
(*Cygnus columbianus bewickii*)

Canon EOS 1Ds Mark II, 400mm f4 lens + 1.4x converter, 1/1,000th sec @ f6.3, digital ISO 400

Gloucestershire, UK

quite late on a winter's day, so the sun is fairly low in the sky, which minimizes the shadow, but even in these conditions it remains a problem. Unless the bird has banked away from you, allowing the underside to be completely lit by the sun (this would give a completely different picture), there will always be a shadow.

Because this is the first example in this chapter, we might as well get a few very relevant practical technique issues out of the way. Firstly, exposure: when photographing birds in flight, always use manual exposure. Set your exposure for the bird and the background will take care of itself. A blue sky varies in tone considerably, being darkest directly overhead and brightest on the horizon. The bird doesn't vary in tone, and if you let your camera work out the exposure for the overall scene it will usually get it wrong. White birds are particularly tricky, as you have to be extra careful not to overexpose the white feathers, which would completely ruin the picture. Secondly, watch how you set your autofocus system. There are usually two modes, tracking and fixed point. In Canon SLRs these are known as A1 Servo and Single Shot – you need the tracking option (A1 Servo). If you try and use Single Shot you'll be very unlikely to get any sharp pictures, as the camera will not track the bird at all.

Finally comes the question of whether to use a tripod or not. For me this depends largely on what lens I am using. I have two main lenses that I use for flight photography, my 400mm f4 DO lens (weighing 2kg) and a 500mm f5 lens (weighing 4kg). There are exceptions, but generally the 500mm is mounted on a tripod using a Wimberley Head (see equipment chapter), as it is just too heavy to carry around and use for any length of time. The 400mm I like to use hand-held. It gives me more freedom of movement, which is essential for fast moving subjects.

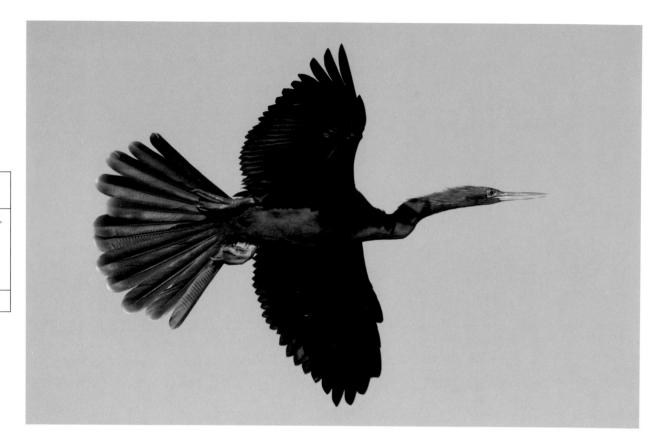

⚫ ANHINGA
(Anhinga anhinga)

Canon EOS 1D Mark II,
500mm lens + 1.4x
converter, tripod,
1/1,000th sec @ f8,
digital ISO 200

Florida, USA

SKY BACKGROUNDS

Now we've established the basics, let's ramp up the degree of difficulty and try more challenging subjects. Venice Rookery in Florida is a world-famous location for breeding waterbirds and provides excellent opportunities for flight shots. Florida is one of the easiest places in the world to photograph birds, because they are generally nowhere near as shy of people as their European counterparts and are very approachable. In addition, the light is very bright, which allows you to shoot at high shutter speeds – a tremendous help when trying to freeze the action.

On my first visit to the rookery (at the end of January) many of the birds were in the early stages of nest building and were quite active, often flying around gathering nest material or simply looking to find a suitable nest site. Anhingas are rather primitive birds and not the world's

greatest flyers, but after watching them for a while I noticed that they would often spread out their tail feathers to help them balance as they flew by. I decided this would make a good picture. On a clear blue day (much more common in Florida than in Britain), I framed the male bird shown above as he flew by, much closer than I had anticipated. To be honest, I'd have been fine without the 1.4x converter, but was very pleased that I managed to frame him nicely with so little spare room to work with. When shooting against a blue sky, it is good to fill the frame with the bird if you can, as the sky contains nothing of interest that will add to the picture.

The picture opposite is essentially the same as the previous two (i.e. a bird in flight against a blue sky), but is more difficult to take. This is because the bird is considerably smaller than the other subjects, and also because it is a very fast flyer and will change direction in

a flash, as many pictures I have of a clear blue sky with no bird in it will testify. You have to be very close to such a small bird to fill the frame. This makes life very difficult indeed, because the bird travels much faster across your viewfinder than a larger bird giving the same size image. This is because, even if travelling at the same speed, the larger bird will be much further away and much easier to keep in your camera's viewfinder. Large birds also tend to be less agile in flight than small ones, so they tend to keep a relatively steady course.

Swallows, swifts and martins are truly birds of the air, and I find they provide an irresistible challenge as they tear by above me. On this occasion I was visiting Hailuoto Island in the Gulf of Bothnia off the coast of Finland, when I came across a large number of newly arrived House Martins (below) flying around a lighthouse building, where

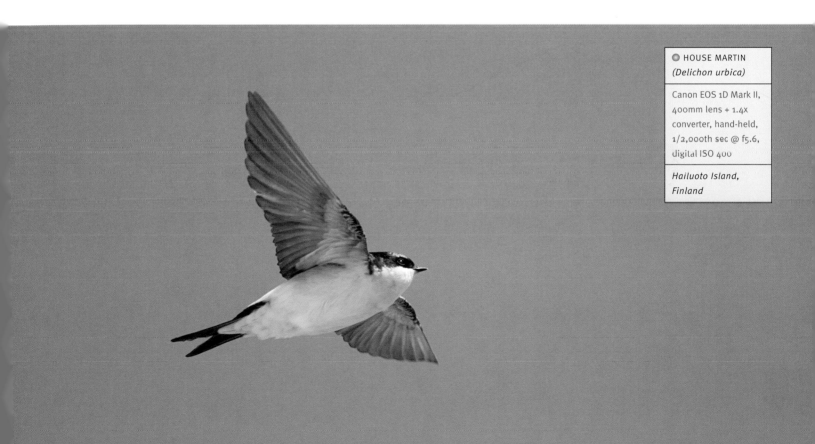

○ HOUSE MARTIN
(Delichon urbica)

Canon EOS 1D Mark II,
400mm lens + 1.4x
converter, hand-held,
1/2,000th sec @ f5.6,
digital ISO 400

*Hailuoto Island,
Finland*

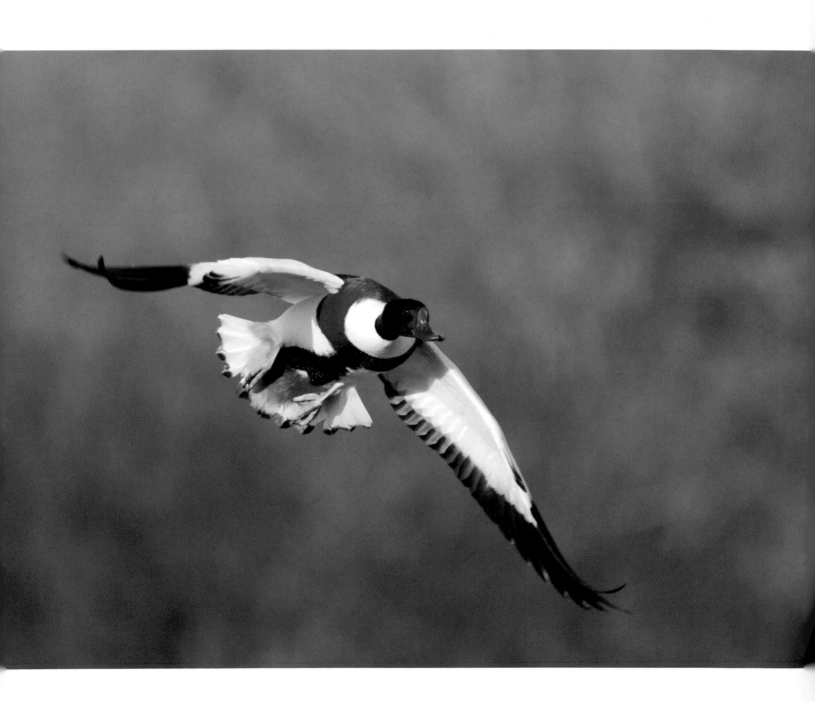

it would appear they were prospecting for nest sites. Now I hadn't gone all the way to Finland to photograph House Martins, but you have to make the most of any opportunity that arises and I set to work. When photographing really fast birds like these I tend to use the Canon EOS 1D Mark II body. Although it has only half the megapixels of the 1Ds, being able to shoot at eight frames per second and having a burst rate of over 20 frames are real advantages in this situation.

Hand-holding gave me total freedom of movement to track the birds in my camera. This would have been much harder to achieve had I been using a tripod, even if fitted on a Wimberley head.

NON-SKY BACKGROUNDS

Photographing against a background other than the sky complicates matters for the autofocus system, because the background now provides alternative targets for it to focus on, unlike the featureless blue sky in the previous pictures. In addition to this, it is just as important to make sure that the background does not distract from the main subject. In the picture of a Shelduck in flight featured opposite,

photographed at Slimbridge reserve in the UK, the soft tones of the shrubs in the blurred background add to the overall effect of the image, rather than detracting from the bird. Once again, though, the suitability of the background is something that has to be decided almost instinctively, since you will have only a fraction of a second to decide.

To give my camera the best chance of locking on to a flying bird, I tend to set all of the autofocus sensor points to 'on'. This means that I have the maximum chance of getting the bird sharp. Using just the central sensor is recommended by some people, but I find this is less successful with all but the slowest birds. It is very difficult to keep the single sensor on the bird's head, and as soon as it is off the head the camera starts searching around for something else to focus on, causing you to miss the shot. This is particularly the case when you are hand-holding a camera, as I was when I was photographing this Shelduck.

Notice also that the bird is flying into the picture. By this I mean that there is more open space in front of the bird than behind it. This gives the most pleasing results in most cases and is relatively easy to achieve – if you get the head in the centre (and it's the head you want to be pin-sharp), the composition tends to be about right if the bird is large enough in the frame.

SHELDUCK
(Tadorna tadorna)

Canon EOS 1Ds Mark II, 400mm lens + 1.4x converter, hand-held, 1/1,000th sec @ f6.3, digital ISO 400

Gloucestershire, UK

⬤ GREAT BLACK-BACKED GULL *(Larus marinus)*
Canon EOS 1Ds Mark II, 400mm lens + 1.4x converter, hand-held, 1/1,250th sec @ f5.6, digital ISO 400
Shetland Isles, UK

HEAD-ON

All of the flight shots shown so far were taken as the bird flew across the camera, which is by the far the most common situation. In the image below, however, the bird is coming straight at the camera, head-on, and this position can add a great deal of drama to any flight photograph. Framing is a little easier in this situation, because you pick up the bird early, simply wait until it fits nicely in the

picture and press the button. In this case the wings are lifted to form a lovely 'V' shape that greatly adds to the overall impact of the image.

We came across this largest of gulls while walking around Noss Nature Reserve, which is an island just off the coast of Lerwick, the capital of the Shetland Isles. It was a cool, overcast day, and as we followed the footpath around the island, we noticed a pair of Great Black-backed Gulls on the edge of a cliff. To be honest, they spotted us before we

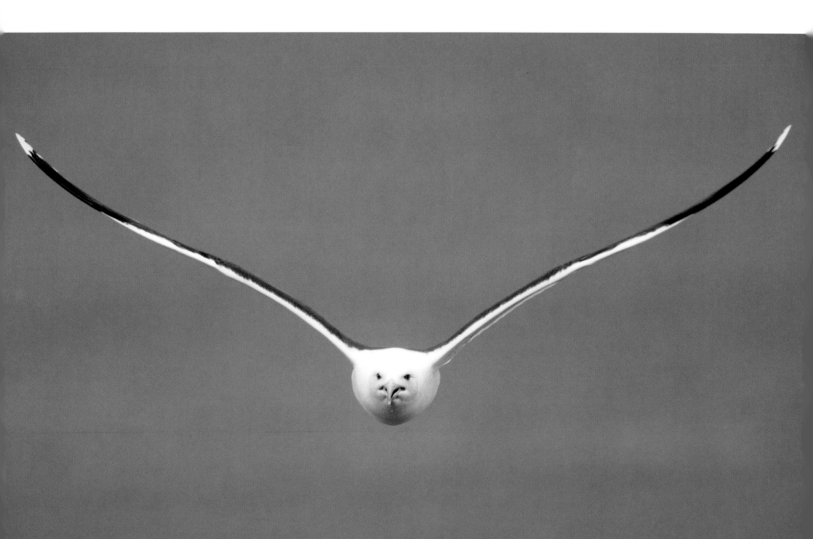

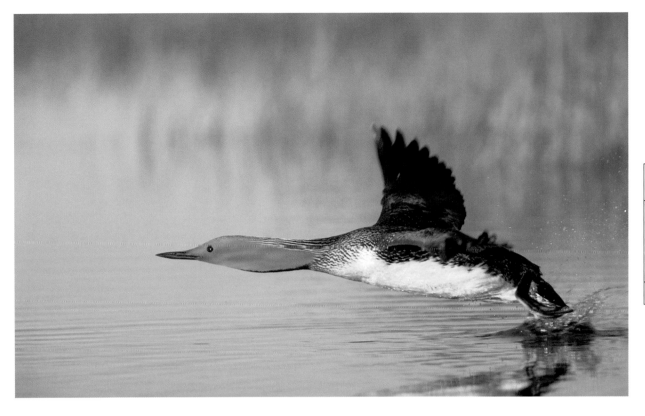

RED-THROATED
DIVER *(Gavia stellata)*

Canon EOS 1Ds
Mark II, 400mm lens +
1.4x converter, tripod,
1/600th sec @ f5.6,
digital ISO 400

Finland

saw them, and the male headed over towards us in a
determined fashion. We stood our ground as he came
closer and closer. Although he looked very threatening it
was all bluff, and he banked away at the last minute.
Having satisfied himself that he had done his duty, he
promptly returned to his mate at the nest site and let us
continue our walk unmolested.

Photographing birds against the sky in overcast
conditions is usually a waste of time, because the
background is both very bright and rather boring. In this
case I was slightly higher than the bird as he approached
from the cliff edge, and this enabled me to get into a
position where I could use the sea as a background, which
worked very well to produce a diffuse backdrop. Despite
the dull conditions, I was still able to shoot at 1/1,250th
of a second, because I had to effectively underexpose
by a full stop to avoid blowing out the white highlights
of the bird.

TAKE-OFF

Generally speaking, there are two methods employed by
birds to get airborne: running and jumping. The runners
are represented here by the gorgeous Red-throated Diver
above, shown as it legs its way across its breeding pond
in an open marsh surrounded by pine forest, deep in the
heart of Finland. Pictures of birds running across water
like this add a whole new dimension to flight photography,
and the impact of such shots can clearly be seen here.
You can almost feel the strain as the bird uses every
muscle to drive itself over the water to reach enough
speed to get up in the air.

Although I was using the 400mm lens for this shot,
I was using a tripod too, as I was sitting in a small hide by
the side of the pond. The hide is in place all summer long
so the birds are very used to it. On this occasion I had
been in the hide for around six hours – a tripod for even

the smallest of lenses is very useful in such scenarios, because holding a camera for this length of time would be nigh on impossible. My feet were also in several centimetres of water, so a secure place for my camera was essential. Exposure was quite tricky, as the bright white belly of the bird was not visible until it started running, and without allowing for this the shot would have been ruined. Knowing my subject was thus crucial in getting it right.

The surroundings were nigh-on perfect, with soft evening light and calm conditions. Red-throated Divers breed on very small ponds, and this one was barely big enough to provide the runway length required for take-off. To get airborne the bird had to swim to one end of the pond, turn around, then run for all it was worth. Observing this behaviour enabled me to prepare for the shot. As a wildlife photographer I've spent far more time watching birds than I did as a birdwatcher. By carefully studying the behaviour of birds you can anticipate their actions, something that is essential for capturing moments like this, which are over in a fraction of a second. In fact, it's freezing such fleeting moments and being able to study them at leisure afterwards that makes this type of photography so rewarding.

In contrast to the Red-throated Diver with its run-up, the Mallard pictured on the right practically explodes from the water as it takes to the air. This is a much more difficult action to capture because it involves just one sudden movement. At least when a bird runs across the water you can try and follow it as it goes. With shots like those of the Mallard, if you don't get it the first time there are no second chances – it's gone.

I was set up on a lake in St Albans photographing Grey Herons nesting on an island in the middle of the lake when a group of Mallards landed in front of me. It was early in the year and they were very active – a couple of males in the group took off almost as soon as they landed. Knowing that the others were likely to follow, I quickly focused on one male, and sure enough within a few seconds he leapt into the air to take flight. Wildlife photographers spend a

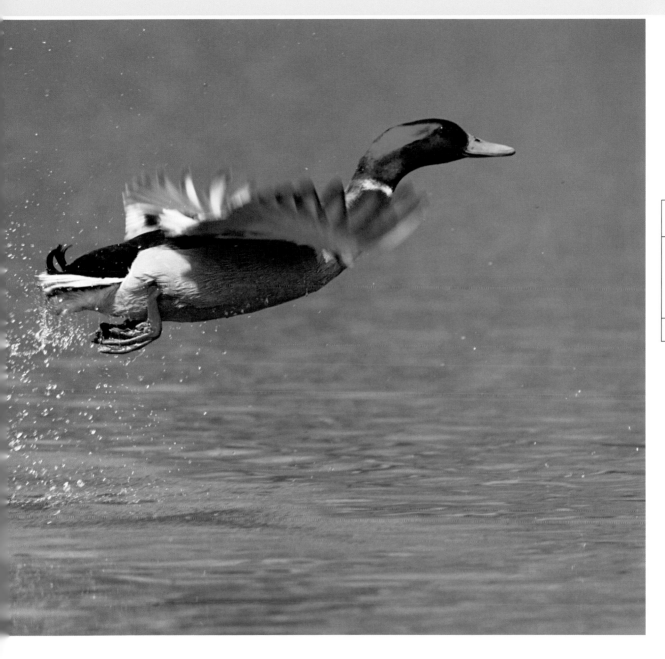

● MALLARD
(Anas platyrhynchos)

Canon EOS 1D Mark II,
500mm lens + 1.4x
converter, tripod,
1/1,000th sec @ f8,
digital ISO 400

St Albans, UK

lot of time waiting around for a particular shot, so when something drops into your lap unexpectedly like this you have to take advantage of the situation and react quickly.

Previously in this chapter we've talked about the bird 'flying into' the frame and how this generally makes for the best composition. In this shot, however, the bird is flying out of the frame – exiting stage right. The picture still works, though, but why?

In this case there is sufficient interest in the left side of the frame to balance the composition, so it works as a picture. The huge splash of water that occupies the left of the picture is a key element and adds a sense of movement and dynamism to the final image. If this wasn't there and if the area contained only plain water, the left side of the picture would effectively be 'dead' space and the overall composition would not work.

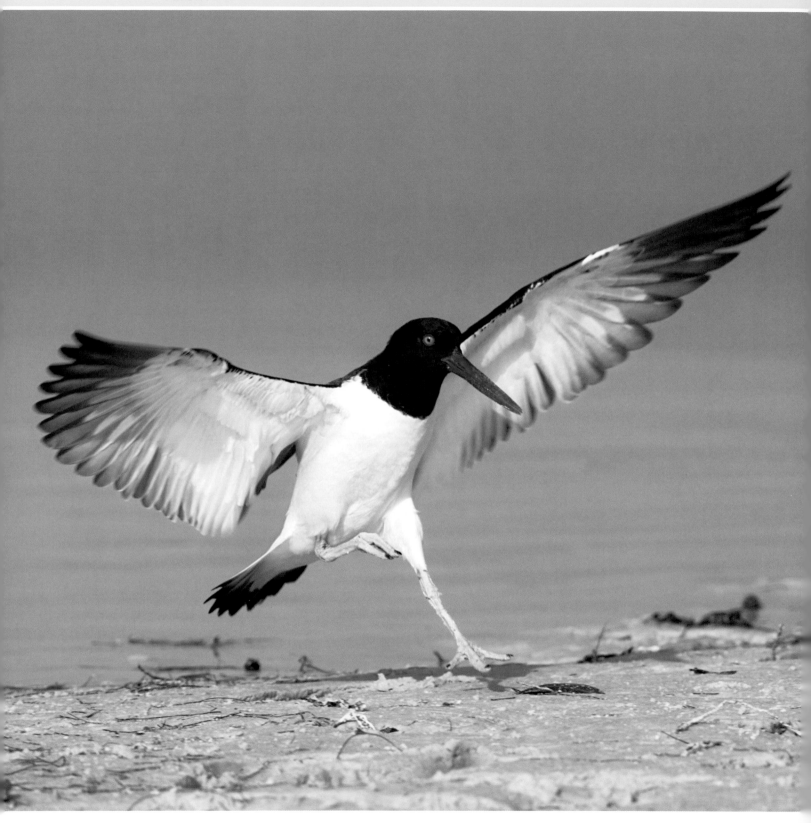

LANDING

What goes up must come down, and birds are no exception. It is capturing the moment of touchdown that we deal with next.

This American Oystercatcher has its left foot just an inch or so above the ground, a split second before landing on the white sand beach. When photographing a bird taking off you have the advantage of it being in front of you to start with, and all you need to do is wait for it to take off. When photographing a bird landing you can't just focus on an empty bit of ground and hope for something to drop in – you have to anticipate the event by careful observation. This is best achieved by finding an area where birds are regularly landing. This was the case when it came to the American Oystercatcher picture. I was on the beach on a rising tide, and the mudflats where many wading birds were feeding were slowly but surely being covered by the sea. There was one spit of sand that was just a few centimetres higher than the surrounding area and quickly became the only bit of dry land around. This was attracting a lot of birds that were flying in to wait until the tide receded, when they could resume feeding.

It wasn't necessary to set up a hide. I simply walked out slowly and carefully onto the spit before kneeling down and setting up my camera on the Wimberley head mounted on my tripod. The birds ignored me completely. In fact, as the tide rose further a few started to settle down and sleep just a metre or so away. I concentrated on framing the bird in the camera as it flew in to the spit, picking it up as far away as possible. As the bird came

● AMERICAN OYSTERCATCHER (*Haemotopus palliatus*)
Canon EOS 1D Mark II, 500mm f4 lens + 1.4x converter, tripod, 1/1,000th sec @ f8, digital ISO 200
Florida, USA

closer and closer and prepared to land, I started shooting. Using this technique gives the autofocus system the best chance of locking onto the bird and tracking it, so when you press the shutter you have the greatest chance of taking a sharp image.

This image is also a very good example of why manual exposure is so essential. Without it the white underside of the bird would have been overexposed – despite the bright surroundings on a sunny day the meter would still have got it wrong.

There are times when using manual focus to capture a bird landing is far more successful than using the camera's autofocus system. This was certainly the case when I was attempting to capture a bee-eater landing on its perch in Hungary (opposite).

Bee-eaters are relatively small, fast-flying birds (they catch insects on the wing), and I was in a small hide set up near a nesting hole. My camera was of course mounted on a tripod and this, combined with the rather restricted view that is inevitable in a hide, combined to make it very difficult to pick up the bird in the camera as it flew in. Even when I managed to pick up the bird early, it proved impossible to track because it dipped low, then shot

up to the perch to land. Ideally I would have stood outside the hide near the perch. Using my hand-held 400mm lens, I would have had the freedom of movement to track the bird in flight and get the shot I was after.

Unfortunately, wild birds (particularly in Europe – I wasn't in Florida now) tend to steer clear of people, and the bird would not have come anywhere near me. So what should I do?

In this situation I knew exactly where the bird was going to land – on the perch that we had so thoughtfully provided for it. All I had to do was focus on the perch and wait. Because the bird was landing quite infrequently, it was the waiting that was the most difficult bit. You couldn't relax because you had to be ready to shoot if the bird appeared. The nice thing about bee-eaters is that they make a very distinctive call, and as the bird approached the perch it would call out (presumably to its mate in the nest hole). This alerted me to its presence, and my shutter finger hovered over the button as I peered expectantly through the viewfinder. As soon as the bird appeared, I pressed the shutter release and made one of my favourite bee-eater shots, beating the autofocus technology hands down – a good day indeed!

● EUROPEAN
BEE-EATER
(Merops apiaster)

Canon EOS 1D Mark II,
500mm lens, tripod,
1/2,000th second @
f5.6, digital ISO 400

Hungary

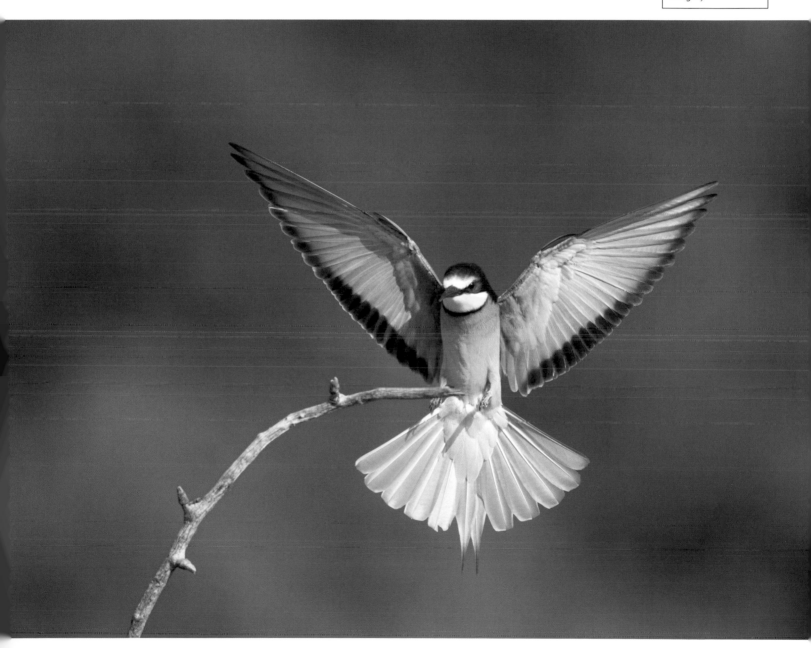

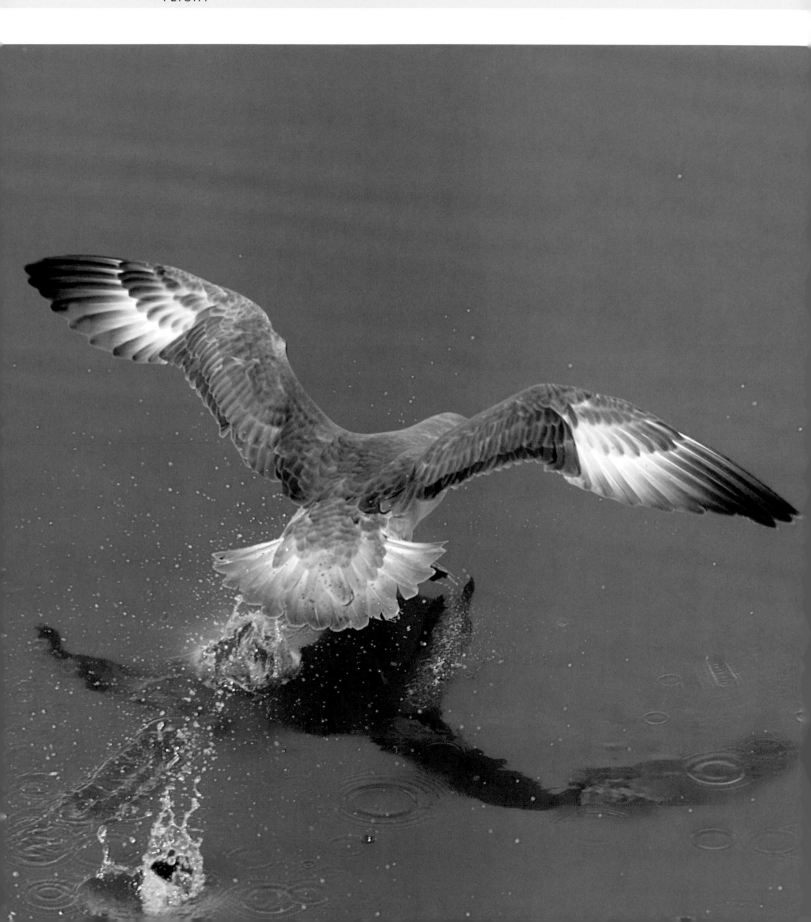

FLYING AWAY

It must be said that taking pictures of birds flying away from you rarely works, and it is not something I do often. However, some pictures like this do work.

We were on a ship cruising slowly through the broken ice around Spitsbergen high above the Arctic Circle, looking (rather unsuccessfully) for Polar Bears. There were a number of Fulmars flying around the ship, and I was passing the time photographing them flying low over the water and the ice. After a while I wandered up to the bow of the ship, and from this point I noticed that occasionally a Fulmar sitting quietly on the clear water between the ice flows would wait until the last second before running across the water to take off as the ship approached.

I thought this would make a slightly different picture than normal, so I positioned myself right on the bow and waited. Needless to say, nothing now happened for some time, but eventually I spotted a Fulmar sitting on the water in front of us, which seemed determined to stay put. With a 2,000-ton ship bearing down on it, this was never a strategy that was going to be successful. At the last moment, it launched itself across the sea as fast as it could go. That was the moment I had been waiting for.

Despite the viewpoint, the image works mainly because of the positioning of the bird in the picture. Although the bird is flying away from us, it is at such an angle that it is still flying into the empty space to the right of the picture. The contrast between the relatively pale plumage of the bird and the dark blue water helps, as does the bird's reflection and the two splash points in the sea.

● FULMAR
(Fulmarus glacialis)

Canon EOS 1D Mark II, 400mm f4 lens + 1.4x converter, hand-held, 1/2,000th sec @ f8, digital ISO 400

Spitsbergen, Norway

FLOCKS

● BRENT GEESE
(Branta bernicula)

Canon EOS 1D Mark II,
400mm f4 lens + 1.4x
converter, hand-held,
1/500th sec @ f8,
digital ISO 400

Kent, UK

Photographing bird flocks in flight can result in very evocative pictures, capturing whole scenes, rather than just isolating single birds. Spectacular as such images can be, they are in fact very easy to take. The relative distance from the camera gives you more depth of field to work with, and the wall of birds is easy for your autofocus system to handle. The difficult bit is being there when something like this happens. When I took the shot below I was visiting the east Kent coast on a rare sunny winter's day specifically to photograph the Brent Geese which a fellow photographer had told me were there in good numbers. I had arrived not long after dawn and the geese were feeding close inshore, as the beaches were pretty deserted at this hour. As the sun got up, so did the local population on this Sunday

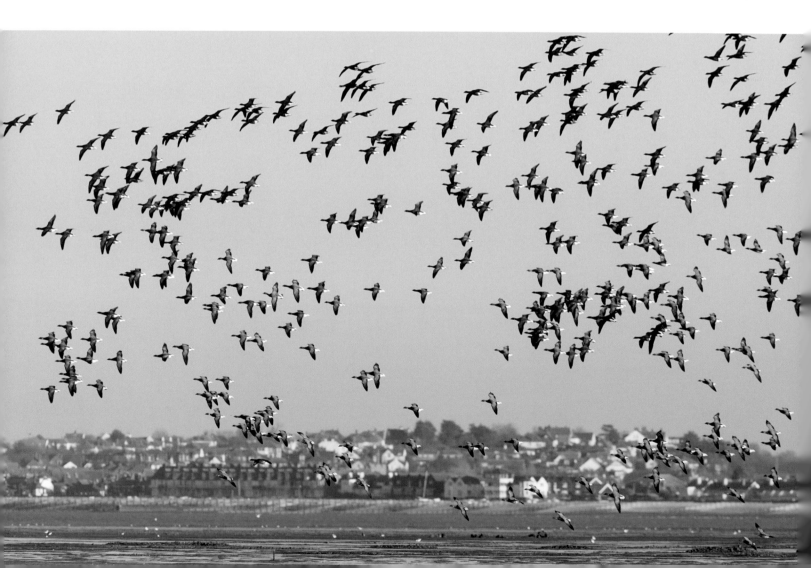

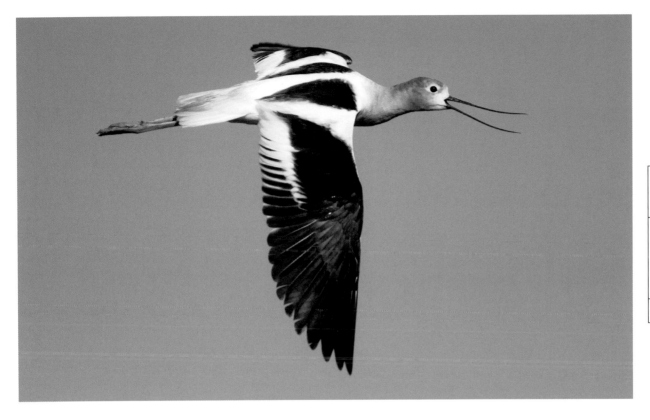

● AMERICAN AVOCET
(*Recurvirostra americana*)

Canon EOS 1D Mark II, 400mm f4 lens + 1.4x converter, hand held, 1/1,600th sec @ f5.6, digital ISO 200

Oregon, USA

morning, and dog walking proved to be a popular pastime. Now birds are not particularly fond of people wandering up and down the beach, but they will not tolerate dogs at all. Consequently the geese flew across the sea wall and onto the adjoining fields.

As the tide went out and the mud flats were revealed, the birds took off as one and flew over the 'danger area' of the dog-infested beach and out onto the mud to feed. Fortunately I was some distance away at the time and was able to frame a large part of the flock as it wheeled around to land. The background shows the seaside town of Whitstable in the distance. I think it really adds a sense of place to the picture, showing a typical winter coastal scene in southern England. I have also captured the very front of the flock to the left-hand side of the frame, with no birds disappearing out of the picture. This gives the flock a pleasing shape. It is also important in a shot like this to keep the horizon straight.

FLIGHT PLUS

In this section we look at taking the flight shot and adding something else to provide additional interest to a picture. In the case of the American Avocet portrayed above, the bird is clearly calling as it flies by. This is one of the easiest behaviours to capture in a flying bird because birds frequently call while on the wing – the sound travels a great distance when the bird is high in the sky.

The picture was taken at Klamath National Wildlife Refuge on the border between California and Oregon in the west of the United States. The American Avocet is a particularly good species to demonstrate the impact that catching the bird in flight can add to a picture, because its long, curved bill shows up very well when it calls. The bird in this picture fills the frame and is pretty central, although there is a little more space in front of it than behind it.

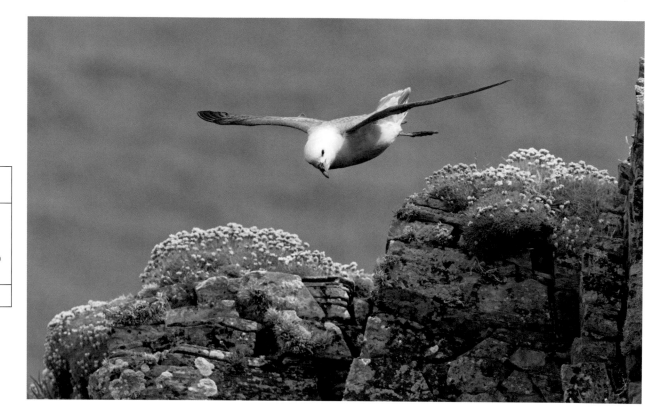

● FULMAR
(Fulmarus glacialis)

Canon EOS 1Ds Mark
II, 400mm f4 lens +
1.4x converter, hand-
held, 1/1,000th sec @
f9, digital ISO 400

Shetland Isles, UK

The other way to add something extra to a flight shot is to include additional elements in the picture. Normally the background tends to be very plain and out of focus, such as sea or sky. This is often good, as an uncluttered background shows the bird to its best advantage. In the picture above, however, I have included some elements of the bird's cliff-edge habitat, which lift the image above a straightforward picture of a Fulmar in flight.

While visiting Sumburgh Head on the very south of the Shetland Isles, I was watching the Fulmars use the updraft along the cliffs to bounce around in the air with seemingly little effort. In windy conditions such as this, Fulmars can take off easily – they simply throw themselves off the nest site and sort themselves out when airborne. Landing, though, is another matter and they will often make several attempts, circling around back out to sea each time before coming in for another go. This particular bird had already made a couple of attempts at landing and I noticed that it

took the same route as it came back each time. There was one part of this route where it came around the corner of the cliff, just over a very attractive lichen-covered rock that was covered with the pink blooms of Thrift. The timing was quite tricky, but after a few attempts I managed to get the shot I wanted.

The key to the success of this image is the positioning of the bird in relation to the cliff. If the background was just the sea, then the bird would be too high in the frame, but in this picture the rocks hold equal interest to the bird, so the bird is positioned to show off the rocks to the best advantage. When using long lenses the depth of field is minimal – I had to try and get the bird just above the rocks so that both elements were in focus. I stopped down to f9 to increase the depth of field, but couldn't go any lower because I needed 1/1,000th of a second to freeze the bird and keep it sharp. This was a surprisingly tricky image to create, but it is one of my favourite Fulmar pictures.

PORTRAIT MODE

So far all of the pictures in the flight section have been in landscape format, but the image of a Black-browed Albatross on the right is in portrait format. It is a difficult shot to take, but does suit some subjects very well.

Many Black-browed Albatrosses were following our ship across the infamous Drake Passage as I was returning back to South America after a trip to Antarctica. Some follow ships for miles, shearing back and forth across the waves without even flapping their wings. Calm weather may be good for the ship's passengers, but it is not good for birds that use the wind to stay aloft. It was pretty rough weather that found me standing on the stern of our small ship as it battled through the waves, rolling from side to side – not the most stable platform for photography.

Albatrosses often fly with their wings at 90 degrees to the ocean as they bank to make the most of the wind. This is the classic albatross image, but it is not best suited to the normal landscape mode picture. I decided to capture the bird in portrait mode. It is awkward to hold the camera and telephoto lens in this position, and tracking the bird is tricky because your horizontal field of view is very narrow.

As you can see from the exposure of 1/2,000th of a second at f8, it was very bright. As is usual with birds that contain a fair amount of white plumage, this would have been at least a full stop underexposed compared with the camera's meter reading. I could have shot at 1/4,000th of a second at f5.6, but I reckoned that 1/2,000th of a second was fast enough for a sharp image, and that f8 would give me that extra little bit of depth of field.

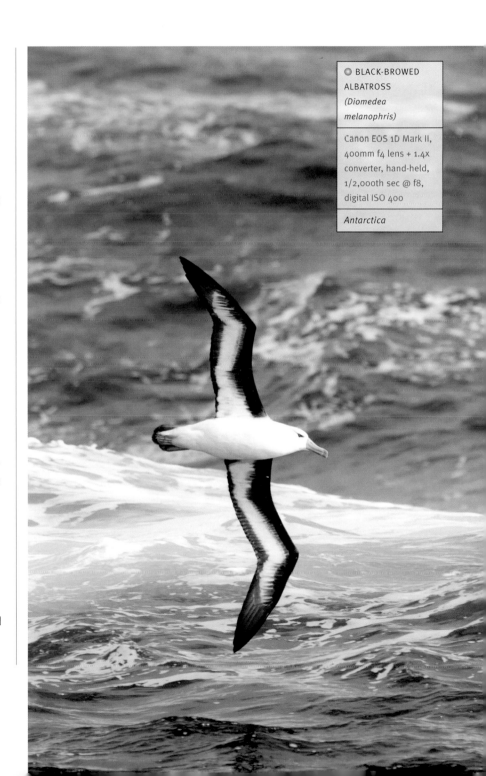

● BLACK-BROWED
ALBATROSS
(Diomedea
melanophris)

Canon EOS 1D Mark II,
400mm f4 lens + 1.4x
converter, hand-held,
1/2,000th sec @ f8,
digital ISO 400

Antarctica

Life cycle

This chapter focuses on the reproductive life cycle of birds, from courtship to rearing of the young. Some of the most impressive bird behaviour can be found in the elaborate ways in which birds seek to attract a partner with which to pass on their genes to the next generation.

NEARLY ALL BIRDS BUILD NESTS, of course, and it was this central part of a bird's life that drew the first ever bird photographers. With their primitive equipment and short lenses, they were never going to succeed by chasing birds around to try and get a picture, but the nest could guarantee the presence of a bird. This required the building and positioning of hides to conceal the photographer. Nesting birds are very vulnerable, so it was essential that the photographer did not disturb the birds as they went about the business of bringing up a family. Not disturbing birds, particularly while nesting, remains paramount today. Many rarer species are specifically protected from disturbance at the nest – photographing them at or indeed near the nest requires permits, and these are not lightly given. Photographing some species near the nest is still a great way to take interesting pictures, because a great deal of activity takes place close by this key structure in a bird's life.

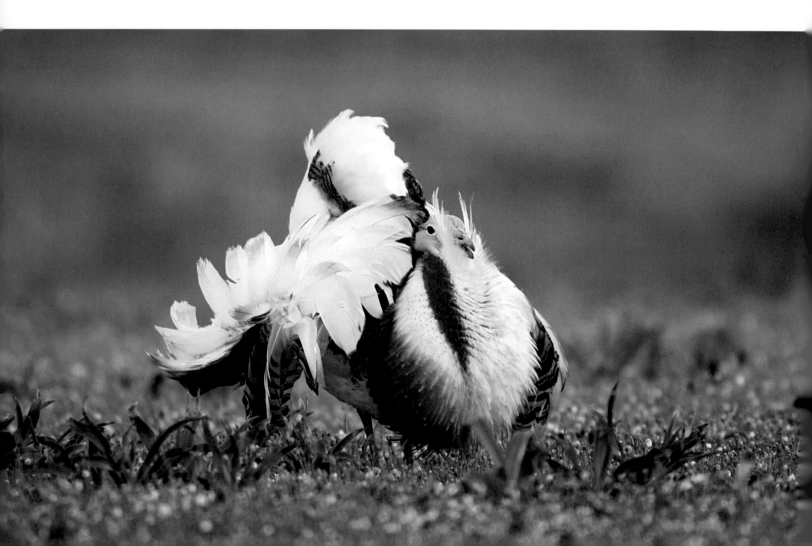

ATTRACTING A MATE

The first step in the reproductive cycle is to find a mate. It usually falls to the male bird to make himself attractive, for in most species it is the female that does the choosing.

It is the behaviour of the males in some species that is of most interest to us here, and the lengths that some species will go to in order to attract a mate are simply extraordinary, making for some of the most interesting bird images you will ever take. The male Great Bustard strolls around the rocky hillsides in the Extremadura region of Spain in small groups at the start of spring. Groups of males will display seemingly at random, either to each other or especially if a female appears nearby. In the display itself the male seems to almost turn himself inside out as he stretches his neck back over his body while inflating an air pouch in his throat, then he turns his wings over to display the white secondary feathers. He can walk around a little while displaying, but usually just stands there holding the position for several minutes at a time if a female is around.

The display is a bit of a moveable feast and is not easy to photograph, because you can never be sure exactly where it will take place. In this particular location in Extremadura there are a number of stone hides built into a hillside where the birds most frequently display. These are small structures, and in order not to disturb the birds it is necessary to enter a hide before sunrise and not leave until sunset. This means that you are in the hide for around 15 hours, which is not the most comfortable way to pass the day. The stone hides don't accommodate tripods well so I would use the 'windows' (simply holes in the stone walls) to rest the long lens on.

You can wait for many hours before a bird wanders by close enough for a picture, but on this particular morning a male (opposite) started to display very early. This was nice to see, but it was still rather dark for photography and an exposure of only 1/125th of a second was the best I could manage. Thankfully technology came to my rescue and in these circumstances I was very glad I was using an image stabilized lens, particularly as I couldn't even use a tripod.

The Great Bustard has a pretty static display, but I guess that this is to be expected for such a heavy bird. Some birds, though, are very active in their attempts to attract a female and the Little Bustard, found in the same region of Spain, is a good example of this. The clue to the manner of the display is in the name, for the Little Bustard is much smaller than its cousin. Its habitat is also slightly different – it prefers lush meadows to the rather arid steppes that the Great Bustard favours.

The problem with the Little Bustard's habitat is that the plants are much taller, making it very difficult to see the bird. This is a real plus-point for the male bustard when he is hiding from potential predators, but a bit of a drawback when he is trying to let any females in the area know that he is available. The solution to this dilemma is remarkably simple – the male bird simply jumps up into the air, so that any female in the vicinity will see where he is. Just in case any of his potential partners are looking the other way when he does his display jump he also lets out a call, rather like blowing a raspberry, to attract their attention.

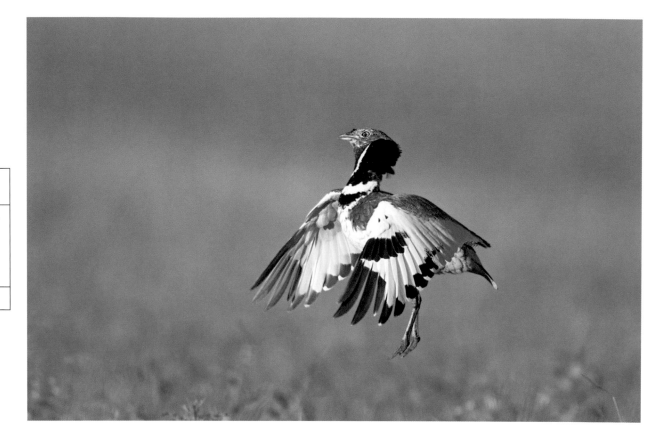

● LITTLE BUSTARD
(Otis tetrax)

Canon EOS 1D Mark II,
500mm f4 lens +
2x converter, tripod,
1/1,250th sec @ f8,
digital ISO 400

Extremadura, Spain

The Little Bustard is a very nervous species, which makes photographing the display quite a challenge. The actual display jump can occur anywhere within the male's territory, so you are never sure where he is going to appear. We'd set up a canvas hide a few days previously and made sure that the bird accepted it as part of his landscape before using it. I entered the hide before dawn to avoid any disturbance and waited. In the half light I could hear him calling, and as the sun rose I finally saw him among the vegetation. As it got brighter he began to display and would pop up, making a small arc, before disappearing again a metre or so from where he started. To get a decent-sized image I used a 2x converter on my 500mm lens, so given the 1.3x magnification of the camera body I was effectively using a 1,300mm lens. I decided to use manual focus, as autofocus is incredibly slow at f8 and the bird only appeared for a second or two at a time.

COURTSHIP DISPLAY

Albatrosses perform some of the most enchanting courtship displays in the entire world of birds, and make wonderful subjects for your camera. They are very large birds and, like most seabirds that nest on remote islands, are tolerant of humans and will often ignore you altogether. The pair bond is very strong with these birds – they often mate for life. They continually strengthen the bond with their displays throughout the breeding season.

We spent a week on Midway Island, a small dot in the very middle of the Pacific Ocean halfway between Japan and the USA. Midway is of course most famous for the Second World War battle that took place in the vicinity between these two nations. Nowadays, although it's still covered in crumbling concrete buildings, it is home to thousands of seabirds, including the Black-footed

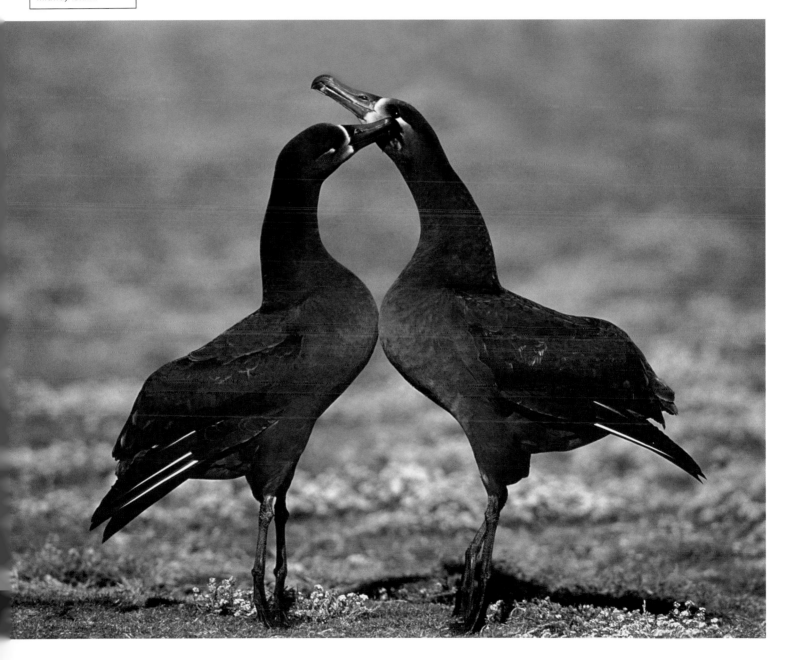

Albatross. The display takes a few minutes to complete and consists of many phases, all accompanied by soft braying calls. The grand finale occurs when the two birds stand on tiptoe, push their chests together and cross their bills as shown on the previous page. It's simply amazing.

We saw the displays regularly, but they were not easy to photograph because the density of albatrosses on the available land was high, and it was very difficult to isolate a pair and get a clean background. This is a common problem when visiting large breeding colonies. I find that the best approach is to work at the very edge of the colony, where bird density is at its lowest. Of course, a low density of birds also resulted in fewer displays. We waited many hours before this pair finally performed in front of us and I got the clear background that was so essential to the success of the shot. To maximize the clear space around and particularly behind the birds, I had to frame them very tightly. I also stood as tall as I could to exclude another pair of birds that would have appeared in the very top of the picture had I been at a lower angle.

FOOD PASS

A food pass like the one shown on the right can take place at two stages during the breeding season. The first is during courtship when the male is trying to convince the female that he will make a good provider should she accept him as a mate. The second is when the female is either on eggs or has very small chicks. At this stage female birds of many species spend most of their time at the nest

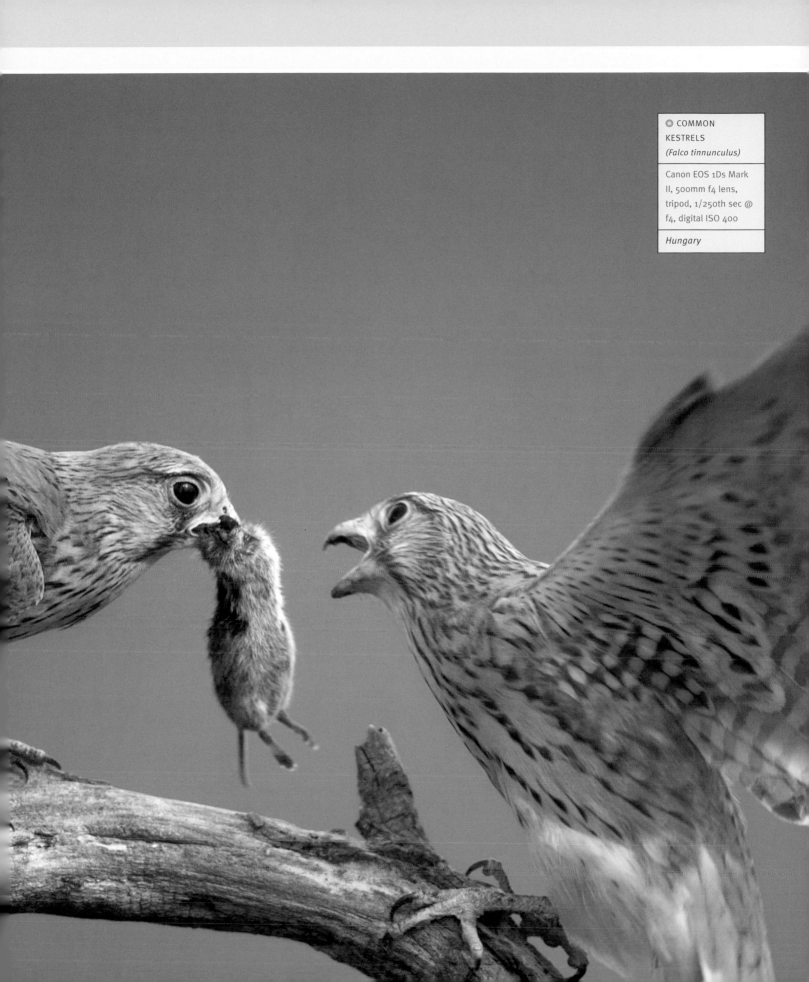

● COMMON
KESTRELS
(Falco tinnunculus)

Canon EOS 1Ds Mark
II, 500mm f4 lens,
tripod, 1/250th sec @
f4, digital ISO 400

Hungary

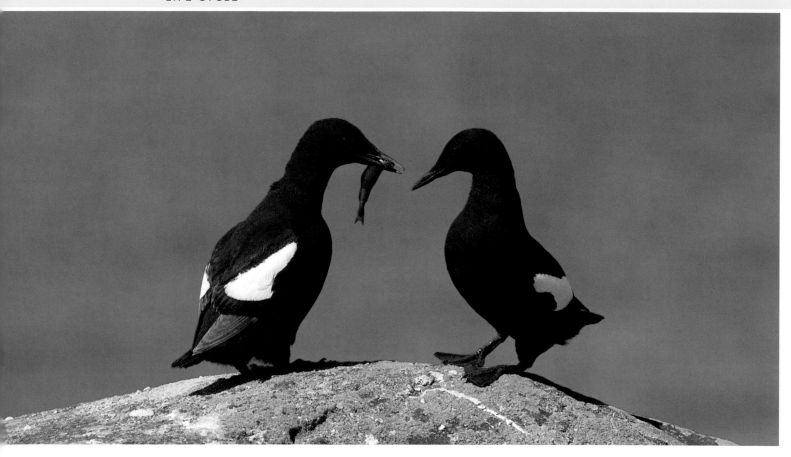

● BLACK GUILLEMOTS
(Cepphus grille)

Canon EOS 1Ds Mark II, 400mm f4 lens + 1.4x converter, hand-held, 1/500 sec @ f11, digital ISO 400

Shetland Isles, UK

and the males bring food. Sometimes the male will take it straight to the nest, but often he will wait around outside on a nearby branch until the female comes out.

I was in a very luxurious wooden tower hide, six metres or so up in the air on a rather muggy afternoon, and the temperature in the hide was over 32°C (unfortunately the luxury didn't extend to air conditioning). After a couple of hours I was wilting, dark stormy clouds were gathering outside and the light levels plummeted.

It was at this moment that the male kestrel arrived with a vole and landed on a nearby tree. He called the female a few times and she responded, and after a few minutes came out onto a bare branch. He then flew down to join her and immediately gave her the vole, which she took straight back to the nest. It was all over in a fraction of a second. The food pass took place a little too close to the hide for my liking, so the resulting picture (shown on pages 78–9) is very tightly cropped, but I think it still works. The low light levels were reflected in the relatively slow shutter speed of only 1/250th of a second. This resulted in the female being blurred as she moved to grab the vole. The male, though, is sharp because he stood very still as the female's powerful bill came towards him. If the male had been blurred the picture would not have worked, but with the male sharp and the female's blur clearly caused by her quick movement, I think that in this case this adds something to the overall feel of the image. I do have another shot of her with the vole in her mouth and both birds are sharp, but it lacks the drama that the female's movement brings to the shot.

Not all food passes are quite as gruesome as those of the raptors. Many seabirds feed on fish, which tends to result is rather less blood in your pictures. The pair of Black Guillemots pictured above were, I believe, in the early

stages of courtship, and the male bird on the left was attempting to present his prize to his prospective mate. I think you will agree that this is a far more tranquil scene than the one depicted in the photograph of the kestrels on the preceding page.

I was on the small island of Mousa, just off the coast of mainland Shetland, and it was the Black Guillemots that I had come to photograph. Unlike many of the other auk species they do not nest in large colonies, but in small groups scattered around remote cliffs.

On first reaching the islands there was no sign of my target birds, but as is usual with successful bird photography a combination of perseverance and patience paid off and eventually a single bird landed on the edge of a low cliff. I approached the bird very slowly and got close enough for a few portraits. After a while a few more birds flew in to join it. One of them had a fish in its bill, so naturally this was the one I concentrated my attention on. It didn't eat the fish as I had expected, but was joined by a second bird that I assumed was its mate or at least potential mate.

The first bird tried several times to present the fish to the other one, but it was consistently rejected. In the end the first bird sat down with the fish in its bill and after a while decided to eat it. So even when the food pass fails it can still make for some interesting pictures.

Unlike the kestrel picture, this photograph was taken on a bright, sunny day. This allowed me to stop down to f11 to ensure that both birds were sharp, while retaining a sufficiently high shutter speed to ensure that there was no camera shake.

MATING

After all the wonders of finding a partner and the rituals of courtship, we now come down to the nitty gritty as it's time to mate. This comes as a bit of an anticlimax (no pun intended) as in most bird species it all seems to be over very quickly indeed. The sex act puts both birds in a rather vulnerable position, and I would imagine they are quite distracted at the time and might not notice a predator approaching. This is almost certainly why the actual copulation doesn't last very long.

Mating often takes place at or near the nest, as was the case with the two European Rollers on page 82, which were photographed on a perch provided for them by the nest box they were using at the side of an old track deep in the Hungarian countryside.

Rollers are late breeders, and even in late May this pair was still in the early stages, with the male bringing food for the female. She was obviously impressed with this particular bug that he presented her with, because no sooner had she taken it from him than she arched herself forwards inviting him to mate. He needed no further encouragement and hopped up on her back. The mating actually took a minute or so, which gave me enough time to take quite a few shots. You'll notice that she is still holding the insect in her bill during the mating.

There are a number of factors that contribute to the success of this image, not least being the softly coloured, out-of-focus background. Shooting at f4 certainly helped with the background, but because the perch for the birds was high and the hide was positioned very slightly higher

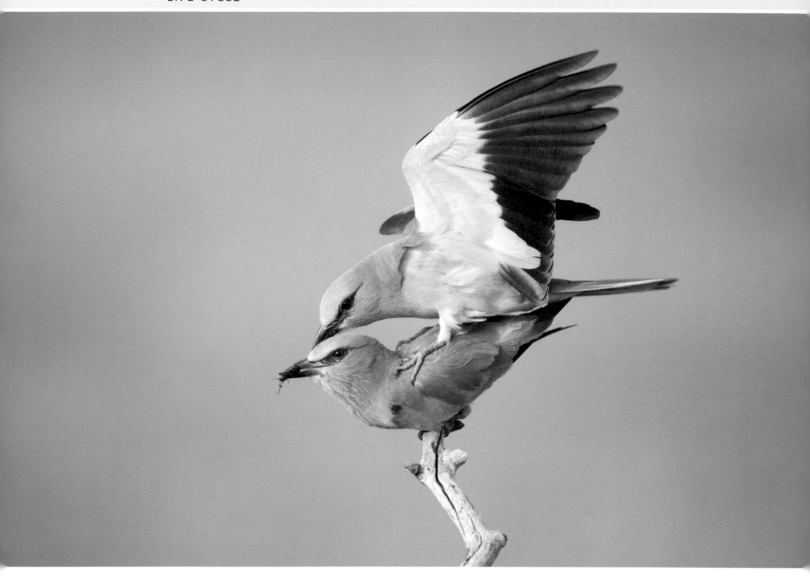

○ EUROPEAN
ROLLERS
(Coracias garrulus)

Canon EOS 1Ds
Mark II, 500mm f4
lens, tripod,
1/1,000th sec @ f4,
digital ISO 400

Hungary

there was no sky in the background. The background that was visible was quite distant, and this provides the softness to the picture.

The birds are well positioned within the frame – although their heads are in the centre, the birds are clearly to one side with most of the empty space in front of them. The most important element, however, was the timing of the shot. The male had to raise his wings briefly to balance himself on the female's back. This happened just the once and only for a second or two, but capturing that moment really added impact to the picture.

Not all couplings are as graceful as the rollers' was, and particularly among ducks they can be a bit rough and ready. In early spring groups of male Mallards roam around large lakes looking for a lone female. If they find one they pursue her as a pack and all try and mate with her at the same time, often pushing her completely under the water in what looks like a rather frightening ordeal.

The male Goldeneye does not hang around in gangs, but as can be seen in the picture opposite he can get quite rough with his mate as he prepares to mount her. Gripping her head firmly in his bill, he twists her around, then gets

on top of her to mate. This doesn't take long, which is just as well because I've seen the female bird completely under the water during mating.

This picture was taken at Pensthorpe Waterfowl Park in Norfolk and the birds are not wild, but part of a collection of waterfowl from around the world. Some people frown on the practice of taking pictures of birds that are not wild, but I find that places like Pensthorpe are ideal for observing and photographing behaviour that would be very difficult to see in the wild. The other plus point, of course, is that these collection birds are very tame and used to people, so by photographing them there is no risk of disturbance at all and no hides are needed. If you want you can even feed them by hand. As mentioned before, such large concentrations of captive birds also attract many wild ducks, which quickly become habituated to people.

When photographing birds that have a sheen in their feathers, such as the male Goldeneye, it is very difficult to capture that sheen in the picture. Unless the light is hitting it just right any colour will be lost. In this image I have been

● GOLDENEYES
(Bucephela clangula)

Canon EOS 1V,
600mm f4 lens,
tripod, 1/1,000th sec
@ f4, Fuji Provia 100

Norfolk, UK

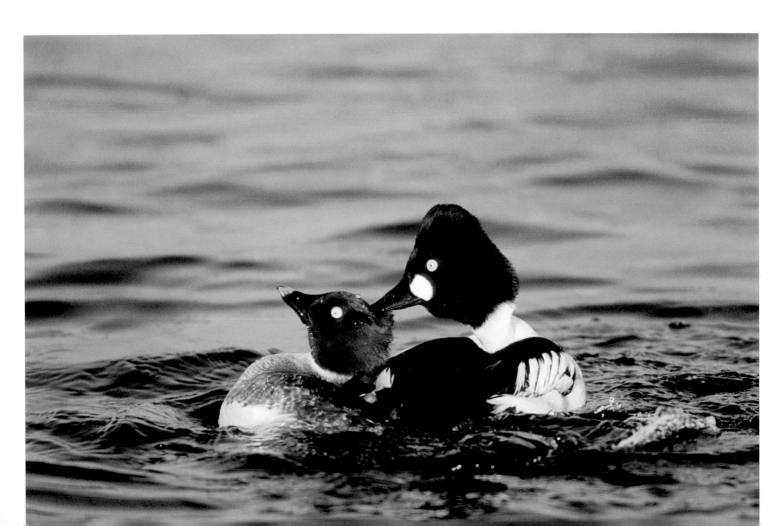

RED-THROATED DIVER
(Gavia stellata)

Canon EOS 1Ds Mark II, 400mm f4 lens + 1.4x converter, tripod, 1/500th sec @ f5.6, digital ISO 400

Finland

only partially successful, because although some of the green colour on the head of the male bird can be clearly seen, the central area is not as well lit as I would have liked and is rather dark. When photographing birds, particularly when they are on a lake such as this, you have little control over the angle at which you shoot. In this case, I think the interesting behaviour that has been captured in the image overcomes the slightly disappointing lack of sheen, and the image still works.

ON THE NEST

Birds do spend a lot of time simply sitting tight on the nest, keeping either eggs or young warm and safe from the attentions of predators. This is not the most exciting time from the photographer's point of view, because there are often long periods of inaction while a bird sits tight. Birds sitting on the nest are not my favourite subject, but I really like the image (shown on the left) of a Red-throated Diver sitting on its nest on a small lake in Finland.

A semi-permanent hide was set up at some distance from the nest itself in front of some open water to enable photography of the adults and young. Although the hide was in place before the birds arrived to set up home, it was not to be used until the eggs hatched – if disturbed when on their eggs, the adults would fly off and leave the eggs vulnerable to predation by the Hooded Crows that were in the area. When one of the parents returned and settled down on the nest it was barely visible from my position in the hide and would not have made a good picture. The other adult was off fishing to provide food for the chicks, and when it returned it flew around the lake a couple of times calling. In response to the call, the bird on the nest raised its head and I got the shot.

This is one of those images that works, but you just can't figure out exactly why. The bird is not only quite small in the frame, but also smack in the middle, which usually doesn't work. Here, however, it seems fine (at least to my eyes – others may disagree). I think the key to this picture is the 'peephole' effect of the gap in the reeds with the

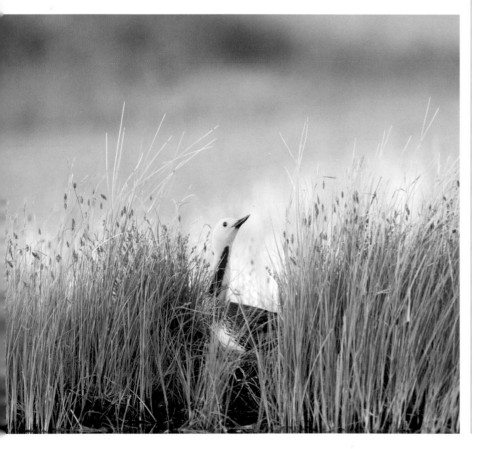

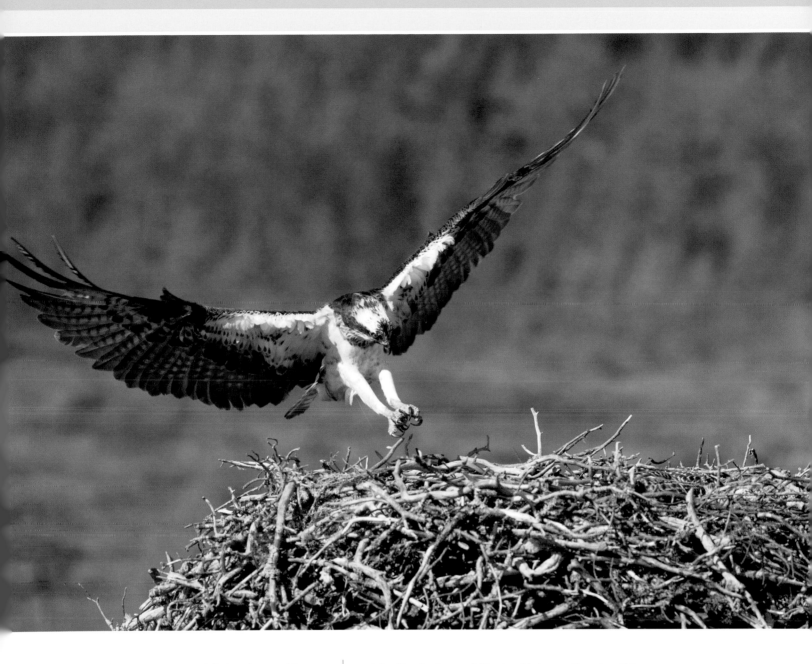

diver in the middle. It was a very dull day; the resulting shadowless lighting adds to the scene, and the colours are rather subtle, also due to the dull conditions. On a bright, sunny day I don't think this shot would have worked nearly as well.

Of course, nest shots don't have to be static. When the young have hatched and grown a little, the parent birds often leave the nest for a short break, frequently settling on a perch nearby so that they can still keep an eye on the nest itself and return quickly should danger threaten. This can certainly liven up an otherwise rather quiet day at a nest site, and gives the opportunity for the photographer to make much more dynamic images.

I had been in a tower hide overlooking the Osprey nest pictured above since 5 a.m. and certainly for the first few hours there was little activity. The male was away fishing and the female was sitting tight on the nest with her two chicks. I was waiting for the male to return with

◉ OSPREY
(Pandion haliaetus)

Canon EOS 1Ds
Mark II, 400mm f4
lens, tripod,
1/1,600th sec @ f8,
digital ISO 400

Finland

85

some food because I thought that this would make for some great pictures, but there was still no sign of him. It wasn't only me that was getting a little tired waiting for him, though – the female was also becoming increasingly restless on the nest. She would stand up and look around as if willing her partner to arrive, but in the end she got fed up and flew off the nest. She didn't go far, just a few metres away to the top of an old dead pine tree close to the nest.

This was my opportunity and I watched her carefully, as I knew she would return to the nest at some point and that would be the shot I wanted. I can't remember exactly how long she took before returning to the nest, but it seemed an age. One of the biggest problems when waiting for something to happen like this is that you need to be constantly alert, even when there appears to be nothing happening. Reach for a sandwich or a much-needed drink, and you could miss the shot you've waited for all day. When she took off from her perch I was ready for her and panned with her as she stretched open her wings and stretched her legs downwards to land. Finally, I could relax and eat that sandwich!

This Osprey nest was on a relatively low dead pine tree and had been used for many years. It was out in the open with the forest far behind, which gave an excellent uncluttered background to the bird. With the background so far away I could stop down to f8 to increase the depth of field without the background becoming intrusive. Due to the bright conditions and the paleness of the bird, I could still shoot at 1/1,600th of a second and give myself a better chance of getting all of the bird in focus using f8.

FEEDING THE YOUNG

Finding enough food to keep their young growing takes up most of the parents' time once the chicks have hatched, and as the babies get bigger, so do their appetites. Small birds often provide a diet of insects and these small food items don't last the chicks very long, so the adults are constantly back and forth to the nest. This provides the photographer with many opportunities to capture the adult holding the various food items at the nest. Predatory birds such as owls deliver larger items such as mice, rats and small birds, and these last the chicks much longer than the food provided by smaller birds for their young. Visits to the nest by the adults are thus far less frequent and much more of a challenge to photograph.

While in Finland we came across the nest of an Ural Owl that was in an old dead pine tree trunk, 3–4 metres high, located in a clearing with extensive forest around it. We set to work to construct a tower hide so that I could photograph the nest from slightly above. This would enable the forest, rather than clear sky, to be used as a backdrop. The female hung around the clearing watching the tower hide go up and took pretty much no notice of all the activity in front of her precious nest. The tower was constructed first, then gradually moved closer, and finally the canvas hide was put on top.

The weather was very warm, and it was only in the morning and evening that the birds would bring food to the nest. The hide was set up with the light behind it in the morning. I spent a total of 14 hours in that little hide, perched up on the tower overlooking the nest tree, and

● URAL OWL
(Strix uralensis)

Canon EOS 1D Mark II,
500mm lens, tripod,
1/2,000th second
@ f5.6, digital ISO 400

Finland

during that time the female only came with food twice. The first time I missed out completely because she flew straight into the open top of the tree and out of the bottom (where the nest was). The whole thing was over in the blink of an eye, and before I realized what was happening she was gone – sitting in a nearby tree, job done.

If she was going to continue to fly into the top of the tree I would never get the shot, but I resolved to give it one more try. The male called from the forest and she flew off to meet him. We never saw him, but he was the one doing the hunting, deep in the forest. When he caught some food he would call to the female. She would then disappear into the trees and collect the vole or whatever the male had caught, and bring it back to the nest to feed the chicks.

This time I saw her fly out of the forest and sit in a nearby tree with a small rodent firmly in her bill. I focused my camera on the hole at the top of the nest tree and waited with my finger on the button. Owls fly silently, so there was no warning as she landed on the nest tree. Her head went straight into the hole, but my finger was now on autopilot and pressed the shutter. She stopped for just a second and looked straight at me, and I got the shot you see on the right. Obviously with her amazing hearing she had heard the shutter fire, which is why she looked around, and it was this that gave me the opportunity I had been waiting for.

Fourteeen hours in a small hide for around five seconds of photography is not my idea of fun, but in the forests of Finland where birds are at such a low density, capturing the bird at its nest is the only way to photograph this beautiful owl.

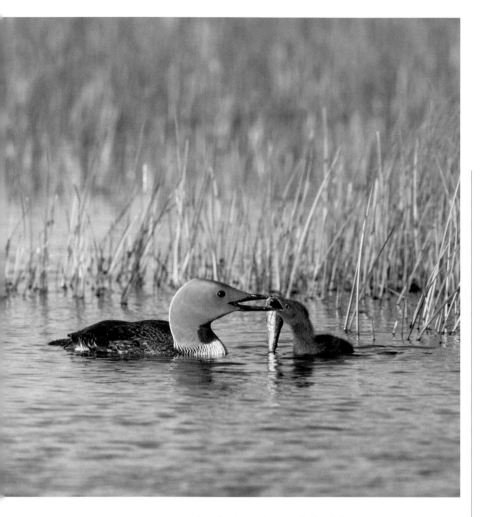

smaller portions to feed it to the two chicks. Much to my surprise, when a young chick swam over the adult bird simply shoved the fish whole into its tiny gape. Amazingly, the little chick managed to turn the fish around to a head-first position, then swallow it whole. The adult swam around for a little while before taking off again, presumably to get a similar prize for its other chick.

As the birds were not that close to the hide when the adult fed the chick, I placed them in the bottom half of the frame. This left the reeds as a background and not too much featureless, out-of-focus water in the foreground, which would have been the case had I simply used centre spot focusing. It was a bright, sunny day, and I was able to stop down to f11 to give a greater depth of field and still retain sufficient shutter speed to stop any movement.

TAKING THE FAMILY PORTRAIT

Family portraits showing mum, dad and offspring are always popular, especially if they capture a sense of caring from the parents. In the case of species that have nests hidden away in vegetation such shots are often very difficult to achieve, but in the icy wastes of Antarctica in which penguins are found this was never going to be an issue. Visiting a penguin rookery can be a daunting experience, as you can be overwhelmed with birds. The picture opposite was taken at the very edge of the colony, where there were fewer birds to get in the way. That may sound easy, but I spent a lot of time searching out such situations and then waiting for something to happen.

● RED-THROATED DIVERS *(Gavia stellata)*

Canon EOS 1Ds Mark II, 400mm f4 lens + 1.4x converter, tripod, 1/500th sec @ f11, digital ISO 400

Finland

When birds such as owls feed their young it happens in the nest itself, beyond the reach of the photographer's camera. Many waterbirds, however, feed their young away from the nest in open water, and the Red-throated Diver is one of these. I took the above shot at the nest site where I photographed the adult on the nest shown earlier in this chapter. The chicks were still very small (only a few days old) and one of the adults spent most of the time with them on the pond, because I guess they were still quite vulnerable at this age.

The other adult had been away for a couple of hours, but finally returned carrying quite a large fish in its mouth. The fish was in fact almost the same size as the chick, and I assumed that the adult was going to tear it up into

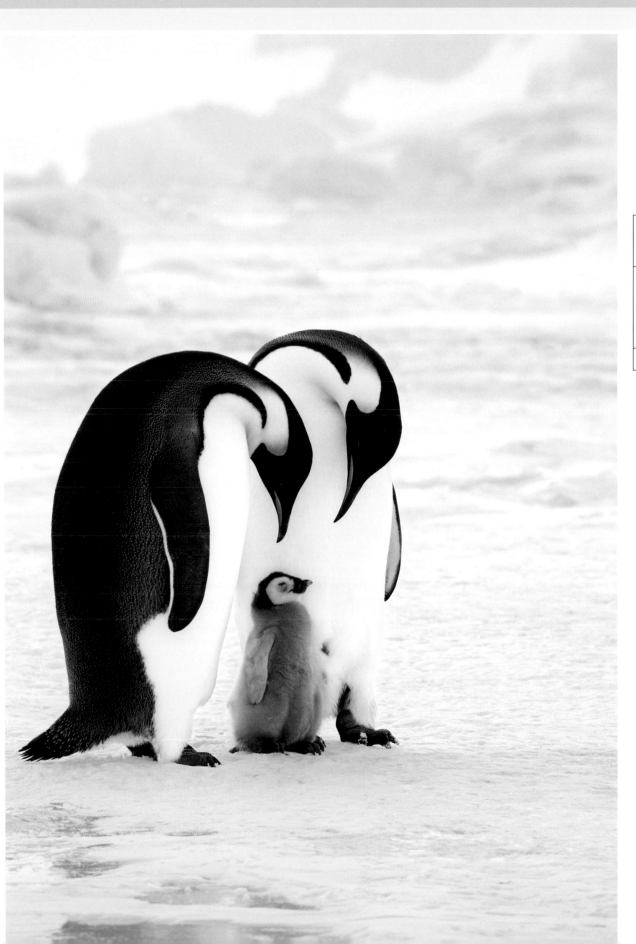

EMPEROR
PENGUINS
(Aptenodytes forsteri)

Canon EOS 1Ds
Mark II, 100–400mm
lens, hand-held,
1/640th sec @ f16,
digital ISO 400

Antarctica

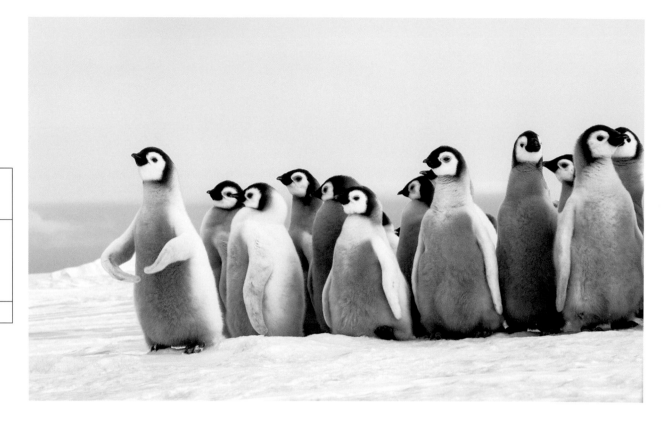

**EMPEROR
PENGUINS**
(Aptenodytes forsteri)

Canon EOS 1Ds Mark
II, 100–400mm @
135mm, hand-held,
1/500th sec @ f16,
digital ISO 400

Antarctica

Getting to an Emperor Penguin colony is not the easiest journey in the world. You have to travel across the southern seas in an ice breaker (not the most stable of ships in rough seas), then crash through the ice to a suitable 'parking' spot. You then need a helicopter to fly you from the ship and land you on the sea ice. To avoid disturbing the penguin colony, the helicopters have to keep at least a mile away from the birds. This leaves you with a gentle mile-long or so stroll over the creaking sea ice in very cold conditions.

Given this rather arduous journey, I decided to travel light and took only two lenses with me: 100–400mm and 24–105mm zooms. Emperors are large birds and very tolerant of people, so big, heavy telephotos were not needed. Since I did not have a big lens, I also didn't need to lug my tripod with me, so this was a double saving. Even in overcast conditions it was very bright, with the light bouncing back off the ice all around. Both lenses are image stabilized, which also helped to ensure that the pictures would come out sharp.

Emperor Penguins are very upright birds and shooting the family group (page 89) in portrait mode was the obvious choice. This also narrowed the frame, so that any birds on either side of the pair were excluded. I spent some time with the single bird and chick. When the other parent arrived they first greeted each other, then both adults looked down at the youngster. This was the moment I had been waiting for, and a fine family portrait was the result.

When photographing on ice it is important to ensure that you allow for the exceptionally bright surroundings. If left to its own devices the camera's meter would underexpose this scene, because it would attempt to turn the whole thing a nice 18 per cent grey. This is not what you want so you have to overexpose, making sure that your histogram is as far to the right as possible without going beyond it and blowing out the highlights.

⬤ GENTOO PENGUINS
(Pygoscelis papua)

Canon EOS 1D Mark II,
100–400mm lens,
hand-held,
1/800th sec @ f5.6,
digital ISO 400

Antarctica

JUST KIDS

Emperor Penguin chicks don't have a nest as the eggs are famously reared on the feet of their parents. As they get older and bolder they wander around the colony and meet up with other chicks, forming small crèches all over the ice. It was one such crèche (shown left) that I came across while searching the colony for interesting images. The bird at the front flapped his wings up and down as the others looked on. It made the picture and looks as if the front chick is conducting the others. As I was dealing with quite a lot of birds I wanted to have as large a depth of field as possible, and because of the bright conditions I was able to stop down to f16 and still shoot at 1/500th of a second.

Once some birds' offspring reach a 'certain age', they become more and more hungry and demanding. The Gentoo Penguin chicks (shown right) were the same size as the adults, although they still retained much of the soft, downy plumage. Several had come down to the shore, and although they didn't enter the water, they hung around in small groups. When an adult arrived and started the long march to the colony, these chicks would run up to them begging for food. Although this rarely worked, the chicks wouldn't take no for an answer and would constantly pester the adult birds. The adult pictured here had had enough and started running across the rocks to escape the renegade chicks' attention. Once again, I used portrait mode for the shot because this best reflected the upright stance of the birds, and using the hand-held zoom lens gave me the freedom to follow the action easily and frame the birds accurately.

Food and drink

The urge to reproduce is a massive driving force for any bird, but the rather less exciting everyday needs for staying alive are equally important. Finding enough food and water to sustain itself through many seasons and conditions takes up most of a bird's life.

THIS CHAPTER IS ALL ABOUT capturing birds going about their business, either feeding or drinking. It may seem a rather narrow subject to which to devote a whole chapter, but for the photographer the simple gathering of food can provide excellent opportunities not only to get up close to birds, but also to make some very interesting images.

Few photographers haven't used bait to lure birds, even if this is only a peanut feeder in the garden. By providing regular food for birds, particularly in cold weather, we not only draw our subjects within camera range, but also help them to survive the bad times. This chapter would be rather dull if it centred around bird feeders, of course, but fortunately birds feed not only on a vast array of different foodstuffs, but also in a fascinating variety of ways, as you can see in the following pictures.

FLOWERS AND BERRIES

Autumn provides an abundant supply of food for birds as shrubs and trees set seed before the winter comes. Of all the goodies that are available at this time of year, it is the bright red and orange fruits of the berry bushes that are the most photogenic and attract my attention. The thrush

● REDWING
(Turdus iliacus)

Canon EOS 1D Mark II, 500mm lens, 1/1,250th sec @ f4, digital ISO 400

Essex, UK

family is particularly drawn to berry bushes, and several species of thrush tuck in to take advantage of the natural seasonal bounty. Exactly what species turn up and in what numbers depends not on our own climate, but on the climate far to the north of us in Scandinavia. In years when the berry harvest has been poor in these countries, or the weather has been particularly cold, vast numbers of thrushes head south, including Fieldfares and Redwings, species that don't breed in the United Kingdom. It is in these conditions that it is best to head out with your camera and try your hand at the birds and berries pics.

In the case of the picture opposite, a fellow photographer kindly gave me the location, close to his home, where a number of Redwings were feeding in a popular country park. Several non-native berry-bearing bushes had been planted adjacent to the car park, and it was these that the Redwings were feeding on.

When photographing birds eating berries the backgrounds tend to be rather cluttered, but this is very difficult to avoid. Wherever possible I like to include as many berries as I can – it is their vibrant colours that add so much to the pictures and scream 'autumn'. When the Redwings were feeding, I noticed that they would take a single berry in their bill, then flick it up into their mouth. This was the shot I wanted and I concentrated on trying to catch the moment, using the Canon EOS 1D Mark II due to its fast eight frames per second shooting capability.

There are some very specialized birds that feed only or mainly on flower nectar. This is a very high-energy food, but as you can imagine not the easiest of things to access. It is also very seasonal, and many of the species that

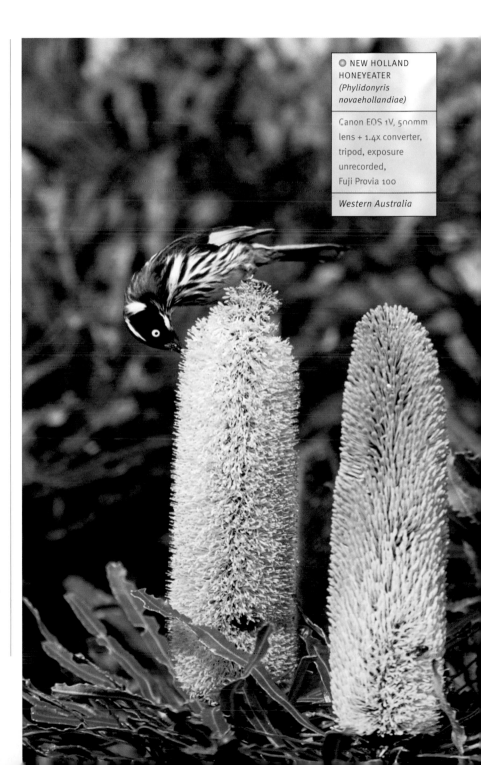

● NEW HOLLAND
HONEYEATER
*(Phylidonyris
novaehollandiae)*

Canon EOS 1V, 500mm
lens + 1.4x converter,
tripod, exposure
unrecorded,
Fuji Provia 100

Western Australia

● PUFFIN
(Fratercula arctica)

Canon EOS 1V,
600mm lens
+ 2x converter,
tripod, around 1/15th
sec @ f32,
Fuji Provia 100

Farne Islands, UK

specialize in feeding from flowers either live in the tropics or migrate to escape the non-flowering seasons. Flowers make fantastic subjects for the photographer on their own, of course, but add a colourful exotic bird as well and you can't go wrong.

It was flowers, in fact, that we'd travelled to photograph in the south of Western Australia at the end of winter. The winter rains had been particularly good that year, and the flower bloom responded with a fantastic display from an array of species, often in huge drifts. It was not only the groundcover plants that were blooming – the Banksia trees were also in full bloom, with huge bright flower spikes reaching up to the sky.

On a visit to the wonderfully named Two Peoples Nature Reserve, we came across a small example of this yellow-flowered Banksia (page 93) growing not too far from the trail. There seemed to be a regular procession of New Holland Honeyeaters coming to feed on the flowers, so I set up my camera on a tripod and simply waited. I was using a long lens and was far enough away from the flowers so as not to disturb the birds, and they quickly obliged and posed on the blooms in front of us.

The birds were feeding from several flowers, but I chose the particular one featured in the photograph because I liked the composition of the two flowers together. The birds ignored the flower to the right because it had not yet fully opened. Needless to say, for a while the birds seemed to land on all the flowers except the one I wanted, but they would not have made such a nice image as 'my' flower, so I stuck to my guns and eventually got the shot I wanted.

THE FISHERMEN

In Britain we are blessed with huge seabird colonies around our coasts, and not surprisingly fish form the bulk of their diets. Unfortunately, humans are doing all they can to destroy the fish stocks and pollute the oceans, so the seabird colonies may soon become a thing of the past. This would be a great tragedy, and the world would seem a less wonderful place without the teeming seabird cities.

It is only during the breeding season that the colonies are filled with birds, and this is undoubtably the best time to visit, with mid- to late June probably being the most productive. Although there are exceptions, it is offshore islands that harbour most of the colonies. Birds that spend most of their lives out at sea can be remarkably tame on land, showing little fear of humans. Despite their apparent indifference to us, you should show respect for them and always move slowly and carefully so as not to scare them.

It was on a visit to the Farne Islands that I took this classic picture of a Puffin with a mouthful of sand eels. I'd been to the Farnes many times and (as always) was looking for something a bit different from the many portraits I had already taken, some with fish and some without. Every visit is different, and on this occasion the Puffins seemed particularly confiding and would stand around near the jetty just a metre or so away from the path. Puffins are renowned for being able to fit a relatively large number of sand eels in their bill at one time, and it was this aspect of the birds' behaviour that I wanted to capture. After several attempts I came up with the picture you see opposite.

● KITTIWAKE
(Rissa tridactyla)

Canon EOS 1Ds
Mark II, 400mm lens
+ 1.4x converter,
hand-held,
1/800th sec @ f5.6,
digital ISO 400

Norway

Despite its seeming simplicity, this was not an easy picture to take and this was way back in the days of film, when you couldn't check your results until a week or so later. I fitted a 2x converter to the huge 600mm lens, giving me an effective focal length of 1,200mm. This enabled me to concentrate on just the head of the Puffin in the frame. At such ridiculously long focal lengths at such close range, depth of field was almost non-existent, and to try and get most of the Puffin's bill and sand eels in focus I stopped down to an effective f32. This meant shooting at a mere 1/15th of a second at 24x magnification, so keeping the whole set-up steady and avoiding camera shake was a bit of a challenge. I took quite a few pictures to increase my chances of success. It was with some relief that I found a couple of sharp slides among the many affected by camera shake when the slides finally returned from the processor.

The second picture in this section (shown opposite) could not be more different from the first. Although it still depicts a seabird with fish, it is all action. The other difference is that, unusually for such pictures, this one was taken in winter rather than during the breeding season. The contrast between these two images goes to demonstrate the variety of pictures that can be created on just a single topic such as birds with fish.

I was well north of the Arctic Circle when I took this picture at Varanger Fjord at the top of Norway, and there was still snow on the ground in March. I certainly hadn't expected to see Kittiwakes here at this time of year – I usually associate them with the breeding colonies in the summer months. There were many thousands of them to be found all around this remote coast, though, bobbing around on the ever-present wind. This particular shot is not exactly as it seems, however, because the Kittiwake is not catching a live fish from the water, but picking up a dead one. Mysteriously, we found hundreds of dead small fish all along the shore of one particular stretch of Varanger Fjord. There was a long line of them along the high-tide mark, but the large flock of Kittiwakes was not taking these, but plucking others from the shallow water just off the beach. Kittiwakes are great scavengers and will follow fishing vessels for scraps thrown overboard, so these dead fish were a real bonus for them.

The key for me to the success of this image is twofold. Firstly, the position of the Kittiwake's wings at the very top of the wing beat adds height to the picture, and in this position the wings are not in the way of anything else. The second thing is the water just behind the bird. The 'hole'

left in the water where the Kittiwake briefly broke the surface is clearly visible, and that marvellous semicircular trail of water lifted into the air by the bird clinches it for me.

THE STROLLERS

So far we have seen some of the different types of food that birds eat, but the various methods that they use to acquire that food are often fascinating and therefore of great interest to the bird photographer. One very common method for birds that feed mostly in shallow water involves simply walking about slowly and snapping up anything that they come across, often using their bill to probe and feel for small fish and other diminutive creatures that inhabit the marshes.

This type of behaviour is relatively easy to photograph – although they are moving, the birds' rather sedate pace makes them easy targets. These 'strollers' are usually quite large waterbirds with relatively long legs to enable them to wade through the water. Among such species is the beautifully plumaged Roseate Spoonbill (above), which is

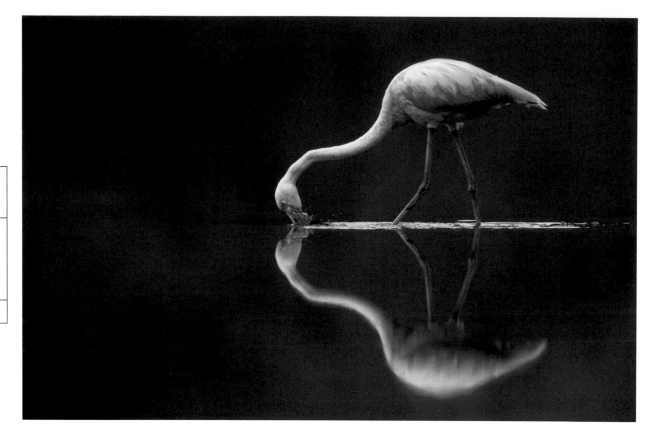

● GREATER
FLAMINGO
(Phoenicopterus ruber)

Canon EOS 1V, 500mm
f4 lens + 1.4x
converter, tripod,
approx. 1/60th sec @
f5.6, Fuji Provia 100.

Galapagos Islands

found in the Americas. One of the easiest places to photograph this bird is Florida, which is where I took the picture. While driving through Merrit Island National Wildlife Refuge, we had stopped to photograph some herons in a large lake when a flock of a dozen or so Roseate Spoonbills flew in. As was usual in Florida I was simply standing by the side of the lake with my camera gear on a tripod in full view of the birds, which were ignoring me. Only a couple of the birds were in full breeding plumage, and it was one of these that I concentrated on, ignoring the paler plumaged birds completely. Knowing exactly what you want and sticking to it is the best way to ensure success.

While watching the bird I noticed that it used its bill to locate its prey under the surface of the water, then threw it up in the air and caught it. The problem was that this all happened so fast that I couldn't see what it was catching.

It was only later, when I was able to blow up the digital image, that I could make out the shape of a small fish perfectly caught in mid-air between the upper and lower bill plates, heading for the throat. Capturing that precise moment of behaviour that you would never otherwise be able to see, let alone examine in detail, is one of the great pleasures of photographing birds in action.

Although many of the larger waterbirds 'stroll' through the water in a similar way, they don't all feed on the same type of food or even feed in the same way. The flamingos have a pretty unique method of feeding – they lower their neck and tilt their head so that their large, curved bill is actually upside down in the water and facing back towards their legs. They then move their head from side to side while walking slowly forwards. Using a specially developed structure within the bill to trap any food particles, they then use their tongue as a simple piston to suck the water

through. Aquatic insects are the main food, although very small fish fry may also be taken.

I took the picture opposite on the Galapagos Islands. After arriving early one morning on Floreana Island on a dull, overcast day, we located a small group of flamingos quietly feeding in the bottom of a caldera filled with shallow water. The still conditions created nice reflections in the water, but it was quite dark so photography was not straightforward. Fortunately the birds were slow-moving, the fastest bits being their heads as they swung back and forth through the dark green water. With a shutter speed of only 1/60th of a second, I used the image stabilization feature on my big telephoto lens to minimize camera shake, and took a few rolls of film to make sure that I had stopped the head movement in at least a few of the shots.

THE REFUSE COLLECTORS

To us humans, probably the least attractive form of feeding is carried out by the bird species that eat dead animals – the carrion feeders. Of course, such birds fulfil a vital role and quickly devour a carcass that would otherwise be left rotting for days or weeks, with the increased possibility of spreading disease to other wildlife. The most famous carrion eaters are, of course, the vultures, many of which are (to our eyes) unattractive birds. Vultures tend to have bare heads and necks that enable them to feed deep inside a bloody carcass without the inconvenience of matting longer feathers that would be almost impossible to clean. This adaptation to their feeding habits gives them a rather reptilian appearance, which

● GRIFFON VULTURES
(Gyps fulvus)

Canon EOS 1Ds Mark II, 100–400mm lens @ 130mm, tripod, 1/100th sec @ f5.6, digital ISO 400

Spain

● AMERICAN BLACK VULTURE
(Coragyps atratus)

Canon EOS 1D Mark II, 100–400mm lens @ 160mm, hand-held, 1/1,000th sec @ f7.1, digital ISO 200

Florida, USA

does little to endear them to us. Their manners also leave a lot to be desired, as they kick and fight with their fellow diners to grab as much meat as quickly as they can.

I had been sitting in a small hide in the mountains north of Madrid since before dawn. In front of the hide was a dead sheep that had been put out specifically for the vultures at a feeding station, or 'vulture restaurant', as they are sometimes called. The location was on the edge of a cliff overlooking a valley far below, and as the sun rose the first vultures started to gather, although they remained some distance from the carcass. Suddenly, without any warning, one vulture swooped down and landed next to the dead sheep. This was the signal, and within seconds the carcass was completely covered with dozens of Griffon

Vultures (page 99). A fully grown adult sheep lasted no more than 15 minutes, after which all that could be seen were a few bones and the odd bit of wool. A primeval scene had come to an end and the vultures left.

It is very difficult to photograph a scene like this because you are faced with a rugby scrum of birds, most of them face down and the nearest ones inevitably with their backs to you as the feeding mob surrounds the carcass. It was also very early in the morning so there wasn't much light available, which didn't help as the depth of field would have to be at a minimum. In the image I have used the spread wings of a newly arrived vulture that had landed on top of the scrum and was trying to force its way in. Notice its raised foot and spread-out toes as it pushes towards the carcass with its neck craning forwards. The picture was also carefully framed so that the vultures were in the bottom half of the image, allowing enough space to also show the white cliffs on the other side of the valley, which put the scene in its environment.

Not all vultures feed in such a frenzy, although American Black Vultures do congregate in reasonable flocks if the size of the carcass allows. This was clearly not the case with the floating dead alligator (shown on the left), which would only really hold a single bird at a time.

I was driving along the Tamiami Trail in southern Florida when I noticed a group of Black Vultures sitting around in the trees by the side of the road. I stopped the car and went over to investigate. A canal runs the entire length of the road, its edges for the most part covered by large cypress trees. It's a very good place to find alligators, and we had seen several live ones already. I found that the

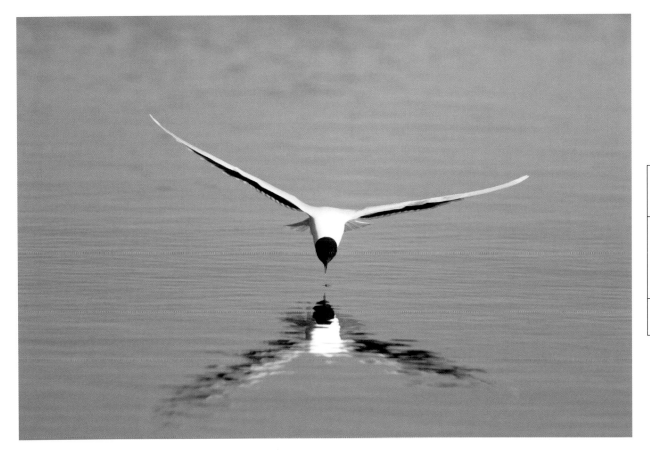

● LITTLE GULL
(*Hydrocoloeus
minutus*)

Canon EOS 1D Mark II,
400mm f4 lens + 1.4x
converter, hand-held,
1/2,500th sec @ f5.6,
digital ISO 400

*Hailuoto Island,
Finland*

vultures had congregated around a dead alligator in the water. As I arrived at the scene a vulture flew up from the carcass to join the others in the trees, but within a few minutes it returned and landed once again on the dead alligator. The carcass was lying in water, and it moved as the large, heavy bird landed on it and put out its wings for balance. That was the moment when I took the picture – you can see the ripples from this movement in the water.

The reflection of the blue sky and cypress wood, as well as the vulture itself, make this a rather unusual picture of a carrion feeder at work. The dappled shade caused by the surrounding trees made it technically difficult to execute – it would have been impossible on film. I had to underexpose most of the image so as not to burn out the sunlit highlights, then balance the picture in post processing using curves.

THE FLYING PLUCKERS

There are some birds that use amazing aerobatic skills to catch their prey. This section deals with those that pluck their food out of the water. These species can provide opportunities for some truly spectacular pictures – full of action as the bird swoops down over the water to claim its prize. By their very nature, however, scenes like this are among the most difficult of subjects to photograph.

My wife and I were on Hailuoto Island in Finland, where we came across a colony of Little Gulls by a bridge that crossed a large lake. The colony itself was some distance away and inaccessible due to the terrain, but many of the gulls were zipping over the water quite close to the bridge, chasing the numerous flies that were on the lake's surface.

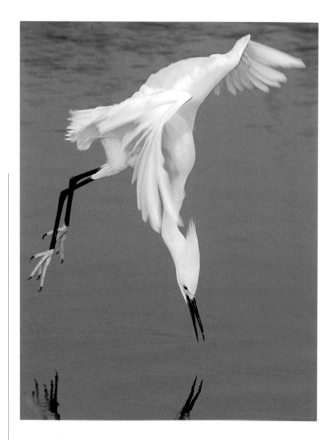

● SNOWY EGRET
(Egretta thula)

Canon EOS 1D Mark II,
100–400mm zoom
lens @ 310mm,
hand-held,
1/1,000th sec @ f5.6,
digital ISO 200

Florida, USA

Little Gulls are surely one of the most acrobatic of all the gulls, and these were constantly changing direction and swooping down to the surface in an instant, giving no warning as they did so. My only chance was to choose a gull and try to follow it as it flew around and (hopefully) went down to chase a fly.

The shot on page 101 was one of my favourites. It shows a gull with its bill open, about to pluck a fly from the surface. The reflection adds to the image, but a fraction of a second later and it would have spoiled the picture because the fly would have been lost. As it is the fly is perfectly positioned between the bill and its reflection. Did I see all of this at the time? Of course not, but I took a lot of pictures that day and finally got the one I wanted.

Small, agile fliers like the Little Gull are perhaps the obvious candidates for this type of acrobatic feeding. Herons and egrets are not species that you would normally associate with impressive flying skills – they are usually seen flapping along rather sedately overhead. The Snowy Egret, however, has developed a method of fishing that is known as 'dip-feeding', something that is also practised by the similarly sized Tricoloured Heron. Quite how the birds achieve this I really don't know. They fly very slowly over the water, sometimes trailing their feet just on the surface. Suddenly they seem to almost halt in mid-air and pluck out a small fish that is just below the surface of the water. They then continue to the shallows or dry land, where they devour their prey. Once again, this is a little tricky to photograph because it is over very quickly indeed.

We had just entered the wildlife drive in Merritt Island National Wildlife Refuge, near to where they launch the space shuttle, when a small pond caught my eye. It wasn't very attractive, but there was a large number of Snowy Egrets sitting around the edge. The pond was right next to the road and a large telephoto lens was just too much, so I set up and hand-held my 100–400mm zoom. It was quite a dull day, but because the birds were white I could still use a fast shutter speed.

The above shot shows a Snowy Egret apparently hovering over the pond. In fact, it still has forwards momentum, otherwise it would have fallen into the water. Its legs at this moment were moving faster than its head, which sort of stretched back towards the water in order to try and catch a fish. A moment after I took this picture the bird dipped its head into the water, but failed to catch a fish. It then continued its flight over the pond to land once again on the edge. The bird may have failed to make a catch, but I hadn't and produced one of my favourite images from our two-month trip to Florida.

PLUNGE DIVERS

Surely the most spectacular feeders are the plunge divers, the birds that hurl themselves head-first into the water at great speed so that they have enough momentum to travel deep under the water in search of fish. In order to do so, they must avoid smashing their wings to pieces as they hit the water at speed. They do this by swinging their wings behind them at the last second to make themselves much more streamlined as they make contact with the water. Needless to say, such actions make great subjects for the bird photographer.

We were on Sanibel Island, and in the afternoon had visited the fishing pier where Snowy Egrets would gather to steal fish from the people that gave the pier its utilitarian name. A couple of immature Brown Pelicans had also put

● BROWN PELICANS
(*Pelecanus occidentalis*)

Canon EOS 1D Mark II, 100–400mm lens @ 400mm, hand-held, 1/1,000th sec @ f8, digital ISO 200

Florida, USA

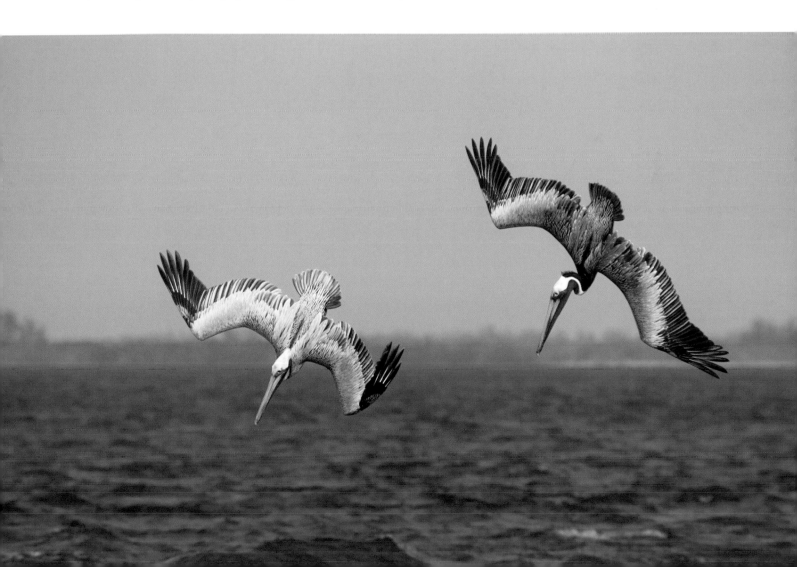

● GANNET
(Morus bassanus)

Canon EOS 1V, 300mm
f2.8 lens, hand-held,
approx 1/2,000th sec
@ f4, Fuji Provia 100

North Sea

in an appearance, but it was when I noticed some adults a little further up the coast that I wandered off to see if I could get some action shots. A big lens certainly wasn't necessary for the extremely tame Snowy Egrets, so all I was carrying was my very useful 100–400mm lens. When the pelicans stared to plunge-dive right in front of me I couldn't quite believe my luck and started shooting. One of my favourite pictures is shown on page 103. It features not just one bird, but two, hurtling towards the ocean head first.

Photographing two birds diving in tandem like this is nigh on impossible due to the very limited depth of field available when using telephoto lenses. It worked in this case because both birds were exactly the same distance from the camera when they dived, and therefore both were in focus. The other thing to notice about this shot is that the horizon is dead straight. In the original it was just a little out, but with digital post processing you can always end up with a perfect horizon.

The Brown Pelicans in Florida are one of the easiest diving birds to photograph due to their large size and relatively slow and telegraphed movements. At the other end of the scale is the Gannet, a true master of the art. These amazing birds can dive from nearly 30 metres above the sea and hit the water at up to 100 kilometres per hour. It is estimated that the momentum of the dive takes them as far as 3.5 metres below the surface, although they can then swim down to a depth of around 15 metres.

The picture on the left shows a Gannet just a few centimetres above the sea, with its wings sweeping back ready for impact. In the split second remaining before the bird actually enters the sea, the wings are thrown back even further to avoid them being broken by the force of the dive.

This has to be the most difficult subject I have ever photographed. I was on a small boat that was bobbing around in the swell. I was trying desperately not only to lock onto the fast-moving Gannets, but also to stay upright myself. I used a lot of film that day and had quite a high failure rate, but finally got a few shots that made it all worthwhile. I must try and find an opportunity to do this again now with digital and the fast-shooting cameras that are now available.

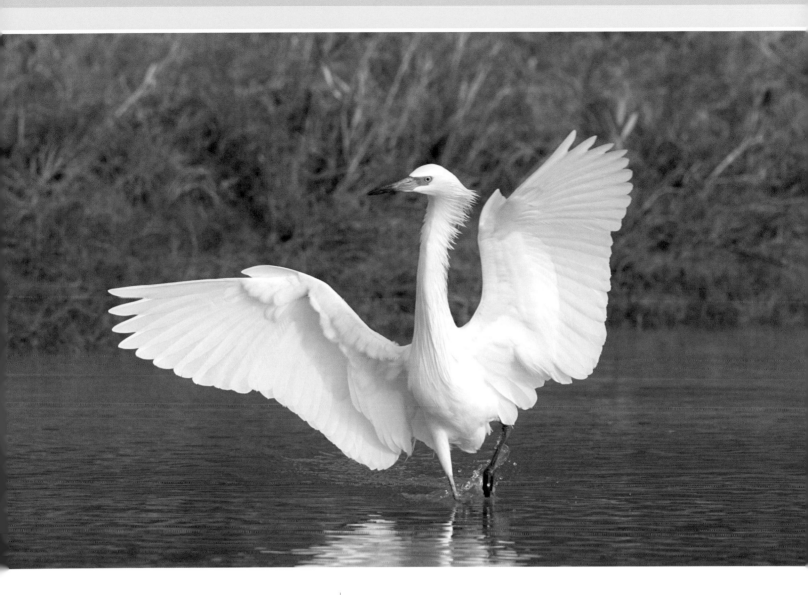

SIMPLY CRAZY

The Reddish Egret has a truly individual method of feeding that is like no other bird's I have ever encountered, and thus deserves a category all of its own. When searching for food these birds make me laugh out loud as they rush across the shallow lagoon, changing direction frequently and sometimes jumping up and down to add to the show, their bristling feathers making them look like classic cartoon 'mad professors'. The apparently erratic behaviour is designed to confuse the fish and take them by surprise. This is a truly wonderful bird and one of my all-time

favourites. Looking at the image above you may wonder why this species is called the 'Reddish Egret', but this is in fact the relatively rare 'white morph' – the normal colour form of the bird is a dull reddish-brown, hence the name. This particular individual was photographed quite late on a bright, overcast day in a small lagoon at Fort de Soto, a park close to the Florida city of St Petersberg. Bright overcast is the perfect condition for white birds as long as you are not photographing them against the sky, when you really need the sky to be blue. Direct sunlight makes the contrast of the white bird against the darker background very high, and you have to underexpose the surroundings

REDDISH EGRET
(Egretta rufescens)

Canon EOS 1D Mark II,
500mm lens, tripod,
1/1,000th sec @ f7.1,
digital ISO 200

Florida, USA

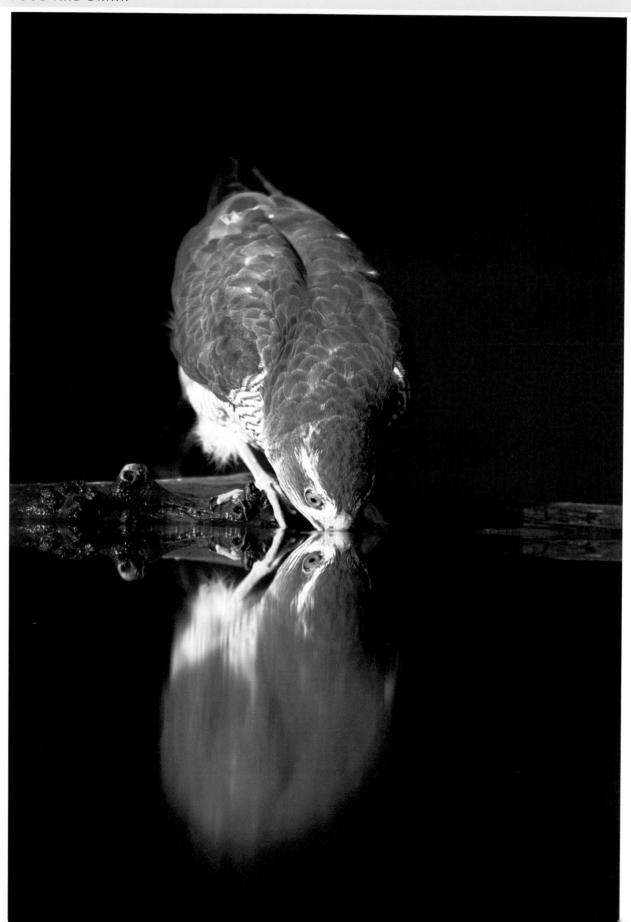

 NORTHERN
GOSHAWK
(Accipiter gentilis)

Canon EOS 1Ds
Mark II, 500mm lens,
tripod, 1/1,000th sec
@ f4, digital ISO 400

Hungary

to ensure that the bird itself is not overexposed. The lack of direct sunlight also results in considerably softer and less intrusive shadows.

As is usual in Florida, we were simply able to stand by the side of the lagoon as the bird danced up and down in front of us until it eventually caught a fish. Clearly this apparently crazy approach to fishing works.

DRINKING

Although this chapter is entitled food and drink, it is the food aspect that produces the most varied images, because the feeding habits of birds are so diverse. This is not the case when it comes to drinking, however, because most birds tend to drink in the same, rather unexciting way

Despite this, I don't think that anyone would consider this picture of a male Northern Goshawk drinking at a forest pool unexciting. Certainly there was some tension in the air when I was photographing this marvellous bird, slowly sipping water just a few metres in front of me. I spent a whole week sitting in hides that had been set up by specially constructed drinking pools, which the birds had got very used to, and quite a variety of species was coming down to drink and wash. I was contentedly photographing finches, thrushes and other small birds, when in an instant they all disappeared, leaving the drinking pool deserted.

Some time passed before all of a sudden this male Northern Goshawk landed by the side of the pool. Given that he was pretty much at the top of the local food chain he seemed remarkably nervous, and simply stood motionless for much of the time, occasionally looking around him. I too was motionless and stayed completely still, not daring to even take a picture in case the sound of the shutter frightened off the bird. The temptation to blast away was almost overwhelming, but I managed to resist until finally he settled down on a log next to the pool and started to drink. Now that the bird was relaxed I started to take pictures, not firing off a great sequence, just a couple at a time so as not to disturb him. He stayed for a wonderful few minutes until he had had his fill, finally flying off into the surrounding forest. This was a truly magical moment and one I shall never forget.

Action and behaviour

As well as flying, breeding and feeding, there is a range of behaviour that birds undertake during their daily lives. This chapter features images showing some of the other things birds get up to that – although they may be related – are not directly linked to the above activities.

ALL THE BIRDS IN THESE PICTURES are engaged in some sort of activity, in contrast to the inactivity that typifies bird portraits. Some of them fall into what is known as 'action' photography, although there is no strict definition of this. All behaviour tends to be 'action' of some sort or other, but usually 'action photography' is where there is a lot of dynamism in the picture, caused either by the vigorous actions of the bird itself (e.g. a bird washing with water flying everywhere), or by interaction between more than one bird (e.g. two birds fighting).

For the sedentary among us, the term 'action photography' may seem a little daunting, perhaps conjuring up images of the photographer rushing around being very adventurous and proactive. This may work in some situations, but I generally find that the two most important elements for photographing birds in action are location and patience. Once you have found a location where there are lots of birds around, get yourself set up and simply wait and wait, then, when you get fed up, wait some more. The most important thing is to remain alert while waiting around for something to happen. When the action starts it is often over in a few seconds, and if you are not ready you will miss it.

Other action pictures are totally opportunistic and can occur anywhere at any time. Whether you take advantage of the situation when it arises is down to you. You can improve your chances by knowing your subject well, which enables you to anticipate when it is going to do something. The other factors are constant alertness and quick reactions to capture the moment. Above all, this type of photography is great fun and can result in great images.

> ● SONG THRUSH
> *(Turdus philomelos)*
>
> Canon EOS 1D Mark II,
> 500mm f4 lens +
> 2x converter, tripod,
> 1/800th sec @ f9,
> digital ISO 400
>
> *Essex, UK*

SINGING

For a vast group of small birds, singing is one of the most significant forms of behaviour in their lives – which is why they're known as songbirds. It's not the most spectacular type of behaviour to photograph, I grant you, but this is what they do, so this is what you photograph. Photographing a small, perched bird singing is often the best you can do as far as behaviour is concerned, but it does add considerable impact over a similar portrait-type

shot, where the bird's mouth would be closed and its posture less engaging. Male birds sing to establish a territory in the spring and to ward off any potential rivals for a prime spot, but singing is not restricted to this time and can occur at almost any time of the year.

The shot opposite was actually taken in my back garden deep in the wilds of Essex. It was a lovely, sunny spring morning and I was carrying out some much-needed garden maintenance. This male Song Thrush landed in the top of a large Leylandii conifer on the boundary of my property and started singing his heart out. 'Song Thrush' is a very apt name, and you can't believe how much noise such a relatively small bird can produce. The infamous Leylandii is very fast growing, shooting up to more than 20 metres in height, blocking people's light and causing many disputes between neighbours. I thought this would be a good opportunity to show wildlife together with the newsworthy tree, and disappeared indoors to get my camera gear.

When I returned the bird had moved to a new perch, this time right at the very top of the tree. The tip curved up and arched over the bird, making a really nice composition. The trouble was that it was very high indeed, and I needed to add a 2x converter to my 500mm lens in order to get a reasonable image size. Because I was using the 2x converter I stopped down just a fraction from f8 to f9. I did this because I find that even this small change in aperture will considerably reduce the inevitable slight vignetting that you get when using the converter, a flaw that would be noticeable against a clear blue sky such as the one in this picture.

PREENING

A bird's feathers fulfil a variety of functions, including keeping it warm, waterproof and attractive to the opposite sex, so keeping its plumage in good order is very important in its daily routine. Of course, apart from this regular maintenance, there will always be that sudden urgent itch to scratch as well. With no hands to rely on, all this work has to be undertaken by using the bill if the area concerned is within reach. If not that it will have to be the claws, although it may require a considerable amount of effort, not to say balance, to reach exactly the right spot.

I was visiting Half Moon Island on the Antarctic peninsula, and had come across a large colony of Chinstrap Penguins. I was sitting fairly close to the colony, trying to visualize a picture. This was not easy because the colony was quite large and a confusion of birds was spread out before me. I just couldn't get a shot without a jumble of bits of other birds in the background, and I was looking for a much cleaner, graphic shot. It was then that I noticed a large boulder to one side of the colony with a lone penguin sitting on top of it. I couldn't get any closer to the rock as the penguin colony was in between us, but after a lot of

● CHINSTRAP PENGUIN *(Pygoscelis antarctica)*
Canon EOS 1D Mark II, 400mm f4 lens + 1.4x converter, hand-held, 1/1,250 sec @ f10, digital ISO 400
Antarctica

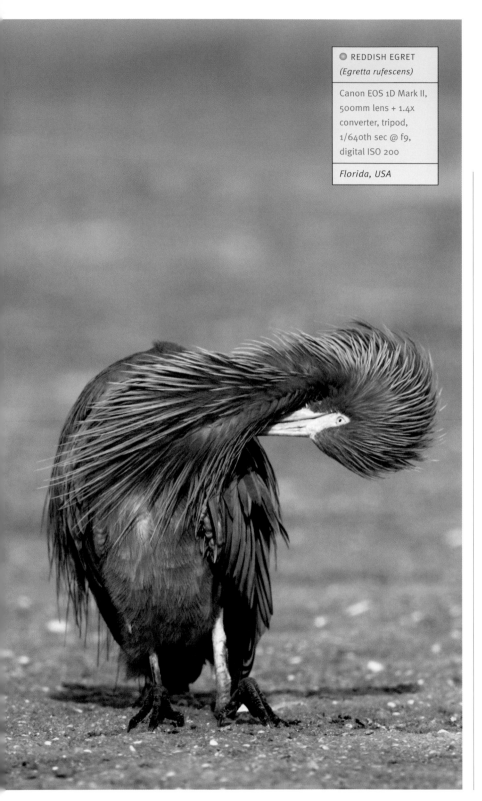

● REDDISH EGRET
(*Egretta rufescens*)

Canon EOS 1D Mark II,
500mm lens + 1.4x
converter, tripod,
1/640th sec @ f9,
digital ISO 200

Florida, USA

shuffling around, I did manage to find myself a position where I could use the sea as a background and exclude the tops of the other penguins that surrounded the rock. It was then that the bird stretched its head to one side and lifted its foot to scratch itself, and I took the picture shown on page 109.

The clean background really makes the picture work – you wouldn't believe the mess just out of frame. When arriving at a bird colony it is very easy to quickly take lots of bad pictures, but I find the best approach is to sit and look until you find a scene that will work. The other aspect to this image is humour, as the rather awkward position that the bird is in does look comical – and anything that brings a smile can be no bad thing.

Some species of bird, like the herons and some waders, have very long bills, which they use to great effect when preening, as can clearly be seen in the case of the Reddish Egret on the left. Unlike the same species depicted on page 105, this bird is the normal form. It is the colour of the rather shaggy looking neck that gives the bird its name. ('Brownish' Egret might have been more accurate, but considerably less attractive.)

The picture was taken at Estero Lagoon in Florida. The lagoon is a long stretch of water just a few metres from the sea, from which it is separated by a sandy beach. The whole area is known as Fort Myers beach and is a popular tourist spot. Just 50 metres behind the bird, the land is completely covered by high-rise hotels packed with holidaymakers. The lagoon is very shallow, and many waders and terns come here to rest up at high tide. I'd found a slightly raised area of mud that had attracted

some birds and set up to take some pictures, when this Reddish Egret flew in. The Reddish Egret is far more coastal than the other Florida members of the heron family, so I wasn't surprised to see one here. However, what it did when it sat down and started preening did surprise me. Something looked odd, but I couldn't work out what it was. Then it dawned on me – the egret was sitting with its legs folded frontwards at the ankle, but of course a bird's ankles are positioned halfway up the visible part of its legs, so we tend to think of a bird's ankles as its knees. Seeing the legs bent 'the wrong way' like this is peculiar to our eyes – I was certainly quite happy to photograph it.

BATHING

Photographs of birds bathing are pretty easy to take, but the behaviour can produce some lovely images. I always think that splashing water really adds impact to a picture, and the more water flying about the better. The water droplets caught in mid-air and the churning of the water around the bird's body just say 'action'. It is, of course, possible to photograph any species of bird having a refreshing bath, but the bigger the bird the more water is likely to be displaced – and they don't come much bigger than the common old Mute Swan shown on the right. It just goes to show that you can produce interesting images of the most familiar of species if you keep your eyes open.

I was wandering around the Wildfowl and Wetlands Trust reserve of Slimbridge on a rare sunny day in the middle of winter. The birds are fed in the afternoon and after all the food has been consumed, many of the wildfowl start to bathe. There was a large number of Mute Swans and many of these started to bathe at the same time. Mute Swans are powerful birds and they splash around very vigorously, water flying everywhere. The biggest problem from a photography point of view was that there were so many of them in a small pond that they would constantly be in each other's way. For the shot below, I had to carefully select my subject and shoot from as high an angle as possible to exclude the other swans behind it, cropping closely to the bird. Having to underexpose by a stop to make sure the white of the bird didn't blow out has left the

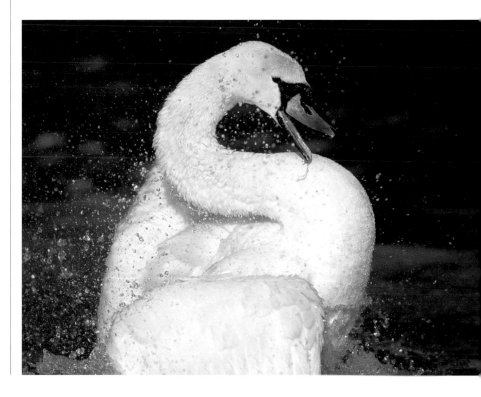

● MUTE SWAN		
(Cygnus olor)		

Canon EOS 1V, 300mm f2.8 lens + 1.4x converter, hand-held, 1/2,000th sec @ f4, Fuji Provia 100

Gloucestershire, UK

111

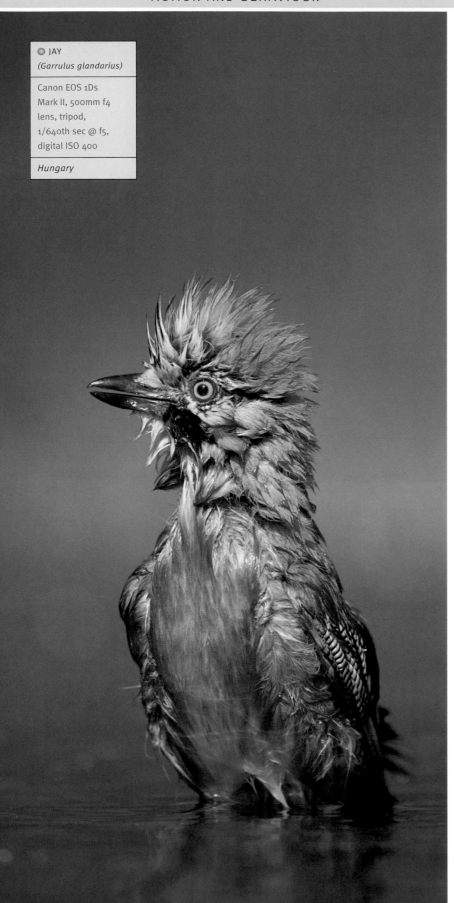

● JAY
(Garrulus glandarius)

Canon EOS 1Ds
Mark II, 500mm f4
lens, tripod,
1/640th sec @ f5,
digital ISO 400

Hungary

water a darker blue than it really was, but the contrast with
the white bird adds to the drama of the picture and shows
those all-important water droplets very well. The open bill
of the swan adds more impact to the image and gives the
impression that it is really enjoying itself.

When birds bathe they do so in bursts. Vigorous
splashing about with their wings is frequently followed
by a pause as they rest themselves before another burst
of activity. They may do this simply to rest their tired
muscles, or it could be that they feel quite vulnerable
while washing, and frequently stop to take stock of their
surroundings, checking for the presence of any predators
before continuing.

Either way, the image of a Jay on the left, caught in
this moment of inaction, is in sharp contrast to the
picture of the swan on the preceding page. It shows no
movement and certainly no splashing water, so it lacks
the action of the previous picture. Clearly, however, the
bird has been bathing, as can be seen by the state of
its feathers.

I'd been photographing the Jay washing merrily away
in a woodland pool in Hungary for some time, when it
suddenly stopped. I had expected it to fly away now that
it had finished, but instead it stood there in the water for
some time. I just loved the way the water had made the
feathers stand up around the head, giving the bird a rather
startled look, which was enhanced by the large, seemingly
staring eye and the slightly open bill. The result is a rather
clown-like view of this species, which demonstrates quite
well that you can make good behaviour pictures even when
little is actually happening at the time.

RUNNING

Most birds don't actually run around very much at all, preferring far more energy-efficient walking instead. This is not a behaviour that you can easily set out to photograph, but one that you may happen upon while out with your camera. The secret to success with this type of image is to pan smoothly, keeping the bird in the same position in the viewfinder as it runs along. In this respect the technique is not dissimilar to flight photography, but with one big advantage: the target bird can only move backwards or forwards, whereas a flying bird can disappear from your viewfinder in any direction.

The picture on the right was taken while I was in the Shetland Isles and had come across a group of Sanderlings in breeding plumage on a remote beach. I didn't have a hide with me and the shoreline was too far away to be able to shoot from the car, so I sat down on the beach with my camera on the tripod and waited for the Sanderlings to wander. After a while they pretty much ignored me, and I got some pictures that I was quite pleased with. It was then that I noticed a Ringed Plover walking along the beach. Unlike the Sanderlings, the Ringed Plover was breeding in the immediate area. It walked quite speedily along the very edge of the shore and would occasionally dash about very quickly, seemingly in no particular direction. As it worked his way along the beach towards me, I focused on it and followed it in my viewfinder. When it started to run I was already on it, so all I had to do was to press the shutter. As I looked through the viewfinder I noticed dozens of those flies that you find on seaweed-strewn beaches. What I couldn't work out was whether the bird was chasing the flies in order to catch them, or if it had simply disturbed them as it ran along the shore (I never saw the bird catch one).

The flies add interest to the picture, but there are other factors that make it work. The first is the positioning of the bird moving into the frame. The second is the back leg, which is raised off the ground giving the impression of speed in a still picture, an effect that is increased by the sand that is being kicked up by the running bird. The positioning of the bird is something we have control over, the foot and sand is something we don't, but a good image is often a combination of both skill and luck.

○ RINGED PLOVER
(Charadrius hiaticula)

Canon EOS 1D Mark II, 500mm f4 lens + 1.4x converter, tripod, 1/1,250th sec @ f8, digital ISO 400

Shetland Isles, UK

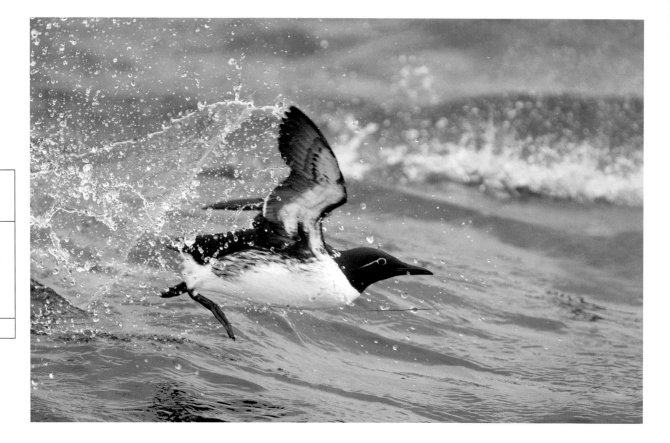

● COMMON
GUILLEMOT
(Uria aalge)

Canon EOS 1Ds
Mark II, 400mm f4
lens + 1.4x converter,
hand-held,
1/500th sec @ f5.6,
digital ISO 400

Norway

Waterbirds probably run more frequently than do land birds, and are often easier to photograph. Many run in order to reach sufficient speed to take off, but some, like the Common Guillemot (above), run over the water to move from one place to another without getting airborne. This is because for these short-winged birds, running uses up less energy than flying. In pictures featuring running over water, like in the bathing pictures discussed earlier, splashing water becomes a major component of the image, adding dynamism to the composition.

One of the best ways to photograph seabirds running over the water is from a boat near a breeding colony. I was off the northern coast of Norway in late winter, bobbing about in a very small boat indeed. We were just off some seabird islands that provided some shelter from the howling winds, although the sea was still rough and it was difficult to stand upright in the boat, let alone take

pictures. Given the time of year, I was surprised to find so many seabirds close to the breeding islands – there were hundreds of guillemots in large rafts on the sea's surface. As the boatman manoeuvred us closer, many birds ran out of our way, giving us the opportunity for shots like this.

It was an incredibly dull, overcast day, and with the boat lurching violently from side to side and the birds running quickly over the sea, this was not an easy shot to take and I could only shoot at 1/500th of a second. Panning with the bird certainly helped to make the most of the speed I had, and I was pleasantly surprised to find a number of sharp images among many that were not. The resulting picture is full of action, although I would have preferred the line of splashes in the top right-hand quarter of the frame not to have been there. These were left by another bird, running out of frame. Despite this I think the picture is strong enough to still be successful.

FLOCKING

So far the images in this chapter have concentrated on the behaviour of a single bird, but some of the most spectacular scenes in nature occur when large numbers of birds join together to form flocks. One of the most striking gatherings can be found around the shores of the United Kingdom at high tide, as wading birds forced off their feeding grounds out on the mudflats come together to rest and wait for the tide to recede so they can continue feeding. The Knot forms the most spectacular, densely packed flocks as the birds huddle down together and catch some much-needed sleep. These gatherings only happen outside the breeding season, and at this time the birds are in dull grey winter plumage, so are not in themselves particularly photogenic. When photographed en masse at

● KNOTS
(Calidris canutus)

Canon EOS 1V, 600mm lens + 2x converter, tripod, approx. 1/250th sec @ f8, Fuji Provia 100

Norfolk, UK

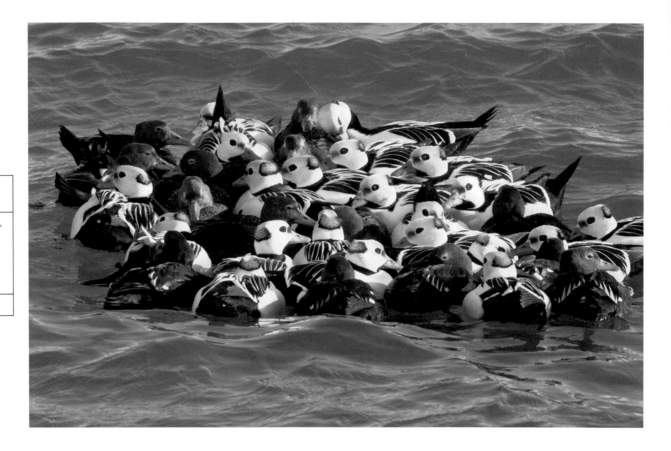

STELLER'S EIDERS
(Polysticta stelleri)

Canon EOS 1D Mark II,
400mm f4 lens + 1.4x
converter, beanbag,
1/500th sec @ f16,
digital ISO 400

Norway

a high tide roost, though, the result is an amazing demonstration of the wonders of the natural world.

High tide was very early on this particular morning, and as I made my way to the public hide at Snettisham RSPB reserve in Norfolk in the middle of winter, it was still rather dark. The birds roost in a large gravel pit just a short flight from the mudflats of the Wash, and the hide I had chosen was directly opposite the bank of gravel that formed the side of the pit. I had been to Snettisham many times before, so I knew that this was where the Knots roosted. Photographing thousands of birds roosting together is nigh on impossible on the flat, but at this spot I knew they would form a 'wall' of birds up the steep gravel bank, which would make a much more interesting image.

Because of the width of the gravel pit the hide I was in was still some distance away, so I needed my 600mm lens plus a 2x converter. Due to the dull conditions (I was still

using film at the time), keeping this huge set-up still was essential to avoid camera shake, since I could only manage 1/250th of a second at maximum aperture. Because of this I took several rolls of film to make sure I got the shot I was after.

The flocking of Steller's Eiders has one thing in common with the roosting Knots on the previous page – it only occurs outside the breeding season. With some exceptions, birds do tend to flock at this time, when they are far less territorial and seek out others of the same species for safety in numbers. I photograph a lot of wildfowl because they are favourites of mine, but I have never seen any of them behave like the Steller's Eiders above. Many ducks form small rafts of birds in winter, but never as squeezed up as these delightful little birds, which were so closely packed that it was more like watching a single organism than 35 – yes, I know it's a bit sad, but

I actually counted the number of birds in this picture. Most of them are the very colourful males, but there are several of the dark brown females in the image as well. Quite why they form these closely packed rafts I have no idea, but they do it all the time – and when I saw this behaviour I just had to photograph it.

Steller's Eider is one of three eider duck species that winter in north Norway, the others being King and Common Eiders. The weather was very rough on the open sea due to the gale-force winds, and a large flock of these birds had taken shelter in the harbour. This was good news because they were far more easy to photograph here than they would have been out at sea; what's more, this could be undertaken from the relative shelter of our vehicle. We had hardly seen the sun for the whole week, but it popped out of the clouds, scudding across the sky for just a few minutes. It was at this moment that I took this picture. As in the case of the picture of the Knots, it was difficult to photograph the flat raft of eiders – the majority of the birds were hidden behind those in the foreground and didn't show the raft very well. There was, however, quite a swell on the water. I watched carefully and waited for the precise moment when the swell passed under the front birds and lifted the back birds up in the air. This gave me the result I was after, as all the birds in the little raft were now visible.

The sun really helped – I was able to stop right down to f16 and still shoot at 1/500th of a second due to the bright conditions, and to allow for the white on the males' heads. I needed as much depth of field as possible to render all of the birds in the raft sharp, because I was shooting with a long telephoto lens.

FIGHTING

In some ways a photograph of birds fighting is the ultimate 'action' shot. It is something I am always on the lookout for, although it is often difficult to predict. Birds fight for a number of reasons: over food, to defend or acquire a territory, or to see off a rival for their breeding partner. Although I have seen females fighting occasionally, it's normally the males that indulge in this practice. To anyone who has been to a disco on a Saturday night, this will come as no surprise.

When I took the shot below I was just off the rocky shore of South Georgia in the South Atlantic Ocean, and it was a miserable day – not unusual in the Antarctic region.

● NORTHERN GIANT PETRELS
(Macronectes halli)

Canon EOS 1D, 100–400mm lens @ 310mm, hand-held, 1/400th sec @ f5.6, digital ISO 400

South Georgia

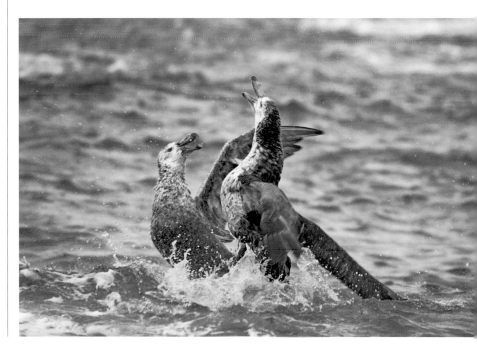

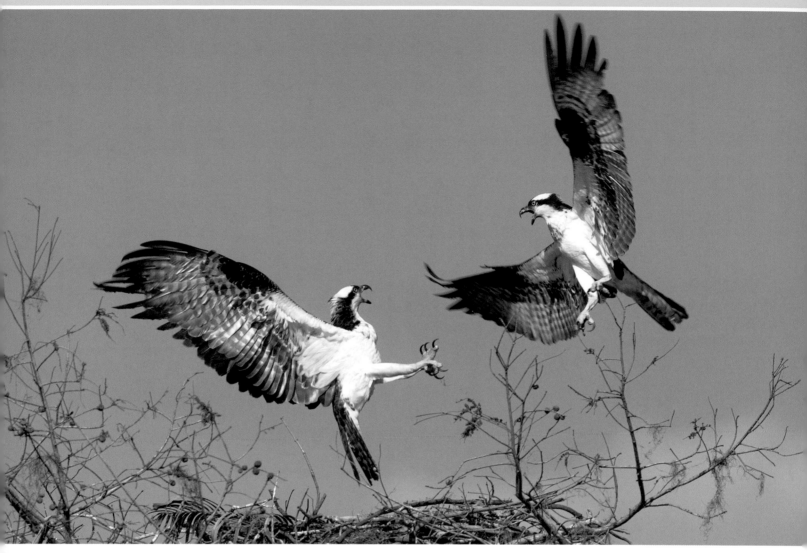

● OSPREYS
(Pandion haliaetus)

Canon EOS 1D Mark II,
500mm lens + 1.4x
converter, tripod,
1/1,000th sec @ f8,
digital ISO 200

Florida, USA

There was a steady drizzle and the sea was too rough to land on the shore, so we set off in zodiacs and cruised around the rocky shoreline to see what we could find to photograph. I decided that a telephoto zoom would be light and easy to shoot with on a crowded, rolling little rubber boat. A male Northern Giant Petrel raised himself up in a threat posture as another came towards him, but at this moment the zodiac spun around in the current. I quickly gathered my bearings and got on the two birds as they leapt out of the water in an extremely brief encounter.

As mentioned, fighting can break out at any time for a variety of reasons, and this was certainly the case when it came to the above picture of two Ospreys fighting over a nest site. Although Ospreys are birds of prey, I have never thought of them as particularly aggressive, and had never seen them fighting before I took this shot on a two-month trip to the state of Florida. However, disputes over nest sites and mates are not that unusual in spring.

We were visiting Cypress Lake in the centre of Florida and away from the main birding areas close to the coast. The lake was surrounded with cypress trees, which made viewing difficult, and access was very restricted unless you had a boat – which I didn't. My wife and I searched around the edge of the lake by a boat ramp and finally found a

spot that gave me a shot through the trees towards an Osprey on its nest. It was a very narrow angle, as tree branches obscured the view on either side. I guess that the lake was pretty full of fish because there were dozens of Ospreys flying around and many nests.

Eventually the female started to call, and I assumed this meant that the male was on his way. What happened next took me completely by surprise – the female on the nest leapt into the air and attacked the incoming bird.

I can only guess that the incomer was not her mate after all, but a stranger that wanted to steal her nest site. The resident bird won, though, and saw off the newcomer. Showing the birds with their talons outstretched and their wings open, this mid-air Osprey encounter was one of my favourite images from the Florida trip.

THE UNEXPECTED

Some bird behaviour is just so unexpected there is no way that you can categorize it or anticipate it. This was the case with an encounter on the Shetland Isles one summer, pictured on the right. It is an example of how putting in time and being out in all weathers sometimes turns up pictures that make all the effort worthwhile.

It was a typical Shetland summer's day – overcast, cold and damp. We were sitting in the car by the side of the road close to the edge of a loch, and there were some Arctic Terns' nests within shooting distance. There was also a family of Oystercatchers nearby with some small chicks that spent most of their time sheltering from the cold

drizzle under their mother's wings. Behind the car a couple of sheep with lambs crossed the road and sauntered along the edge of the loch. The Arctic Terns were not amused and went crazy, screaming at the sheep, which seemed oblivious to their presence or the havoc they were causing. Meanwhile one of the young lambs thought he had found a new playmate and wandered over towards the male Oystercatcher. With his family close by the Oystercatcher wasn't very keen on the presence of the little lamb, and walked towards it. The lamb stopped just short of a small mound. This was very convenient for the Oystercatcher, because by climbing the mound he was able to give the young lamb a sharp peck on the head. Thus chastised, the lamb turned around and headed back to mum.

● OYSTERCATCHER
(Haematopus ostralegus)

Canon EOS IDs Mark II, 500mm f4 lens + 1.4x converter, beanbag, 1/500th sec @ f5.6, digital ISO 400

Shetland Isles, UK

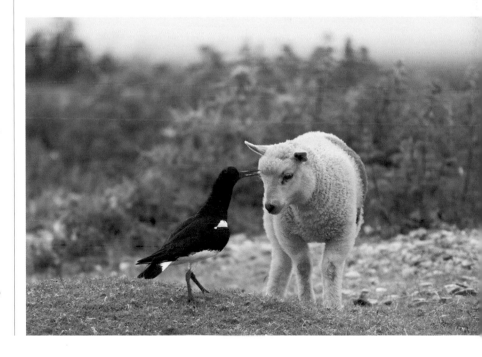

119

PENGUINS

Penguins are very photogenic birds and are not shy of people, so one of the usual major problems of bird photography (getting up close) does not apply with them. This means that as a photographer you can concentrate on taking interesting pictures rather than on concealing yourself from the subject. Although penguins make good subjects, because they spend a lot of time standing around action photography is not straightforward – it's easy to end up with a lot of rather dull pictures of this fascinating group of birds.

Penguins are utterly unlike any other birds, which is why I've dedicated a section in this action chapter just to them. One key difference is that they are of course

⬤ CHINSTRAP
PENGUIN
(Pygoscelis antarctica)

Canon EOS 1D Mark II,
100–400mm lens
@ 235mm, hand-held,
1/2,500th sec @ f5.6,
digital ISO 400

Antarctica

flightless, although I have managed to get some images when they are actually completely off the ground.

In the picture on the left, the Chinstrap Penguin has just returned from the sea, where it has been feeding. Penguins often come ashore at the same spot, and if I can find this I like to position myself nearby and wait for them to appear from the cold Antarctica waters. I find this has several advantages over photographing at the breeding site. One is that the birds are very clean, having just come out of the sea. There is of course water around, which adds another dimension, and they come ashore individually or in small groups, which makes the pictures relatively uncrowded. When they first come ashore they tend to rest on the rocks closest to the sea before heading inland. The shoreline at Ronge Island, where this picture was taken, was covered with boulders, and the Chinstraps found it quite difficult to navigate their way through these rocks as they headed inland. Sometimes to avoid a long detour they would simply jump from rock to rock, and this is the shot I wanted – a flying penguin!

As I sat quietly in one spot the penguins often came very close to me, and the 100–400mm zoom lens I was using was ideal for framing them, whatever the distance. For this shot I was shooting at just 235mm, which shows how incredibly close the birds were to me. I should point out that you should not approach penguins this closely, but if you settle down in one spot and they come that close to you that is fine – they can break the distance rules, but you shouldn't.

Although penguins don't fly in the air, they certainly fly underwater, travelling through it like little torpedoes.

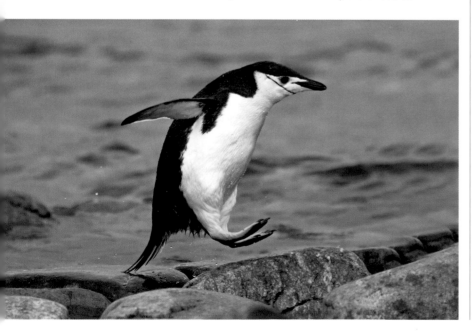

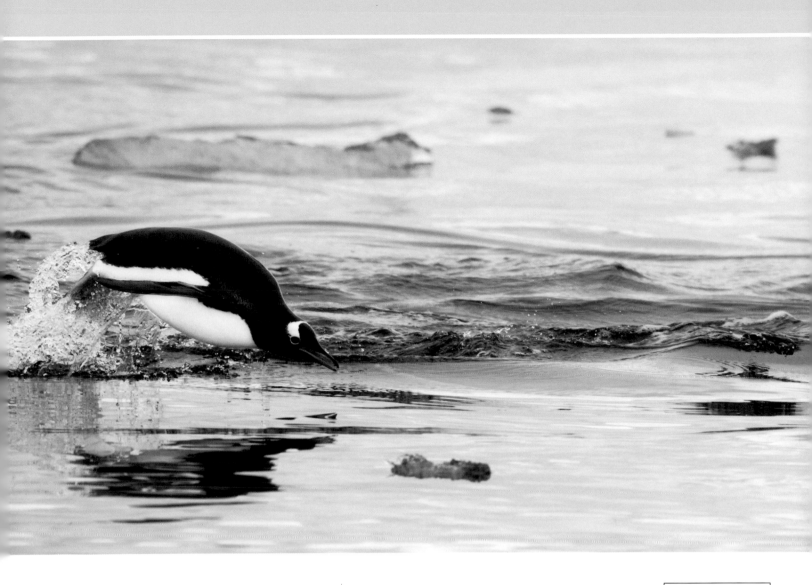

Unless you are an underwater photographer this is impossible to photograph, but sometimes a penguin will leap out of the water, retaining forwards momentum before re-entering and continuing on its way. It is thought that this porpoising behaviour may actually save energy, but as it happens so infrequently this is not certain. Regardless of why they do it, this aspect of penguin behaviour does give the surface-based photographer a chance to obtain some spectacular images.

There are serious difficulties in taking pictures like that of the Gentoo Penguin in 'full flight' above, since it is almost impossible to predict when the penguin is about to leap out of the water. When I took this shot I was standing on the deck of the ship as we were cruising slowly around the Antarctic peninsula. I noticed a few Gentoo Penguins coming towards us, and some of them were porpoising at regular intervals. I locked on them when they were still too distant for photography, and followed them as they came close. I noticed that the lead penguin would break the surface first, followed by the others, so I waited for the lead penguin to start, then concentrated on the spot behind it. As you can see, I just caught this one at the edge of the frame completely out of the water and with a slight reflection as a bonus. The small pieces of ice floating on the water certainly add atmosphere to the image and highlight the penguin's cold environment.

GENTOO PENGUIN
(Pygoscelis papua)

Canon EOS 1D Mark II, 100–400mm lens @ 400mm, hand-held, 1/1,000th sec @ f8, digital ISO 400

Antarctica

121

● MACARONI PENGUIN
(Eudyptes chrysolophus)

Canon EOS 1D Mark II,
100–400mm lens
@ 400mm, hand-held,
1/400th sec @ f5.6,
digital ISO 400

South Georgia

The sea is the where the penguins are most at home, and getting ashore is often quite an effort for them as they make the transition from sea to land. This is particularly true of species that build their colonies on rocky coasts, as do the aptly named Rockhopper Penguin and the closely related Macaroni Penguin. These birds bounce around like rubber balls in the pounding surf that often separates them from their nest sites, and watching them crash against the rocks you wonder how they survive. They are very resilient little birds, however, and have sharp claws with which to hold onto the wet rocks as best they can.

This final penguin shot shows a Macaroni Penguin that has just managed to scramble out of the rough sea onto a low rock, although the rock itself has been covered by the previous wave and the water is still draining from it. The bird is using its stumpy wings to try and balance itself before heading off inland. It is not going to make it, though, because that big wave in the background is about to crash onto the rock and knock it back into the sea, where it will have to start all over again. This picture was taken from a zodiac off the rocky coast of Royal Bay on South Georgia, just a few minutes before I had photographed the fighting Northern Giant Petrels shown on page 117. It was a very good afternoon's work indeed.

Although the bird is not spectacularly active, the picture does not lack drama, most of this coming from the splashing water around the bird and the large wave in the background that is clearly heading for it. As usual the positioning of the bird in the frame is key, but this was particularly the case in this instance because I wanted to include as much of that dramatic wave action as possible.

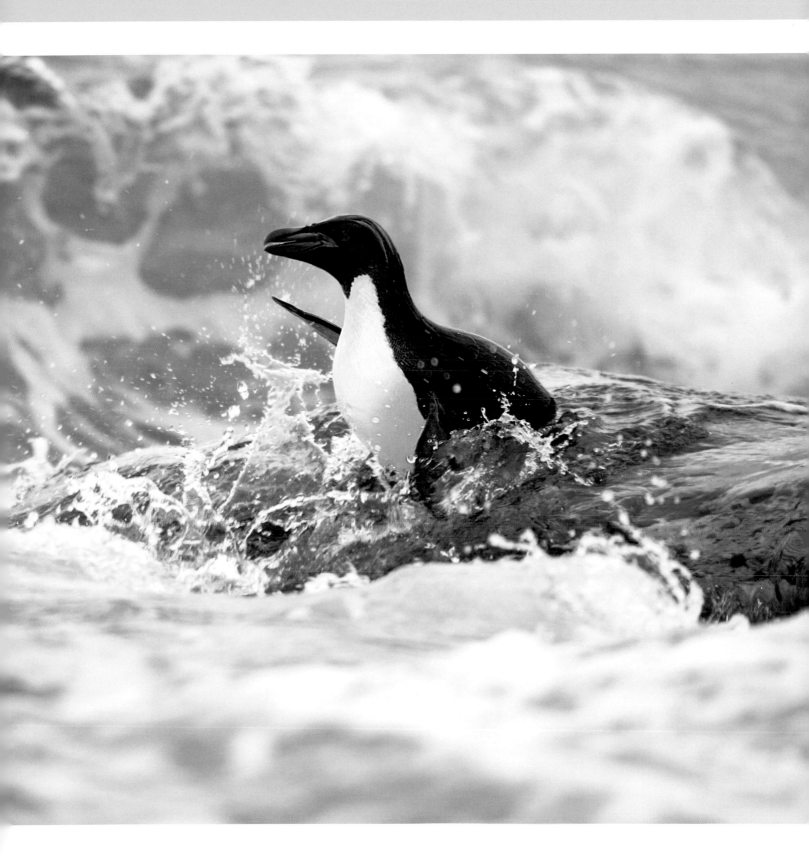

Dawn and dusk

The magical light that occurs around sunrise and sunset can enhance a view and bring out the mood of a location. This chapter is dedicated to using the times around dawn and dusk to create atmospheric images that capture the essence not only of a place, but of nature itself.

IN THESE SITUATIONS the birds are more often than not thrown into silhouette, and in many cases it is not possible to identify exactly which species has been photographed. There is a school of thought that doesn't consider such pictures to be 'real' nature photography. I don't share this view – bird photography is a varied art and there is plenty of room for all approaches within its boundaries.

The quality of the sunrise or sunset is paramount in many images of this type, and I have spent hours waiting for sunsets that drifted into a dreary 'non-event' in the end. Location is important, because open areas give you a clear view of the sky, which will form the backdrop to your shots. Wetlands are particularly good, since they are generally open, and have the advantage of being home to lots of birds that are often on the move at the crucial times.

PRE-DAWN FLIGHT

Wildfowl make probably the best subjects of all for dawn photography, particularly in winter when they can gather in huge flocks – ideal to place before that spectacular sky that we are hoping for. These large flocks would be very vulnerable to predators during the night while they are sleeping, so they gather together in the centre of a lake or marsh where the surrounding water makes access by predators difficult. The birds need to make the most of the rather short winter daylight hours, so they start to get very restless as soon as the first light can be seen in the sky, before the sun has risen. As the sky continues to brighten, the birds suddenly take off en masse to move back to their feeding grounds, and this is the time to strike.

⦿ SNOW GEESE
(Anser caerulescens)

Canon EOS 1NHS,
300mm f2.8 lens,
hand-held,
around 1/180th
sec @ f2.8,
Fuji Provia 100
pushed to 200

Delaware, USA

On one particular morning I looked out of the motel room at around 4.30 a.m. Although it was still dark the sky was covered in thick grey cloud. I very nearly went back to bed at that point, but instead decided to head off to Bombay Hook National Wildlife Refuge in Delaware at this early hour for the fifth time that week. When I arrived at the reserve, I noticed that although the clouds covered nearly all of the sky, there was a small strip of clear sky in the east – just where the sun would rise. As the Earth rotated towards the sun, the light from our life-giving star lit the undersides of the clouds long before it broke the horizon. This had the effect of turning the eastern part of the sky a deep red colour, with a concentrated bright 'sun pillar' where the sunbeam was strongest. It looked fantastic, and I took a couple of scenic shots of the whole sky. I turned to my wife (who as always had accompanied me on this freezing cold morning), and said 'Wouldn't it be nice if a flock of geese took off now.' Thinking this unlikely, I was fitting the 300mm lens to my camera to be prepared, when a flock of Snow Geese took off from just below the sun pillar. I didn't even have time to put the camera on the tripod, and simply aimed and pressed the button. The whole thing was over in seconds, and this was the only shot (shown left) I took all day, because the day grew duller and it started raining.

The birds in the picture are Snow Geese, but it really doesn't matter what species they are as this is not what this picture is about – it's simply a celebration of the incredible beauty that can be found in the natural world. Lucky to get this sky? Well, no, quite honestly, as we kept going and got up well before dawn every day during

our two weeks on the eastern seaboard of the United States, when the temperatures were often below zero. Perseverance, as is so often the case, is the key to success.

Bosque Del Apache National Wildlife Refuge in New Mexico is one of the best places for dawn and dusk photography that I have ever visited, and several images from this location, including the one above, appear in this chapter. It has the perfect ingredients – lots of birds, a wetland habitat and easy access before dawn. It's one of the few long-haul destinations that I have visited several times and never fails to produce good images. Around 30,000 Snow Geese regularly winter in the reserve and roost in its watery centre. The weather in this part of the world is usually sunny, so clear dawn skies are common.

● SNOW GEESE
(Anser caerulescens)

Canon EOS 1V,
500mm f4 lens,
tripod, around
1/30th sec @ f4,
Fuji Provia 100
pushed to 200

New Mexico, USA

Without clouds the skies begin to brighten very early as the sun approaches the horizon in the east. The geese therefore often fly around the roost site well before sunrise, and they can be photographed in huge flocks against the first light.

On this morning it was well below zero when a huge flock took off in front of me. When the birds first take off you can't actually see them, because they are hidden against the black of the distant hills. You can certainly hear them, though – thousands of calls fill the cold morning air, a magical moment never to be forgotten. As they break the line of hills they become visible as a whirring mass of black silhouettes. It is still quite dark, so slow shutter speeds are inevitable, but with careful panning it is possible to capture the bodies of the geese reasonably sharply. There is no chance of freezing the fast-beating wings, however, and these come out as ghostly shadows attached to the dark bodies. This greatly adds to the overall effect of the resulting image, bringing movement and atmosphere to it and delivering something a little different.

THE FIRST RAYS

If there is little or no cloud, once the sun rises the colour in the sky quickly disappears, but there is a short period when the sky immediately either side of the sun can be bright yellow or orange. On a clear morning the sun will be very bright and far too dangerous to point a long telephoto at – great care must be taken to avoid this as it could cause blindness in the careless photographer. However, the colourful areas of sky on either side of the sun can make great backdrops for your bird photography.

In this situation I am constantly on the lookout for groups of flying birds that may look good against the sky. When I spot such a group I position my camera to the side of the sun, so that the birds will be flying away from the sun rather than into it in the picture. As I pick up the birds and track them, there is thus no danger of me accidentally pointing into the sun. Only when the camera is in place do I look through the viewfinder and prepare to pick up the birds as they fly past.

At the top, opposite is the third shot of Snow Geese in a row, but as you can see the pictures are completely different, despite them all being of flocks of birds silhouetted against the early morning sky. That's what is so great about this type of photography – every dawn and every dusk has the potential to yield unique images. This is another Bosque image, and this time you can see those hills I mentioned in the previous section. Here, however, the hills are golden yellow as the sun is now above the horizon. If you look carefully you can see that the right-hand side of the image is brighter than the left because the sun is behind the birds (I used the technique described above). The sun has caught and highlighted the tops of the reeds, making them shine out, an effect that can also be seen on the wing of the last bird.

If you look at the picture at the top, opposite and imagine it taken on a bright, sunny day with the sun behind you, the resulting group of white Snow Geese against a blue sky would be a little boring and would not capture the atmosphere of the location. It's the background

● SNOW GEESE
(Anser caerulescens)

Canon EOS 1V,
500mm f4 lens, tripod,
exposure unrecorded,
Fuji Provia 100

New Mexico, USA

● BLACK BRANTS
(Branta bernicla
nigricans)

Canon EOS 1V,
24–85mm lens,
hand-held,
exposure unrecorded,
Fuji Provia 100

New Jersey, USA

that makes this image work, not the birds themselves, as is so often the case at both ends of the day.

Earlier I warned against including the sun in your pictures as this could damage your eyes, but in the picture on the right the sun is clearly visible. There are two factors that make it possible to include the sun in this image but not the previous one. Firstly, although the sun is obviously pretty bright in the picture it is partially obscured by cloud, which reduces the light level considerably. Secondly, I am using a wide-angle lens, so that the sun is much smaller in the frame than it would have been with the large telephoto I used in the previous picture.

This picture was taken at Brigantine National Wildlife Refuge in New Jersey, which is home to large numbers of Black Brant geese in the winter months. These are coastal birds and the reserve borders the Atlantic Ocean, so they spend much of their time flying back and forth between the

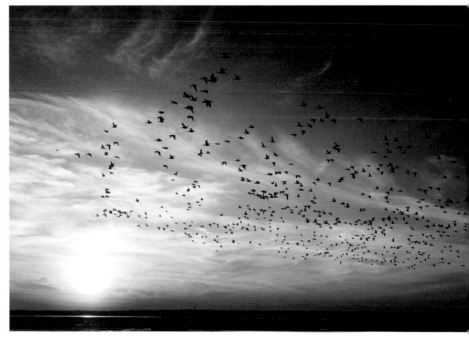

● BROWN PELICAN
(Pelecanus occidentalis)

Canon EOS 1D Mark II, 500mm f4 lens + 2x converter, tripod, 1/1,000th sec @ f8, digital ISO 400

Florida, USA

freshwater lagoons of the reserve and the sea. This constant movement of large flocks of geese gives excellent opportunities for photography, and as they fly quite low over the reserve access road they come surprisingly close. Taking advantage of this, I set about capturing the whole scene one morning with a wide-angle lens.

The geese in the picture look almost the same as the Snow Geese because they are simply black silhouettes, which emphasizes the point I made earlier about the species of bird being pretty irrelevant to this type of picture. Note how the elements in the picture have been carefully balanced, with the sun itself positioned in the left-hand bottom corner and the geese flying towards it and scattered reasonably evenly across the sky, so that there are no 'dead' areas within the frame. It would have been nice if the dawn sky had been a bit more interesting, but it does demonstrate how a nice image can be made in less than perfect conditions and, let's face it, this is what you have to deal with most of the time.

BIG SUN

There are times when it is possible to photograph directly into the sun with a big telephoto lens, and I usually find that these opportunities tend to occur more around sunset than sunrise. As you can see in the picture opposite, there is some high cloud visible around the sun, but it was the very hazy conditions that turned the sun into a soft yellow ball that you could easily look at with the naked eye. I'm always on the lookout for these conditions, but they don't occur very often, and when they do it is even rarer to find birds flying about that can be used as a foreground subject. Any old bird won't do, either – you need a flock of birds or a large single bird that has a distinctive shape, like the Brown Pelican in this image.

I had spent the afternoon at Fort de Soto on Florida's west coast photographing waders that were gathering at high tide. As the sun dropped low in the sky over the sea, I saw the possibility of a 'big sun' shot. I set up the camera using the 2x converter and my 500mm lens, giving me an effective focal length of 1,000mm. Add the multiplication factor of 1.3x for the camera body I was using and the focal length equivalent of a 35mm film camera rises to 1,300mm, so a sturdy tripod was essential to keep the whole rig steady. Unfortunately there were very few birds around over the sea and the sun was rapidly going to disappear below the horizon. It was then that I noticed a few Brown Pelicans far out to sea. I moved quickly along the beach to position the birds roughly in front of the sun and waited. Most of them kept far too low over the water and therefore beneath the sun, but just one popped up against the yellow ball and I got the shot I was after.

Exposure is critical when making a 'big sun' picture, and you need to give the sun itself as much exposure as possible without bleaching it out. The best way to do this is to take test exposures before you start looking for birds, but remember to adjust the exposure, because the light intensity will fade as the sun gets lower in the sky. Putting the bird slightly to one side and breaking through the sun circle makes for a more interesting composition than if the bird had been slap in the middle of the sun.

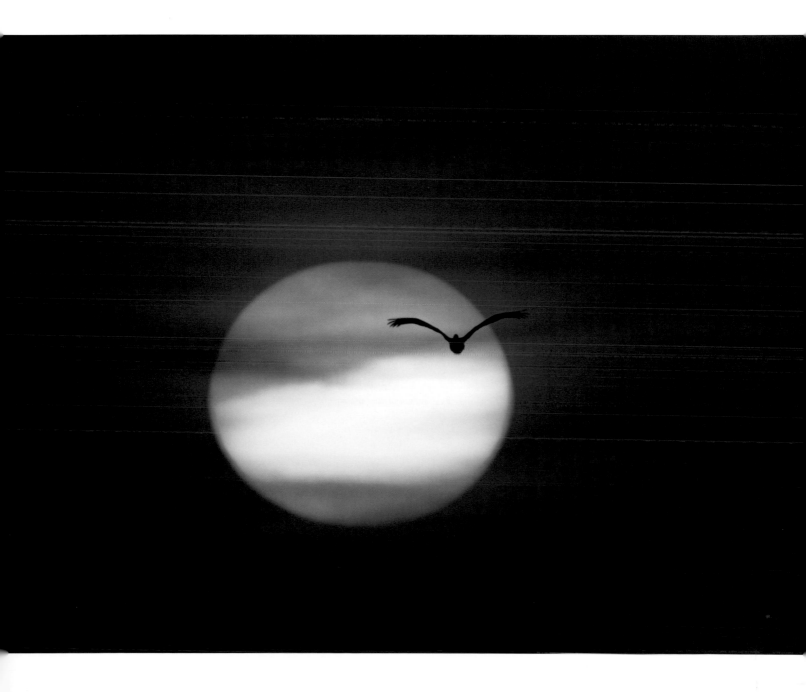

MISTY MORNINGS

Mist can create interesting atmospheric conditions, which if used creatively can make for some unusual and eye-catching photographs. Early morning is the best time for mist, which forms when moist air cools overnight. Cold air cannot hold as much water as warm air, so the tiny water droplets condense to form mist. As the sun rises the air heats up and once again holds more water, so the mist effectively evaporates into the air.

I had been photographing Galapagos Flightless Cormorants the previous afternoon on Fernandina Island while on a photographic trip to the remarkable Galapagos Islands. This was in full sunshine, but when we returned early the following morning, we found that a mist covered the sea behind them. This gave a great opportunity to do something a little more creative. I noticed the bird shown below preening while holding out its sad little wings to dry. I wanted to isolate the shape, but it was surrounded by rocks and other birds. To achieve this picture I had to get as low as possible to cut out the surrounding distractions, and to do this I had to lay my camera on the volcanic rock that formed the ground, and lie flat on the ground myself to be able to see through the viewfinder. I couldn't get the bottom half of the bird in the photograph without including some ugly rocks, so I concentrated on the graphic form of the top half of the bird. Although the bird is shown as a silhouette, there is no doubt that it is a Flightless Cormorant.

The distinctive shape of the bird is everything in this image – when making simple silhouettes like this with no background interest, an interesting shape is essential. You only see the outline of the bird, so it is this that you have to concentrate on. The head is turned to one side, which

● FLIGHTLESS
CORMORANT
(Nannopterum harrisi)

Canon EOS 1V,
500mm f4 lens,
exposure unrecorded,
Fuji Provia 100

Galapagos Islands

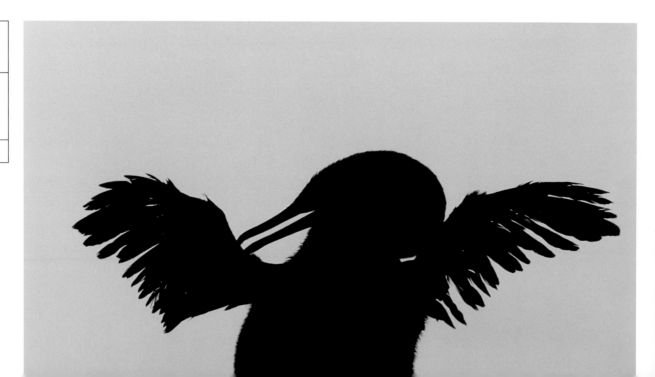

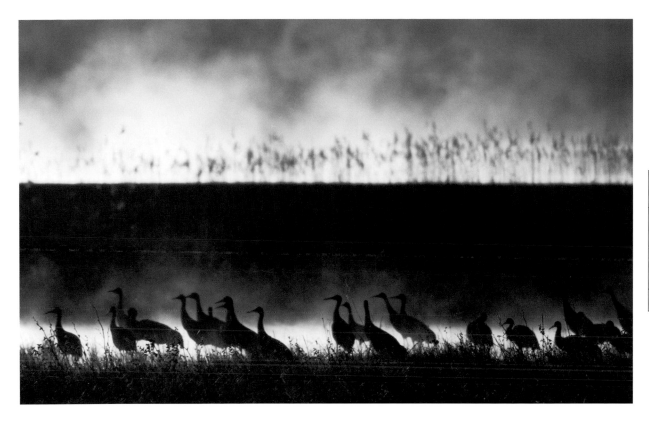

● SANDHILL CRANES
(Grus canadensis)

Canon EOS 1V,
500mm f4 lens +
1.4x converter, tripod,
exposure unrecorded,
Fuji Provia 100

New Mexico, USA

was the only way that I could have made this image work, otherwise it would have just been an anonymous round ball with wings. I exposed for the background as I didn't want this to be too bright, and simply metered without the bird to set the background at 18 per cent grey (normal AV reading). This I then set manually, so the meter would not be affected by the large area of black when I included the bird in the frame. Having got this picture on film, I have no record of the actual exposure at the time – all I remember is that it did require some thought.

Mist often forms over wetlands because of their moist air. If you position yourself correctly with the sun rising behind the mist, you can make best use of the conditions to make some very attractive images. The image of Sandhill Cranes, above, caught in just this situation, was once again taken in Bosque del Apache National Wildlife Refuge in New Mexico. As the sun rose it streamed through the rising mist, turning it bright yellow, and the birds were perfectly

silhouetted against this amazing light. The whole scene is so bright and dynamic that it looks as if it was photographed against a raging fire rather than a gentle misty morning.

I've spent many a morning at Bosque del Apache over the years, but have only once come across this early morning mist effect. The temperature always drops at night at Bosque, and the winter dawns are usually below freezing with clear skies. This particular morning seemed the same as any other, so quite what subtle weather conditions are at play here I can't say. When the mist effect does occur it is fantastic, and there are always birds at Bosque that you can find to put in the foreground. In this instance the Sandhill Cranes were ideal, as they are tall enough to show above the surrounding vegetation and produced a very distinctive 'skyline' as silhouettes.

The area in front of the cranes held little interest because it was not catching the light and was rendered

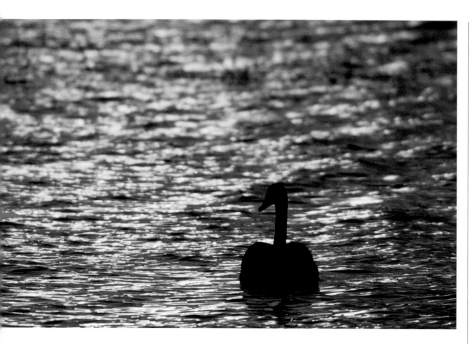

● WHOOPER SWAN
(*Cygnus cygnus*)

Canon EOS 1V,
500mm f4 lens + 1.4x
converter, beanbag,
exposure unrecorded,
Fuji Provia 100

Norfolk, UK

section I deal with how reflections of the low sun in water can provide colourful backdrops when photographing birds. Winter is the ideal time for this type of photography. The wetland areas you need to visit hold far more birds in the winter than in any other season. During the winter the sun rises and sets at a far more civilized time, so that many reserves that provide good opportunities for this type of photography are still open, especially at the end of the day. Finally, as the sun is always relatively low in the sky during the winter months, there is quite a long period before sunset when you can use the reflections on the water to good effect.

The Wildfowl and Wetlands Trust reserve at Welney in Norfolk is an excellent place for this type of photography – if you are not a member of the trust I would urge you to join, as its reserves are excellent places for photographing wildlife and you will be supporting an extremely worthwhile cause. Having spent the best part of the day at Welney photographing the Whooper Swans, I noticed that although it was still an hour or so before sunset, the water had a distinct yellow hue. I decided to try and use this as a background for some swan silhouettes. I don't remember the exposure, but it was very bright indeed and I was using a small aperture and fast shutter speed because it was essential that I didn't blow out the highlights in the water. By underexposing slightly I ensured that the silhouette was black and the water would appear even more yellow than it was (this was in the days of film and you couldn't check your exposure until you got your slides back).

The composition is key in the image. Importantly, the bird is looking into the frame, but the background is of

a dull brown. I therefore composed the shot with the cranes close to the bottom of the frame to minimize the dull foreground. When I first framed the shot the cranes were looking around in all directions. Then something caught their eye and they all looked in the same direction – this was when I took the shot. Notice also that I left a little space in front of the first crane in order to give a pleasing composition. In doing so I ignored the rearmost cranes, which are far less important.

USING WATER

So far in this chapter we have looked at using mainly the sky as a backdrop to the silhouettes of birds, but in this

equal interest and the swan itself, being relatively small in the frame, creates a feeling of space. As nature photographers we spend much of our time and effort getting close to a subject, and I think that getting close in itself has often been seen as 'a good picture'. This had led us to shy away from using space in our pictures, although I think attitudes are changing a little nowadays.

When the bird is used as a small object in the overall picture, it is very important to position it well in the frame. If the swan was in the middle of the picture it would just not work, and would only look as though you needed a longer lens.

In the picture of the swan silhouette, the water is a lovely pale golden-yellow colour, as the photograph was taken well before sunset. Later on, as the sun is actually setting, the reflections in the water change, and at the last moment before the sun disappears below the horizon the water can take on the appearance of liquid gold. The incredibly rich colours, as seen in the picture of a Mallard on the right, which was taken at Slimbridge Wildfowl and Wetlands Trust Reserve on the River Severn, are only present for a very short time so you have to work fast. You must position yourself facing the sunset with water in between, and then wait (hope!) for a bird or two to cross your chosen spot.

It was the end of the day at Slimbridge and almost everyone had left. I was making my way towards the exit myself when I noticed the beautiful colour of the water on one of the large wildfowl ponds. The best colour was in quite a narrow band, and I set up my long lens on the tripod and watched the pond carefully. There were a lot

of ducks in the pond, but when they did eventually cross the golden water they were either in small groups that got in each other's way or would be swimming away from me. A good side-on silhouette was essential, and before the sun finally set a Mallard drake swam into view and I got the shot I was after.

There were a number of photographers at this well-known location on this particular winter weekend, but they had all packed up and left long before I got this shot. This goes to prove that it pays to stay around if the sky looks promising, because you never know what picture opportunities will turn up.

● MALLARD
(Anas platyrhynchos)

Canon EOS 1V,
500mm f4 lens, tripod,
exposure unrecorded,
Fuji Provia 100

Gloucestershire, UK

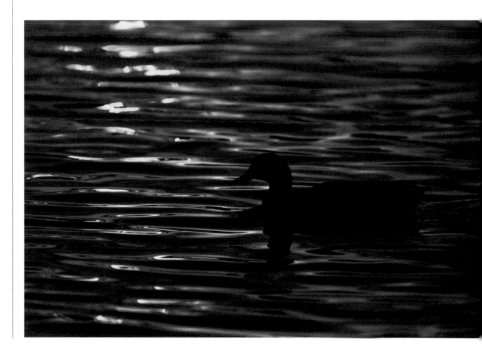

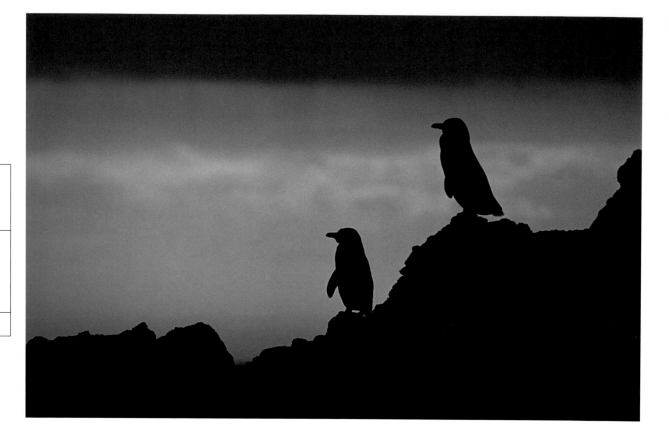

● GALAPAGOS
PENGUINS
*(Spheniscus
mendiculus)*

Canon EOS 1V,
100–400 mm f5.6
lens, hand-held,
1/250th sec @ f5.6,
Fuji Provia 100

Galapagos Islands

LESS SPECTACULAR SUNSETS

Spectacular sunsets make wonderful backdrops for your
pictures, but in my experience they are pretty rare events
and most of the time (at least when it's not completely
cloudy, when you get nothing) you have to settle for a
much less impressive event. With a really colourful sky you
can hardly go wrong as long as you can find some birds to
put in front of it, but with a lesser sky you need to provide
a much stronger composition for the picture to work. The
above image of two Galapagos Penguins standing on some
jagged rocks, silhouetted nicely against a pinkish, but
otherwise unspectacular sky, is very graphic and has all the
elements playing their part.

Although the shot may look straightforward, it was in
fact very tricky to make, mainly because we were on a
small zodiac that was moving about quite a lot in the swell

off some small offshore islands. The area of pink sky was
very narrow and shooting from a safe seated position
posed a problem – because of the angle the topmost
penguin was silhouetted against the dark grey sky, which
did not look very impressive. To place the bird within the
pink band I had to stand up in the rocking boat, then frame
and take the shot while attempting to keep my balance
and not fall overboard. In fact, I would have liked to have
moved just that little bit higher, but this was impossible
because I was virtually on tiptoes when I got this shot, and
I'm well over six feet tall. I took a couple of rolls of film to
ensure that I got the shot, and I'm very glad that I was
using an image stabilized lens at the time.

The jagged rocks play an important part in this image,
as does the positioning of the two birds. I needed them to
be a reasonable distance apart and roughly parallel to
each other, so they would both be in focus.

CHOOSE YOUR SPOT

When the final rays of the sun catch the undersides or backs of clouds at sunset, they glow from yellow to red and every shade in between. It's this that provides the wow factor in any sunset. Sometimes there is very little cloud in the sky, but you can still produce interesting images by making the most of what nature has presented you with.

At the end of a very sunny day at Bosque Del Apache National Wildlife Refuge, the sky was almost completely devoid of clouds so a colourful sunset was out of the question. Looking around the sky I noticed a single, rather elongated cloud over the distant hills to the west. As the sun slowly slid towards the horizon the cloud began to show the first signs of colour, so I framed it using a long telephoto lens and converter.

> ● SANDHILL CRANES
> (*Grus canadensis*)
>
> Canon EOS 1V,
> 500mm f4 lens +
> 1.4x converter, tripod,
> 1/500th sec @ f5.6,
> Fuji Provia 100
>
> *New Mexico, USA*

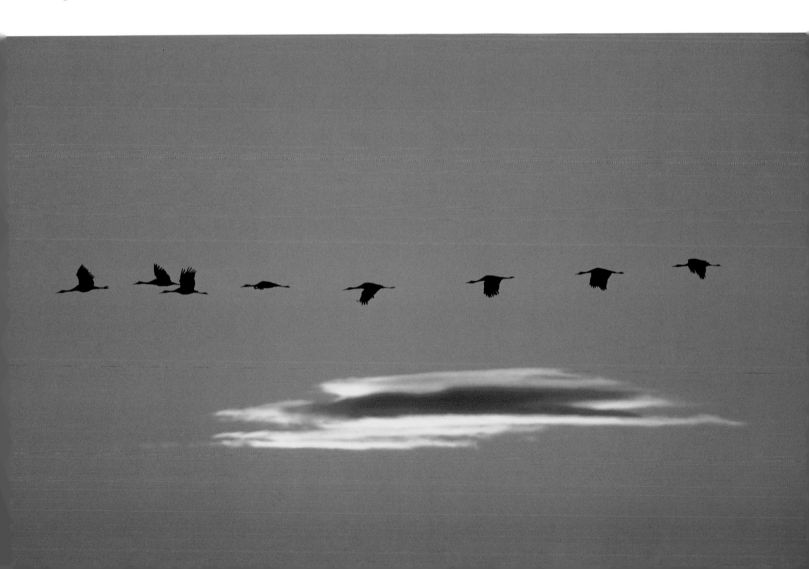

● BLACKIRD
(Turdus merula)

Canon EOS 1Ds
Mark II, 500mm lens,
tripod, 1/250th sec
@ f4, digital ISO 400

Hungary

The cloud glowed even deeper when the sun was almost below the horizon, and I saw a line of cranes approaching from my right at about the correct height. Willing them not to veer off course, I waited until they were perfectly spread across the frame and pressed the shutter. I got just one chance – this was the only group to cross in front of the cloud, which soon after lost its colour as the sun finally disappeared.

BACKLIT WATER SPLASH

Sunset is a favourite time for birds to visit ponds and drinking stations to have a bath before retiring for the night. Normally, of course, you would want to photograph this behaviour with the sun on the bird, but as is usual with dusk and dawn photography you need to position yourself facing towards the sun. The water thrown up by the bird as

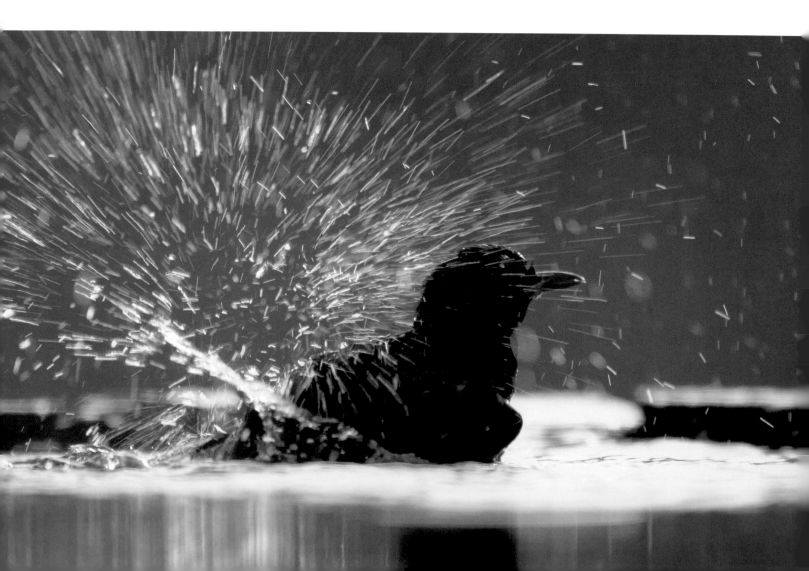

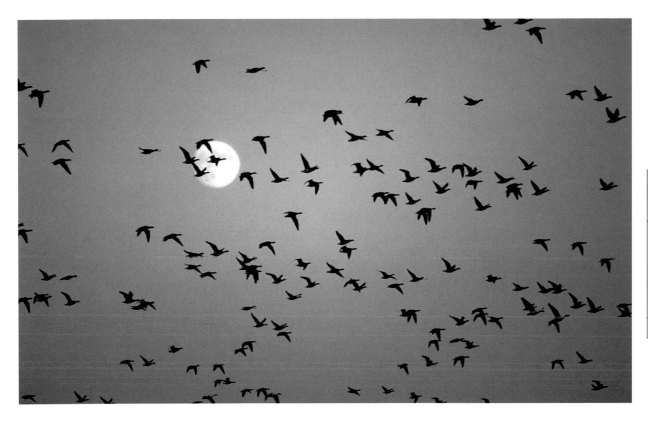

● BLACK BRANTS
(Branta bernicla
nigricans)

Canon EOS 1V,
300mm f2.8 lens,
tripod, around 1/250th
sec @ f2.8,
Fuji Provia 100
pushed to 200

New Jersey, USA

it washes catches the rays of the low sun and appears as golden sparks in the image.

I took the shot opposite from a hide in Hungary. In these conditions the correct exposure is very difficult to establish, but at least with digital this can be checked very easily. This needs to be done frequently, because the light is fading almost constantly. The biggest problem is coping with the contrast range in the image. The water in the pond can be very bright, and in this shot there are a couple of small areas in the water in front of the bird that are overexposed. This is a compromise that I was prepared to accept to get more detail into the darker areas. Make sure that the highlights are not overexposed (or that as in this case just a small area is overexposed) and use that as your guide. In post processing you can increase the exposure in the dark parts of the image while leaving the highlights alone. This creates more digital noise in the picture, but is the only way to deal with such a high-contrast subject.

THE MOON

If the moon is out just after sunset, there is enough light in the sky to use this as a backdrop to your bird pictures. The timing has to be just right, because the light fades very fast at this hour.

I was in Brigantine National Wildlife Refuge at the end of the day when I noticed that the Black Brant geese were still flying around in large flocks. The geese were still active partly because of the light coming from the full moon. To get the shot I used my 300mm lens because I could shoot at f2.8, gathering as much of the fading light as possible and shooting at 1/250th of a second after I had pushed the film to give me another stop. Positioning the moon in the frame was the most crucial thing in this image, and I found what I thought was the best place for it. Later I realized that I had applied the 'rule of thirds' instinctively and had placed the moon a third in from the right and a third down.

Being more creative

In this chapter I explore the idea of pushing the art of bird photography just that little bit further. This varies from the simple concept of zooming in on one part of the subject, to capturing movement and using birds as small elements in a landscape.

SOME OF THE THEMES in this chapter take ideas covered in previous chapters, but push them further, resulting in pictures that go beyond what would be described as 'normal' bird photography. To some this may be going too far, but I sometimes find the conventions surrounding nature photography somewhat limiting, and I enjoy the challenge of trying out new ideas. There are many bird photographers who are very happy with producing beautiful images of birds that show every feather detail, and have no interest in anything that would be considered 'arty'. I've even met people who think that silhouettes are a step too far. On the other side of the fence are those who seem to believe that any traditional composition is no longer worthy of consideration, and that anything 'new' must be good just because it is different – a surprising number of people who hold such views seem to pop up as judges in photo competitions. The danger here lies in the triumph of originality over quality. Appreciation of any art form is subjective, and with the sheer numbers of excellent images being produced nowadays the temptation to be overawed by something a little different is considerable, but not all these images warrant this reaction.

So are you arty or traditional? Actually, I don't consider this to be a valid question. Any photograph you take has artistic considerations, whatever type of image you are making. A better question might be: is it editorial or interpretive? Editorial pictures demonstrate a species or particular behaviour, and interpretive ones attempt to capture the mood or impression of the subject rather than the absolute detail. There are photographers firmly in one camp or the other – I prefer to have a foot in both.

HEAD SHOTS

Let's start with expanding on the portrait just a little. Opportunities to get really close to birds to enable 'head shots' are not that common, but if they do arise they can result in pictures with a high impact, as in the shot opposite of a Crowned Crane, taken in a bird park in East Anglia. Working in a bird park is ideal for this type of shot because the captive birds are very used to people and often allow a close approach, although you still have to move carefully and slowly to avoid scaring the subject. Photographing captive birds rather than birds in the wild can be a controversial subject among bird photographers, but this type of image would be almost impossible to make in the wild – and if you are considering purely the aesthetics of a picture, then it really doesn't matter where it was taken.

When I saw this Crowned Crane walking slowly around the grounds, I was immediately drawn to the head with that magnificent circular 'crown'. This was the most startling part of the bird, so I decided to concentrate my composition on the head. It was late in the day and the light was fading, so flash was required. I could have used fill flash, but the background was a bit messy and I wanted no distractions around the bird's head. I therefore used full flash to render the background completely black. This would give me the graphic image I wanted, and by using a small aperture I would record no background detail, but achieve a good depth of field.

A simple head shot can thus produce a real eye-grabbing image. This direct, front-on view elicits an

emotional response from the viewer more than any other view, and the angle of the bird's head gives the bird a quizzical look and adds a lot of character to the picture. There is a 'connection' between subject and viewer, and this 'unnatural' image is a very powerful one. After all, who said that every bird photograph had to look natural? The key point here is that this is about producing an interesting image, which does not necessarily mean representing everything in an entirely 'natural' way.

INCLUDING THE ENVIRONMENT

Having gone in ultra close for the first image in this chapter, I'm now going to the other end of the spectrum and showing birds as part of the wider environment in which they live. In this type of picture the landscape around the birds plays as important a role as the birds themselves. It is not just a shot taken where you couldn't

● CROWNED CRANE
(Balearica regulorum)

Canon EOS 1N,
300mm f2.8 lens,
tripod, flash,
1/200th sec @ f22,
Fuji Provia 100

East Anglia, UK

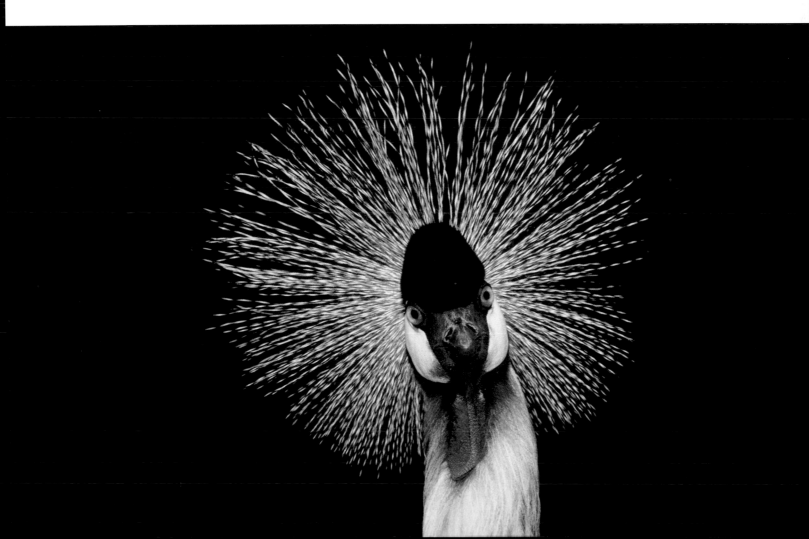

get close enough to your subject, resulting in the subject appearing small in the frame – although I have seen some pictures described as 'bird in its environment' that were clearly the result of this. A really successful picture of this type has to be driven by the surroundings and not the bird.

I was visiting Fowlsheugh, an RSPB reserve south of Aberdeen on the east coast of Scotland. Many seabirds breed on the cliffs at the Fowlsheugh Reserve, and when I visited in late May the cliff tops were covered in the soft pink flowers of Thrift. Walking along the clifftop, I came across an area where the Thrift was growing among rocks that were covered in yellow lichens, the combination of the two making a very colourful scene. There were a few Kittiwakes collecting nesting material close by. I had settled down to try and photograph them when a pair of Oystercatchers (opposite, above) flew in and landed on the cliff edge. They looked superb in this setting, and I decided to try and include plenty of rocks and plants in my picture. I placed the Oystercatchers at the top of the frame, which enabled me to get as much of the colourful foreground in the picture as possible. To ensure this was reasonably sharp I stopped down to f16 and took the shot.

Both Oystercatchers were facing the same way, and this dictated their horizontal positioning in the frame, with the lead bird being much further away from the right frame edge than the rear bird is from the left-hand edge. This is important to the overall balance of the picture, which requires any space available to be in front of the birds, rather than behind them.

This shot concentrated on the immediate surroundings of the Oystercatchers, picking up as much detail in the surrounding environment as possible. In the shot of the Puffins (opposite, below), the environment is a much broader view of the entire landscape in which the birds live. It could in fact be equally described as a landscape with birds in it. This type of shot is actually a lot harder to accomplish than it looks, because you will not be able to obtain the broad view of the landscape behind the birds with a long telephoto lens. When using a wide-angle lens you must get very close to your subject, but of course birds have a habit of flying away if you approach them too close.

Hermaness National Nature Reserve is located on the north-west tip of Unst, the most northerly inhabited island in the Shetland Isles. In the summer it is home to some 25,000 pairs of Puffins that nest on the high cliffs, as well as other seabirds. While I was taking a rest during a walk around the reserve, I noticed a few Puffins standing around on the very edge of the cliff. They were at one side of a deep bay, so that the other side of the bay and the offshore islands that supported huge Gannet colonies could be used as a backdrop – if only the Puffins would allow me to get close enough. The other slight drawback was that the Puffins were not right on top of the cliff near the path, but further down, which made for a rather precarious approach high above the sea below. I decided that the best way to approach the birds was to make my profile as small as possible, and slowly crawl on my belly towards them. The birds would look at me occasionally as I edged towards them, and when they did so I froze until they looked away again. It took ages to get close enough for a shot, but eventually I managed to frame the picture as I had envisioned it while still safely on the footpath.

● OYSTERCATCHERS
(Haematopus ostralegus)

Canon EOS 1D Mark II,
400mm lens + 1.4x converter,
hand-held, 1/320th sec @ f16,
digital ISO 400

Scotland, UK

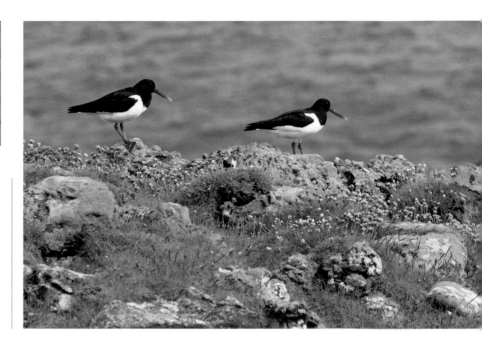

Seabirds are pretty tolerant birds and are thus ideal subjects for this type of picture. They still require a careful approach – the last thing you want to do is disturb your subject. Once you've got the shot you want, it is important to continue to respect the bird and put just as much care into retreating from it. I'm happy to say that when I got back to the safety of the pathway at the top of the cliff, the two Puffins were still exactly where I first saw them.

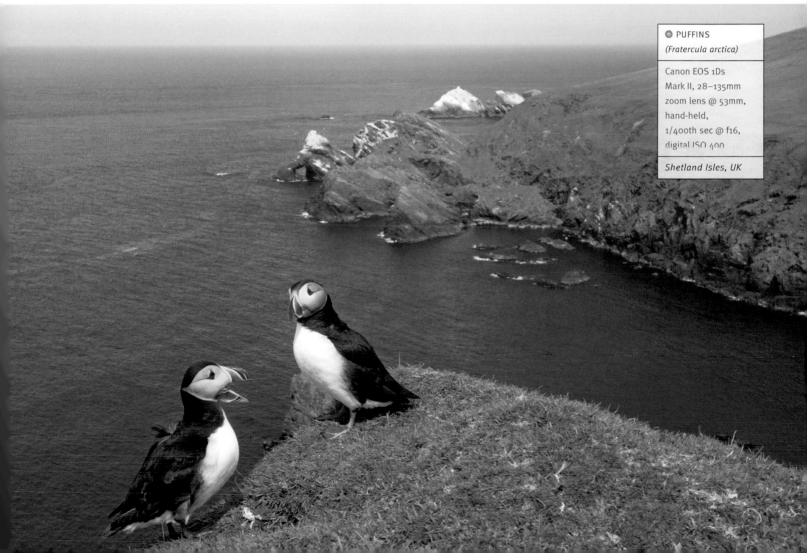

● PUFFINS
(Fratercula arctica)

Canon EOS 1Ds
Mark II, 28–135mm
zoom lens @ 53mm,
hand-held,
1/400th sec @ f16,
digital ISO 400

Shetland Isles, UK

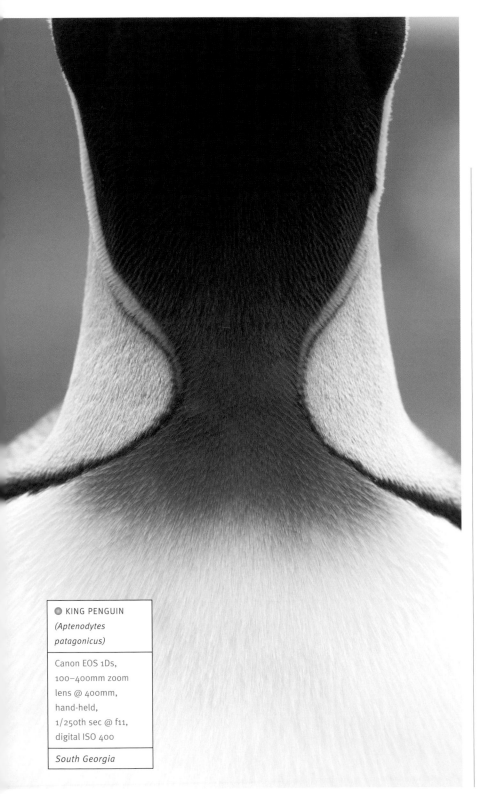

ABSTRACT

Some of the most artistically satisfying images of birds can be obtained when you see beyond the limitations imposed by the shape and location of the bird itself, and use your understanding of shape and form to produce an abstract picture that works more as a piece of art than a bird photograph. To some this may sound a little pretentious, but photography is an art form and it is no more pretentious to try and achieve an artistic goal with a camera than it is with a paintbrush. The art is the vision in your head, the craft is using the equipment (be this a camera or a paintbrush) to realize this vision. By far the most important piece of equipment in an abstract image is not the camera, or the lens, but the photographer's brain.

Salisbury Plain was the setting for the abstract of a King Penguin on the left, although I should point out that penguins haven't colonized Wiltshire and that the Salisbury Plain in question is not the one with the stone circle, but a location on the island of South Georgia that is home to a huge colony of King Penguins. I spent a couple of full days photographing these lovely birds, and as usual was looking for a new angle. When first visiting a new location or photographing a new bird, there are so many 'normal' pictures to take, covering portraits, behaviour, family life, and so on. These keep the photographer very busy, but as this type of photography is so familiar it can be done in a semi-automatic sort of mindset. This is not a criticism, because an experienced person in any occupation will be familiar with this. When creating abstracts, however, you really do need to stop and smell the flowers.

● ANDEAN FLAMINGO
(Phoenicopterus andinus)

Canon EOS 1Ds,
400mm f4 lens + 1.4x
converter, hand-held,
1/320th sec @ f8,
digital ISO 400

Gloucestershire, UK

While sitting a short distance from some King Penguins away from the main, rather crowded colony, a number of them would approach me out of curiosity, sometimes coming to just a metre away. One particular bird would throw its head back at regular intervals and call, a sound not unlike the braying of a donkey. When it did so, the characteristic orange and yellow of the neck was shown off to best advantage, so it was this that I concentrated on capturing. I decided to exclude the head and make the abstract you see opposite.

In the second image (above), it is not immediately apparent what the viewer is looking at. Exactly what it is, though, is not really the point. It is the overall impact of the subtle blends of colour and texture that make it work. The fact that it is a species of flamingo – specifically an Andean Flamingo – is irrelevant. It could be mistaken for a flower close-up until you notice the feather detail. It could even

be a dead museum specimen, but again this is not important. The result (at least to me) is a thing of beauty, unfettered by any reference to the shape or size of the bird.

At Slimbridge Wildfowl and Wetlands Trust in Gloucester, there is a captive colony of flamingos. In my experience they tend to spend a lot of their time in the large shed provided for their shelter, but early one morning a few of them were nonchantly walking around outside the shelter, sometimes coming quite close. The head of a flamingo is distinctive, so I took head shots to start with. It was a dull morning, but I knew that because I was shooting on digital I could bring out the colours to their best effect during post-processing. In fact, the overcast conditions would enable me to capture the subtle tones of the feathers much better than harsh sunlight, so I then concentrated on isolating the body of a bird and produced the image above.

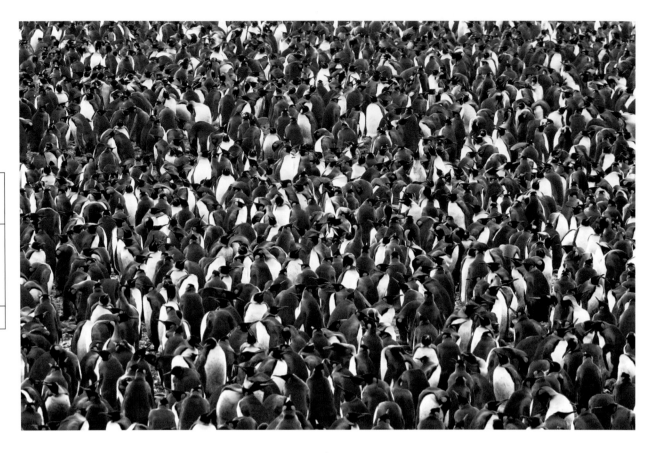

● KING PENGUINS
(Aptenodytes patagonicus)

Canon EOS 1D, 400mm lens + 1.4x converter, tripod, 1/125th sec @ f16, digital ISO 400

South Georgia

PATTERNS

Images that contain patterns of repeated subjects are popular in all types of photography. There is a strange beauty to be found in the symmetry of one object repeated many times, and we use such patterns in our everyday lives to decorate our environment on things such as furnishings, clothing and so on. Bird photography is not something that immediately springs to mind when considering creating patterns in photography, but with careful observation they can be found. As with much of bird photography, finding the opportunity is often a lot harder than executing the shot. Although some do scream out at you, like the penguins above, others take a lot more searching out through careful observation.

This image of the King Penguin colony on Salisbury Plain on the island of South Georgia was taken less than 100 metres from the King Penguin neck picture on page 142. In some ways the two photographs of the same species could not be more different, one being the detail of an individual, the other a great mass of birds. Despite this they do have something in common, in that they both have a symmetry about them, and both are studies in the same range of colours. The gathering of King Penguins in huge colonies has to be one of the most spectacular sights in the world of birds. In February when I visited South Georgia, nearly all of the birds were in adult plumage. Earlier in the year the dark brown chicks are present throughout the colony – their presence would have produced an entirely different image.

The difficulty in photographing the colony on Salisbury Plain is that, as its name suggests, it is flat. Therefore capturing the patterns made by this avian gathering at ground level was not really possible. What I needed was

some height. When scanning the edge of the colony I saw a small mound on the far edge. I made my way carefully to it, and climbed up it so that I could look down on the colony. It was only a few metres high, but it made all the difference. With a long lens I took the shot I had seen in my mind's eye when I was at ground level. Using a tripod I was able to stop down to f16, which gave me a greater depth of field to get the penguins as sharp as possible.

The second picture on the theme of patterns (right) is different from the first, because there are far fewer birds in the frame and they come nowhere near to filling it. This is a far less spectacular image than that of the King Penguins, but much more difficult to spot in the field as potential for a pattern picture. The pattern of the sleeping birds across the frame is repeated more softly by their reflections in the water. The reflection isn't perfect because of a light breeze, but it does add a considerable compositional element to the final image.

It was while I was driving around the dirt roads in the Merritt Island National Wildlife Refuge that I spotted the group of American Avocets roosting some distance away in one of the many lagoons in this superb reserve. It was high tide, so many of the wading birds had flown in from the nearby shore to rest in the shelter of the shallow lagoons. The birds are vulnerable while sleeping, so they tend to congregate towards the centre of the lagoon, where they feel safest from land-based predators. This gave me a bit of a problem because they were so far away, but by fitting a 2x converter to my 500mm lens I was able to get the image size I was looking for. Although the birds were in a straight line, I needed to position myself so that they

were parallel with the back of my camera to ensure that they would all be in focus using such a long lens. As they were roosting they were unlikely to be going anywhere quickly, so I took my time finding the right position before taking a series of shots, the best of which is shown here.

The position of the birds in the frame is critical to the success of this image, and I deliberately left the top part of the frame empty as I wanted the line of birds and their reflections off the central horizontal. The bird on the right of the image is a bit close to the edge, but as it is looking into the picture I can get away with this. Had the bird's head been up and looking right the picture wouldn't have worked – I would have needed much more space on the right-hand side of the frame for it to work.

● AMERICAN
AVOCETS
*(Recurvirostra
americana)*

Canon EOS 1D Mark II, 500mm f4 lens + 2x converter, tripod, 1/250th sec @ f13, digital ISO 200

Florida, USA

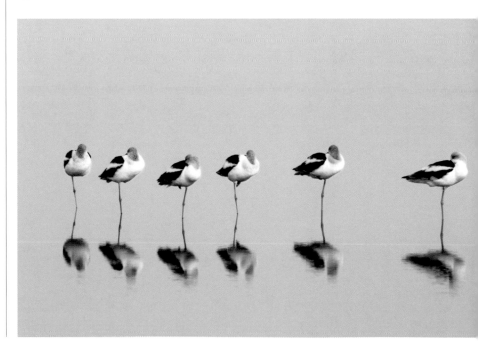

● ARCTIC TERN
(Sterna paradisaea)

Canon EOS 1N,
24mm lens, flash,
hand-held, 1/200th
sec @ around f16,
Fuji Provia 100

Farne Islands, UK

FILL FLASH FOR EFFECT

Fill flash can be used to lift the details of a bird on a dull day; it can also be used creatively to produce images that have more impact than just a straightforward shot. Fill flash involves exposing for the subject normally, then using a flashlight to put additional light onto the subject. This differs from full flash, which provides the only light on the subject and is often used when there is insufficient light for a natural light exposure. Full flash therefore often produces a black or dark background as the flash falls off with distance, but fill flash does not, as the available natural light is sufficient to correctly expose the background.

This picture of an Arctic Tern could well be entitled 'How to liven up a dull day', because this was, in effect, how it came about. I was visiting the Farne Islands off the Northumberland coast in north-east England on an afternoon when the skies had filled with white cloud.

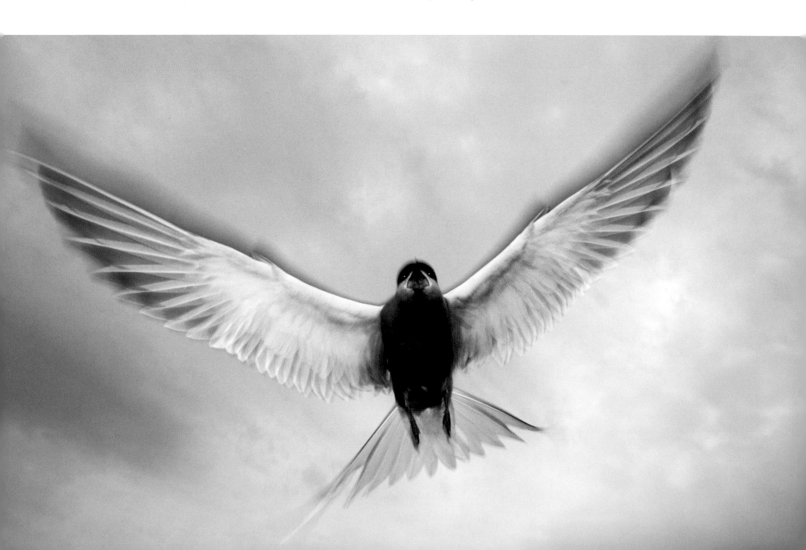

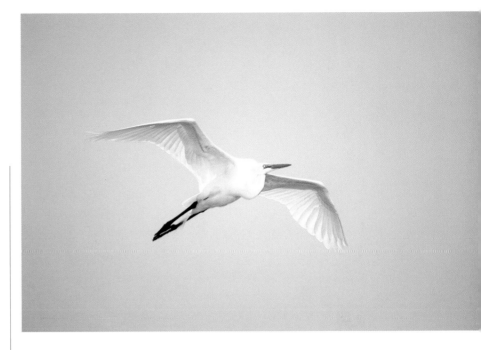

I had planned to photograph Arctic Terns as they attacked the human visitors, and was hoping for clear blue skies. Photographing birds against white skies rarely works in my experience, but then I realized that by manually controlling the exposure I could make the sky whatever shade I liked. Making the sky darker added to the drama of the picture, and by using fill flash I was able to light the main subject separately. The birds swoop in very fast and the flash only froze the final position of this bird, leaving the wings blurred at the edges and adding movement to the scene.

When photographing a fast-moving subject like this with fill flash there are effectively two exposures made. The first is by the natural light and the second by the flashlight. Because I was using a relatively slow shutter speed of 1/200th second (the flash sync speed of the camera I was using), the wings of the subject are blurred. As the flash exposure was very short the image of the bird by flashlight is sharp. It is the combination of these two exposures on the one frame that gives the interesting effect. For the best results the sharp flash exposure should be at the end of the exposure, not at the start, so you need to ensure that you use second shutter sync on your flash set-up – the flash fires just before the shutter closes, so that the sharp image is effectively 'on top' of the blurred one.

Immediately after the sun sets, the sky in the west often has just enough light for a reasonable shutter speed to be used to accurately record the sky, but any bird set against it would be badly underexposed with no direct light on it. In these conditions it is possible to use fill flash to provide the light on the bird and use the ambient light for the sky. In most cases the bird will be some distance away and you will need a telephoto lens. Modern-day flashguns are very powerful, but when using one with a telephoto lens I always use a plastic fresnel lens attached to the flashgun, which concentrates the flash in a narrow band and more than doubles the distance that the light travels.

The above picture of a Great White Egret was taken just after sunset at the Venice Rookery in Florida. The birds continue collecting nesting material and food even after sunset, so I thought this was an ideal opportunity to try out this fill flash technique. This species was an ideal subject, as its white plumage would stand out well against the pale blue/grey sky. It is also quite a slow flier, so I would be still be able to get a sharp image at the flash sync speed of only 1/250th second if I panned carefully with the bird. I manually set the ambient light exposure to capture the sky at a mid-tone, then dialled in flash compensation of minus one and a third stops to allow for the white bird.

In this image the underside of the bird is nicely lit and detailed. It has a slightly surreal look, as if the bird has been cut out and placed against the sky. The bird's eye has reflected the flash more effectively than the feathers, which adds a slight spookiness to the picture.

GREAT WHITE EGRET *(Casmerodius albus)*
Canon EOS 1D Mark II, 500mm f4 lens, flash, tripod, 1/250th sec @ f4, digital ISO 200
Florida, USA

MOVEMENT — SLOW PAN

We normally use fast shutter speeds to effectively freeze a moment in time, but to show movement we generally need to use a much slower shutter speed to allow some of that movement to be recorded, usually as a blur. One of the ways to do this is to track the bird during the movement by carefully following it in the viewfinder while making the exposure, a technique that is known as the slow pan.

The trick is to pan with the bird at exactly the same speed as it is travelling, and with practice this is not too difficult to achieve. In this picture of the Whooper Swan running across the water, the bird's wings and feet are lost in a blur, but the head is relatively sharp. A clearly visible head always lifts an image, but is quite difficult to achieve. The key to achieving such a shot lies in keeping the pan smooth, with no movement other than in the direction in which the bird is moving. If your pan is faster or slower than the bird, the head will be blurred, while any vertical movement will blur the head even more.

Setting a shutter speed of around 1/15th of a second works well for large, relatively slow birds. To be able to use such a slow shutter speed, you'll probably need an overcast day when the light is not too bright, or to shoot very early in the morning or late in the evening.

I also set the digital ISO to its minimum setting (typically ISO 50, referred to as simply 'Low' on many cameras), and the aperture is whatever I need to shoot at my required shutter speed. In this case this was f16, although I prefer f11 or larger to reduce the effect of any small specks of dust on the sensor that show up really badly at small apertures.

● WHOOPER SWAN
(Cygnus cygnus)

Canon EOS 1Ds Mark II, 500mm f4 lens + 1.4x converter, tripod, 1/15th sec @ f16, digital ISO 50

UK

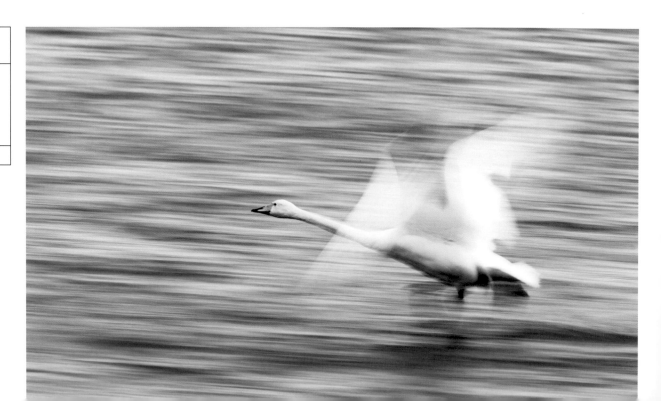

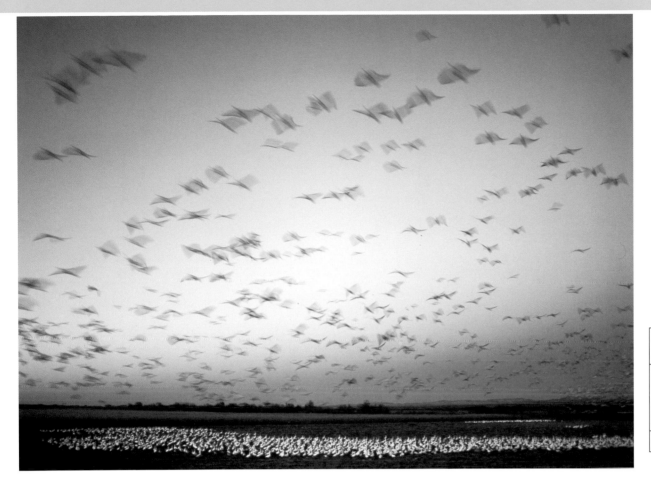

● SNOW GEESE
(Anser caerulescens)

Canon EOS 1N,
24mm lens, tripod,
around 1/8th sec
@ f11, Fuji Provia 100

New Mexico, USA

MOVEMENT
WITHOUT PANNING

The other technique that is used to record movement is to again use a slow shutter speed, but instead of panning with the movement of the subject you keep the camera still. This results in a completely different effect from the slow pan, because the birds are recorded as blurs as they move across the film plane. How much blurring occurs is dependent on both how fast the birds are flying and how slow the shutter speed is. Conditions best for this type of photography are when there is low light, otherwise it is difficult to obtain a low enough shutter speed, even at small apertures. With digital cameras the situation is even worse, because using a small aperture such as f22 or f32 will show up every single small dot of dust on your sensor,

which would probably not be visible at around f8 or f5.6. With the ability to switch the ISO speed so easily with digital cameras, it is a pity that you cannot set it to below 50 – a speed of 10 ISO or even lower would be very useful for this type of work. Camera manufacturers seem to be concentrating their efforts in the other direction, constantly seeking low-grain high-ISO images, but I'm sure that many photographers would find the ability to increase the range at the lower end very useful as well.

The above image of Snow Geese taking off is another from Bosque Del Apache. It was just after sunset and a couple of large flocks of geese were still on their feeding grounds. I knew these would soon leave to fly to their roost site, so I set up my camera with a wide-angle lens, ready for the action. It was the furthest of the two flocks that took off first, and as they flew over the nearest group they made

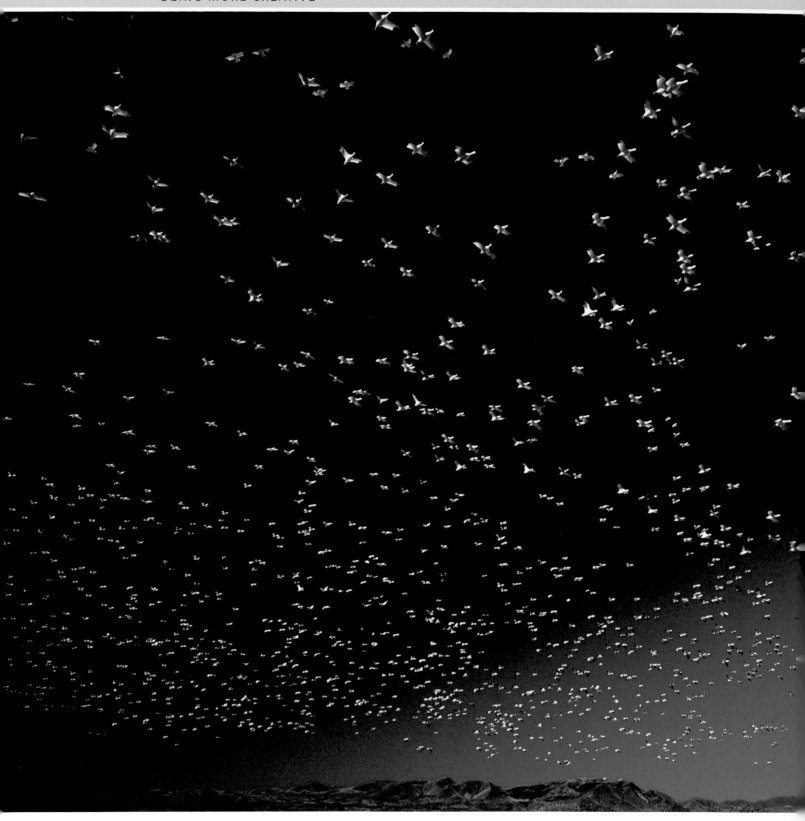

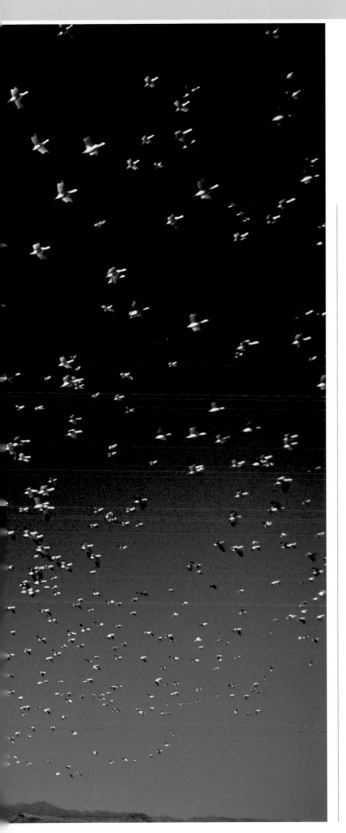

a wonderful contrast with the flock on the ground, which came out sharp compared to the blurred movement of the geese in flight above them. When making images like this it is often a good idea to have a non-moving object in the frame to anchor the picture and emphasize the movement of the birds. In this case I was able to use the flock of geese on the ground, but a tree, reeds in a marsh or even a fence would add that extra element.

● SNOW GEESE
(Anser caerulescens)

Canon EOS 1N,
20mm zoom lens,
polarising filter,
hand-held,
exposure unrecorded,
Fuji Provia 100

New Mexico, USA

POLARISER

I have always loved the effect of a polarising filter on clear blue skies, and nearly always use one when photographing landscapes. In fact, to be honest I overuse the polariser in many of my landscapes and turn the sky far too dark. The agents trying to sell my work are not impressed with such abnormal skies, but I love the surreal effect of the almost blackness, although clearly this is not very commercial. A polarising filter is very good at making the fluffy white clouds stand out against a blue sky, so I thought it could well have the same effect on the fluffy white Snow Geese at Bosque Del Apache – and it did.

The geese were flying around our heads as usual at Bosque Del Apache on a bright, sunny day without a cloud to be seen. As they circled, the geese were coming very low over the dirt road on which we were standing, so I decided to try out something a bit different and fitted my camera with a 20mm lens and a polarising filter. You can see the effect of the polarising filter as you rotate it in its mount, and I set it to maximum effect. To enhance the effect even

more I pointed my camera at 90 degrees from the sun, which made the sky look almost black. Exposure was very difficult indeed, because it would be extremely easy to overexpose the white birds against the blackened sky, but I used the dirt road as my mid-tone and underexposed one stop from that, which proved about right. With such a wide-angle lens it would have been easy to get the horizon crooked, so I concentrated on this and let the birds fly into the frame. I wanted the hills at the bottom of the frame to anchor the shot.

Does it look natural? No. Does this matter? You must make up your own mind, but the whole point of this shot was to produce a surreal image, something beyond a simple record of what was happening at the time and, above all, something that I, personally, was pleased with.

MINIMALIST

Bird photographers spend a lot of effort getting close enough to their subjects to make a large image, and close-up pictures of birds are very popular and commercial. It is possible, however, to take interesting pictures where the bird or birds make up a very small, but essential element of the overall image. I refer to these images as minimalist bird pictures, and it is important to distinguish them from the numerous bird pictures in which the main subject is simply too small in the frame. In a minimalist image, however small the bird is in the frame, not only is it important to the overall composition, but also the viewer's eye is instantly drawn to it because it is at the very heart of the picture.

Bosque Del Apache provides another picture to demonstrate this approach. A stormy sky gave a dramatic backdrop, and I searched carefully around the horizon for an interesting scene. The shape of a distant hill attracted me, but because I wanted to include the amazing contrast between the black cloud and the sunlit clouds just below it, I had to turn the camera through 90 degrees into the portrait format to include both elements. This was the shot I wanted, but there were no birds to be found that I could use as the focal point of the composition. Bosque is, however, such a great place for birds that I thought a crane or Snow Goose was bound to fly by at some stage, so I held my position. I knew the cloud and sun combination wouldn't last for long, so it was a relief when I spotted two cranes approaching in the distance. They seemed to be heading in the direction I wanted, but would they keep to their current course? I waited and waited, and at last they appeared exactly where I wanted them in the viewfinder and I got the shot.

The position of the cranes in the 'empty', plain area of the image is important – they would be lost against the dark shadows or the bright sky. They are actually one behind the other, but you can't really tell this from the picture and they appear to be side by side. They were matching wingbeats, so both cranes have their wings in the same position, which adds to the composition. With the main subject being so small it is important that you don't put it smack in the middle of the picture, because this doesn't really work. Here I was restricted as to where I could put the cranes, but they are both above and to the right of the frame centre.

SANDHILL CRANES
(Grus canadensis)

Canon EOS 1V,
500mm f4 lens, tripod,
exposure unrecorded,
Fuji Provia 100

New Mexico, USA

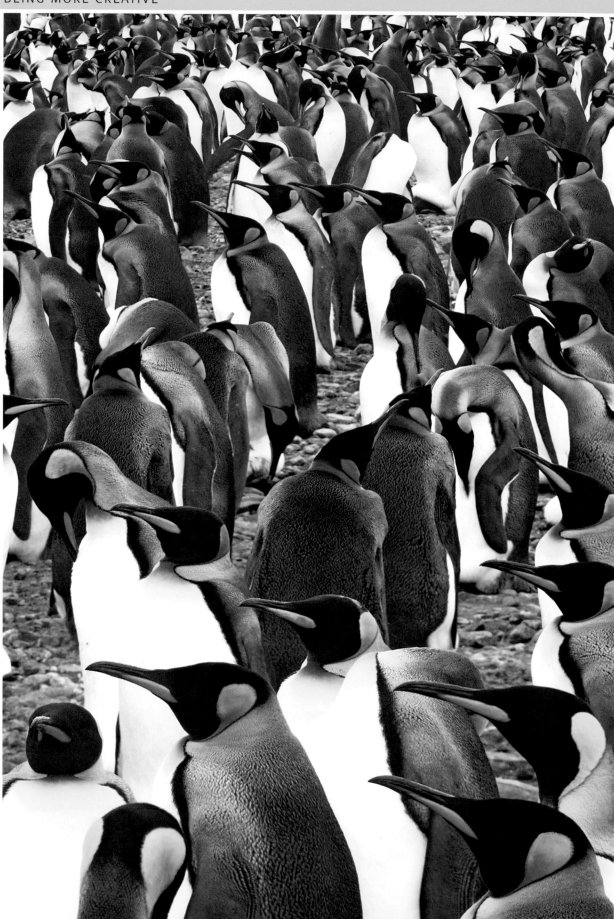

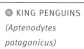 KING PENGUINS
(Aptenodytes patagonicus)

Canon EOS 1D Mark II, 90mm tilt and shift lens, tripod, 1/125th sec @ f9, digital ISO 400

South Georgia

TILT AND SHIFT LENS

Tilt and shift lenses are very specialized lenses that I most often use for fields of flowers. Put very simply, the shift mechanism is used to control perspective and allows you to straighten vertical lines of, say, tall buildings, when you point your camera up to photograph them. I hardly ever use this, because it's the tilt mechanism that interests me. This allows you to change the plane of focus by tilting the lens forwards or backwards until it matches the subject you are photographing.

With any lens the plane of focus is parallel to the back of the camera, so when photographing a flat subject like a field of flowers, unless you are hanging directly above the field (nice trick if you can do it), only a slim band of flowers will be in sharp focus. By using the tilt mechanism you can alter the plane of focus so that it is no longer parallel to the back of the camera, but parallel to the field you are photographing. This means that most of the flower field will be in focus. Now I'm sure that the technical explanation as to how this works is a lot more complicated than this, but let's not worry too much about that – the point is that it works.

Having seen the massed ranks of King Penguins on South Georgia before I went to Antarctica, I decided that what a tilt and shift could do to a field of flowers it could do to a field of penguins, so I took it with me. When I reached Salisbury Plain in South Georgia, the penguins were stretched out before me as I had expected. I set up my Canon 90mm tilt and shift on the Canon EOS 1D Mark II body, which gave me an effective 117mm lens, and slowly approached the edge of the colony. I didn't get too close, but as I waited patiently the penguins gradually filled the space in front of me and I was ready for my shot. The conditions were quite overcast so it wasn't particularly bright, but using the tilt mechanism I was able to shoot the scene at f9 and get everything in focus, something that would have been impossible with a normal lens even if I had stopped down to f32, which would have led to an impossibly slow shutter speed anyway.

I wanted the penguins in the foreground to be large in the frame, but they were constantly on the move and the scene was changing by the second. When the penguins to the right of the frame paused and started looking around, I concentrated on them, taking the shot at a moment when they all briefly looked in the same direction. I can't say I've used this very specialized lens often for bird photography, but when the circumstances dictate it can be useful for something a little different. After all, that's what producing interesting pictures is all about.

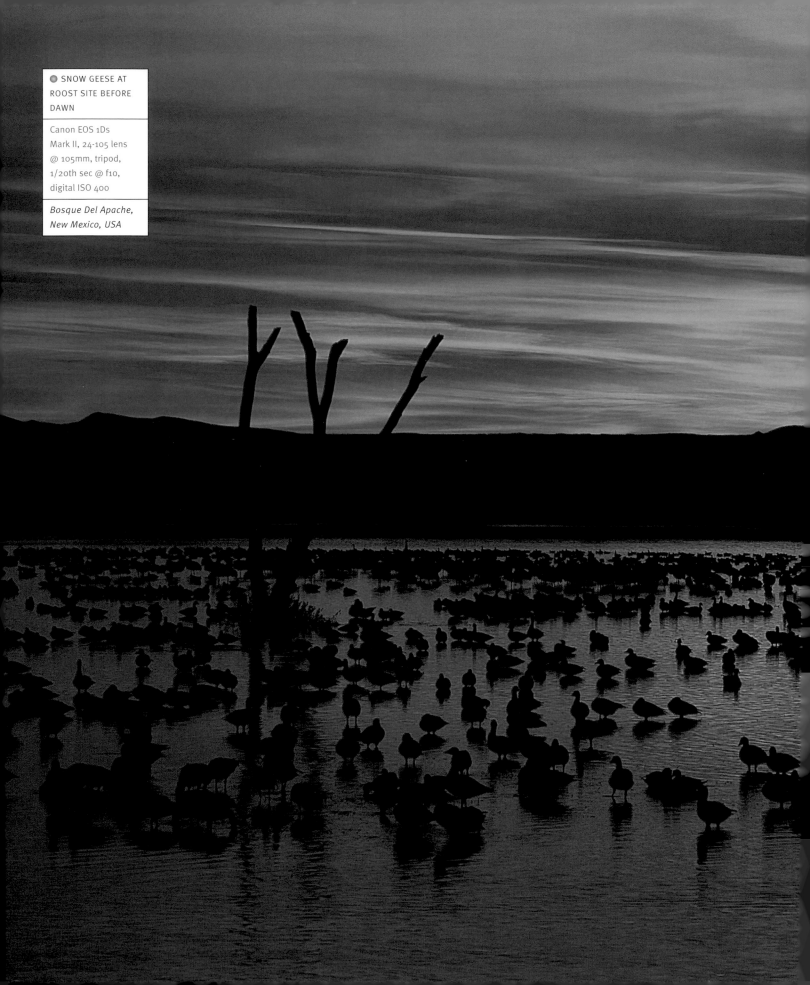

SNOW GEESE AT
ROOST SITE BEFORE
DAWN

Canon EOS 1Ds
Mark II, 24-105 lens
@ 105mm, tripod,
1/20th sec @ f10,
digital ISO 400

Bosque Del Apache,
New Mexico, USA

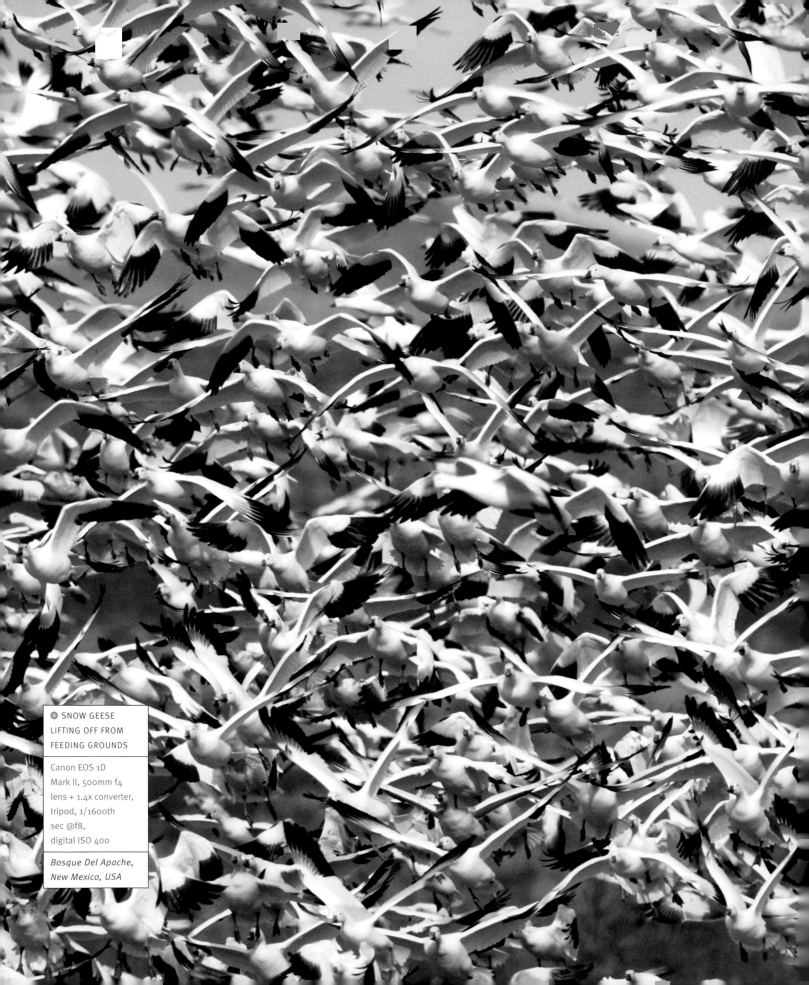

SNOW GEESE
LIFTING OFF FROM
FEEDING GROUNDS

Canon EOS 1D
Mark II, 500mm f4
lens + 1.4x converter,
tripod, 1/1600th
sec @f8,
digital ISO 400

*Bosque Del Apache,
New Mexico, USA*

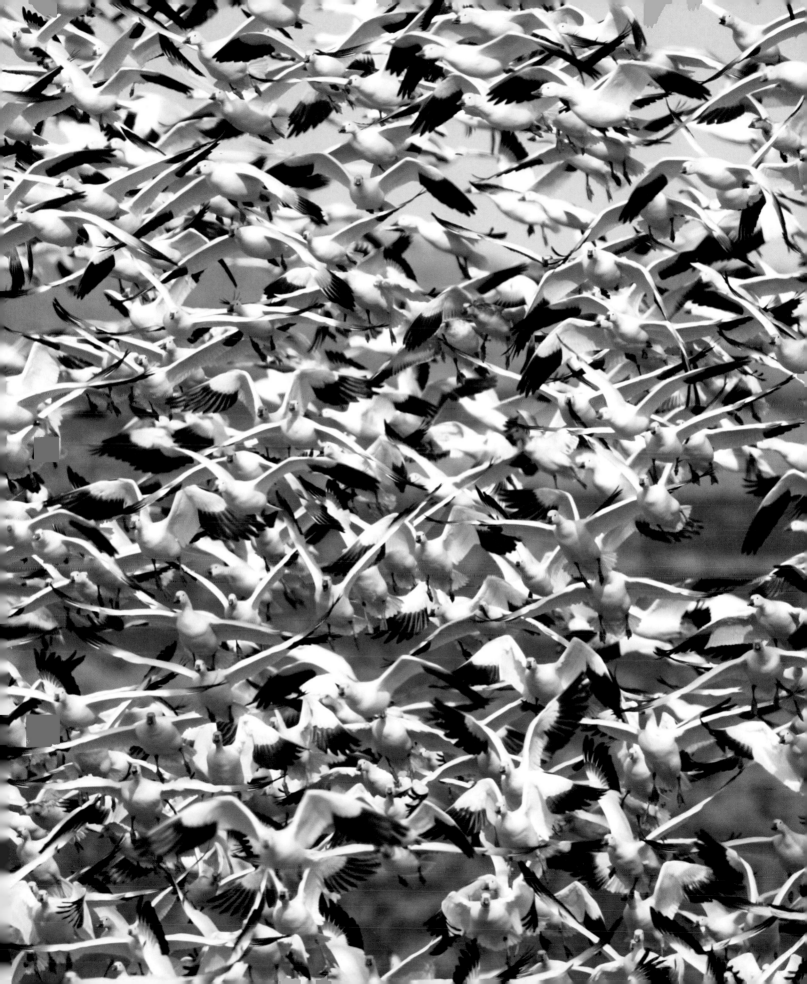